The
Substance
of
Style

How the Rise of Aesthetic Value

Is Remaking Commerce,

Culture, and Consciousness

HarperCollins*Publishers*

The
Substance
of
Style

VIRGINIA POSTREL

HarperCollins books may be purchased for educational, business, or sales promotional use. For information, please write: Special Markets Department, HarperCollins Publishers Inc., 10 East 53rd Street, New York, NY 10022.

FIRST EDITION

DESIGNED BY SARAH MAYA GUBKIN

Printed on acid-free paper

Library of Congress Cataloging-in-Publication Data

Postrel, Virginia I.
 The substance of style: how the rise of aesthetic value is remaking commerce, culture, and consciousness / Virginia Postrel.
 p. cm.
 Includes index.
 ISBN 0-06-018632-1
 1. Aesthetics. I. Title.

 BH39.P6692 2003
 111'.85—dc21
 2002191276

03 04 05 06 07 ❖/RRD 10 9 8 7 6 5 4 3 2 1

To Steven

And in memory of

Edith Efron and Margaret Inman

CONTENTS

PREFACE

As soon as the Taliban fell, Afghan men lined up at barbershops to have their beards shaved off. Women painted their nails with once-forbidden polish. Formerly clandestine beauty salons opened in prominent locations. Men traded postcards of beautiful Indian movie stars, and thronged to buy imported TVs, VCRs, and videotapes. Even burka merchants diversified their wares, adding colors like brown, peach, and green to the blue and off-white dictated by the Taliban's whip-wielding virtue police. Freed to travel to city markets, village women demanded better fabric, finer embroidery, and more variety in their traditional garments.

When a Michigan hairdresser went to Kabul with a group of doctors, nurses, dentists, and social workers, she intended to serve as an all-purpose assistant to the relief mission's professionals. Instead, she found her own services every bit as popular as the serious business of health and welfare. "When word got out there was a hairdresser in the country, it just got crazy," she said. "I was doing haircuts every fifteen minutes."

Liberation is supposed to be about grave matters: elections, education, a free press. But Afghans acted as though superficial things

were just as important. As a political commentator noted, "The right to shave may be found in no international treaty or covenant, but it has, in Afghanistan, become one of the first freedoms to which claim is being laid."

That reaction challenged many widely held assumptions about the nature of aesthetic value. While they cherish artworks like the giant Bamiyan Buddhas leveled by the Taliban, social critics generally take a different view of the frivolous, consumerist impulses expressed in more mundane aesthetic pleasures. "How depressing was it to see Afghan citizens celebrating the end of tyranny by buying consumer electronics?" wrote Anna Quindlen in a 2001 Christmas column berating Americans for "uncontrollable consumerism."

Respectable opinion holds that our persistent interest in variety, adornment, and new sensory pleasures is created by advertising, which generates "the desire for products consumers [don't] need at all," as Quindlen put it, declaring that "I do not need an alpaca swing coat, a tourmaline brooch, a mixer with a dough hook, a CD player that works in the shower, another pair of boot-cut black pants, lavender bath salts, vanilla candles or a KateSpadeGucciPradaCoach bag."

What's true for New Yorkers should be true for Afghans as well. Why buy a green burka when you're a poor peasant and already have two blue ones? Why paint your nails red if you're a destitute widow begging on the streets? These indulgences seem wasteful and irrational, just the sort of false needs encouraged by commercial manipulation. Yet liberated Kabul had no ubiquitous advertising or elaborate marketing campaigns. Maybe our desires for impractical decoration and meaningless fashion don't come from Madison Avenue after all. Maybe our relation to aesthetic value is too fundamental to be explained by commercial mind control.

Human beings know the world, and each other, through our senses. From our earliest moments, the look and feel of our surroundings tell us who and where we are. But as we grow, we imbibe a different lesson: that appearances are not just potentially deceiving but frivolous and unimportant—that aesthetic value is not real except in those rare instances when it transcends the quotidian to become high art.

We learn to contrast surface to substance, to believe that our real selves and the real world exist beyond the superficiality of sensation. We have good cause, of course, to doubt the simple evidence of our senses. The sun does not go around the earth. Lines of the same length can look longer or shorter depending on how you place arrows on their ends. Beautiful people are not necessarily good, nor are good people necessarily beautiful. We're wise to maintain reasonable doubts.

But rejecting our sensory natures has problems of its own. When we declare that mere surface cannot possibly have legitimate value, we deny human experience and ignore human behavior. We set ourselves up to be fooled again and again, and we make ourselves a little crazy. We veer madly between overvaluing and undervaluing the importance of aesthetics. Instead of upholding rationality against mere sensuality, we tangle ourselves in contradictions.

This book seeks to untangle those confusions, by examining afresh the nature of aesthetic value and its relation to our personal, economic, and social lives. It's important to do so now, because sensory appeals are becoming ever more prominent in our culture. To maintain a healthy balance between substance and surface, we can no longer simply pretend that surfaces don't matter. Experience suggests that the comfortable old slogans, and the theories behind them, are wrong.

Afghanistan is not the only place where human behavior confounds conventional assumptions, raising questions about the sources of aesthetic value. Consider "authenticity," which aesthetic authorities consider a prime measure of worth. Here, too, experience suggests a more complex standard, or perhaps a more subjective definition of what's authentic, than intellectual discourse usually provides.

Built atop one of the hills that divide the San Fernando Valley from the core of Los Angeles, Universal CityWalk is deliberately fake. Its architect calls the open-air shopping mall "a great simulacrum of what L.A. should do. This isn't the L.A. we did get, but it's the L.A. we could have gotten—the quintessential, idealized L.A." Like the rest of Los Angeles, CityWalk's buildings are mostly

stucco boxes. Their aesthetic energy comes from their façades, which are adorned with bright signs, colorful tiles, video screens, murals, and such playful accessories as a giant King Kong. Unlike the typical shopping center, CityWalk has encouraged its tenants to let their decorative imaginations run wild. The place has a tiny artificial beach and, of course, palm trees. A fountain shoots water up through the sidewalk. A fictional radio station sells hamburgers, and a real museum displays vintage neon signs. The three blocks of city "street" are off-limits to vehicles.

When CityWalk opened in 1993, it was roundly condemned as an inauthentic facsimile of real city life. Intellectuals saw only a fortress, a phony refuge from the diversity and conflict of a city recently torn by riots. A conservative journalist called it "Exhibit A in a hot new trend among the beleaguered middle classes: bunkering," while a liberal social critic said CityWalk "has something of the relationship to the real city that a petting zoo has to nature."

The public reacted differently. Almost immediately, CityWalk became not a bunker but a grand mixing zone. "Suddenly CityWalk was full of people. And they were all grinning," wrote a delighted veteran of European cafés shortly after the new mall opened. He predicted that the artificial city street would soon become a beloved hangout, that locals would never want to leave. He was right. A decade later, CityWalk may be "the most vital public space in Los Angeles," declares a magazine report. On a Saturday night,

> *People from all across L.A. have gathered here in one great undifferentiated mass, as they rarely do in the city itself. Toddlers are tearing across CityWalk's sidewalk fountain. Salvadoran, Armenian, Korean, black, and white, they squeal as the hidden water jets erupt, soaking their overalls. Hundreds of teenagers who have made CityWalk their hangout are picking each other up and sucking down frozen mochas. Families from Encino to East L.A. are laughing, stuffing their faces, gawking at the bright spires of light.*

So much for the assumption that artifice and interaction are contradictory, that the only experience a "simulacrum" can produce is inauthentic. By offering a place of shared aesthetic pleasures, CityWalk has created not an isolated enclave but a space where people from many different backgrounds can enjoy themselves together.

Half a world away is an even more artificial environment, where not only the street but the sky itself is fake. The social results are similar. "It's a very special building, very different, very beautiful," says a black South African of Johannesburg's Montecasino, a casino that replicates a Tuscan village, right down to imported cobblestones and an old Fiat accumulating parking tickets by the side of the make-believe road. Unlike many places in Johannesburg, Montecasino attracts a racially mixed crowd, including unemployed black men who chat beneath its artificial trees and watch the gamblers at play. Like CityWalk, the casino offers its aesthetic pleasures to all comers. Its deracinated design is central to its appeal.

"Montecasino imposes nothing on anyone. It is completely, exuberantly fake," writes a Togo-based critic. "And, as in Las Vegas, it is this fakeness that ensures its egalitarian popularity. Blacks and whites feel equally at home in this reassuringly bogus Tuscany. The price of democracy, it would seem, is inauthenticity." Or maybe something is wrong with aesthetic standards that would deny people pleasures that don't conform to their particular era or ethnicity. Maybe we've misunderstood the meaning and value of authenticity.

And perhaps our love of fine art has similarly blinded us to the nature of aesthetic appeals. While "art" can certainly be a meaningful category, it can also be deceptive, forcing sensory value into a transcendent ghetto separated from the rest of life. Again, recent experience offers a cautionary tale.

Like most museums, the Cooper-Hewitt, National Design Museum, in New York owns a much larger collection than it has space to display. While its exhibits mostly showcase finished artifacts, the offstage collection includes boxes and boxes of designers' drawings—not art to be displayed but instructions to be followed. In April

2002, Timothy Clifford, director of the National Galleries of Scotland, went through about eight thousand of those drawings as research for a book about the relationship between the fine and applied arts. In Box D366, which was labeled "Lighting Fixtures II," he made an extraordinary find:

> *It's a big drawing of a candlestick in black chalk, heightened by a brown wash applied by brush, with some under-drawing done with a stylus. . . . It not only shows the elevation of the drawing, but also the plan of the object. I believe it was going to be cut in marble. It is of a massive candelabrum, about 15ft-high—probably commissioned for the tomb of Pope Leo X di Medici, and never used.*

Clifford identified the sketch as the work of Michelangelo. Other experts concurred.

If a drawing is by Michelangelo, we presume it's art. But the candlestick sketch is still a blueprint—a design, not a display piece. It's not even clear that Michelangelo himself would have constructed the candelabrum. Like architecture, artifacts need not be crafted by their creators. Today's commentators denounce art museums for "dumbing-down" their exhibits with motorcycles, guitars, and Armani clothes, but the line between art and artifacts was not always so rigid. "Renaissance artists of the highest caliber were commissioned to design decorative objects such as lamps, salt cellars and tapestries," notes a Cooper-Hewitt decorative-arts expert. Modern manufacturing does not reduce the importance of initial design.

You no longer have to be a Medici to enjoy aesthetic abundance, including ever more customized combinations. Not only monuments but the humblest of objects increasingly embody fine design. This book is not about art per se but about the profusion of style in everyday life. It is about life and work, pleasure and meaning, in a new age of aesthetics.

Several themes run throughout the book: that aesthetic value is subjective and can be discovered only through experience, not deduced in advance; that sensory pleasure and meaning are funda-

mental, biologically based human wants but that their particular expressions vary; that people make different trade-offs among goods depending on the alternatives they face; and that aesthetics is not a value set off from the rest of life. Decoration and adornment are neither higher nor lower than "real" life. They are part of it.

The

Substance
of
Style

One

THE AESTHETIC
IMPERATIVE

People don't generally go to Selkirk, New York, to look for the future. Manhattan, yes. L.A., San Francisco, even Seattle. But not Selkirk.

There are a million people in a fifteen-mile radius, my host tells me, but you wouldn't know it as we drive past snow-covered fields. The place looks empty. We're a few miles outside Albany, in what might as well be rural New England. Western Massachusetts is less than half an hour away, Vermont not much farther.

The area is much more influential than the picturesque country-side suggests. Selkirk is smack in the middle of General Electric territory, snuggled between the research labs and power systems operations in Schenectady and the GE Plastics headquarters in Pittsfield, Massachusetts. That means Selkirk is more than just another out-of-the-way place, because GE is more than just another

big corporation. GE has been, year after year, the most admired company in the business world, an enterprise known for its technological prowess, consistent growth, and hardheaded management.

We turn up a narrow drive and park in front of a small building, the sort of corrugated prefab structure that might house a small construction company or insurance office. This modest site is the American center of a multimillion-dollar bet on the future. GE Plastics believes we're entering an era in which the look and feel of products will determine their success. Sensory, even subliminal, effects will be essential competitive tools. GE wants to make those tools, and to help customers use them more effectively.

"Aesthetics, or styling, has become an accepted unique selling point—on a global basis," explains the head of the division's global aesthetics program. Functionality still matters, of course. But competition has pushed quality so high and prices so low that many manufacturers can no longer distinguish themselves with price and performance, as traditionally defined. In a crowded marketplace, aesthetics is often the only way to make a product stand out. Quality and price may be absolutes, but tastes still vary, and not every manufacturer has already learned how to make products that appeal to the senses.

The modest building in Selkirk houses a design center that customers can visit to brainstorm and develop new products, inspired by the materials available to make them. Instead of just telling engineers and purchasing managers how cheaply GE can sell them raw materials, plastics managers now listen to industrial designers and marketing people "talk about their dreams."

We enter through humdrum gray offices, walk through the plant floor where plastic samples are mixed with pigments and extruded, and open a bright blue door. On the other side lies an entirely different environment, designed for creativity and comfort rather than low-cost function. This end of the building proclaims the importance of aesthetics for places as well as plastics. Gone are the utilitarian grays of cubicles and indoor-outdoor carpet, replaced by contrasting blue and white walls, light wood floors, shelves of design books, and comfortable couches for conversation. Customers' hit products are

displayed in museum-lit alcoves: Iomega's Zip drive in translucent dark blue plastic, the Handspring Visor in a paler shade.

The center's most striking room isn't "decorated" at all. It's lined with row upon row of GE Plastics' own products—about four thousand sample chips, each a little smaller than a computer diskette, in a rainbow of colors and an impressive range of apparent textures. Since 1995, the company has introduced twenty new visual effects. Its heavy-duty engineering thermoplastics can now emulate metal, stone, marble, or mother-of-pearl; they can diffuse light or change colors depending on which way you look; they can be embedded with tiny, sparkling glass fragments. The special-effects plastics command prices from 15 percent to more than 100 percent higher than ordinary Lexan or Cycolac. With that incentive, company researchers are busy coming up with new effects, having accelerated introductions in 2001 and 2002. "The sky's the limit," says a spokesman.

The Selkirk plant will mix up a batch of any color you can imagine, and the company prides itself on turning barely articulated desires into hard plastic: "You know how the sky looks just after a storm? When it's late afternoon? But right at the horizon, not above it? When the sun has just come out? *That* color." That's from a GE Plastics ad. In the real world, designers come to Selkirk to play around with color, paying the company thousands of dollars for the privilege. That's how the trim on Kyocera's mobile phone went from bright silver to gunmetal gray. The project's lead engineer told technicians he wanted something more masculine. "I figured that they would look at me as if I were nuts. But they didn't," he says. "They came back a few minutes later with exactly what we wanted." Once you've got the perfect color, the Selkirk center will (for a fee) preserve a pristine sample in its two-thousand-square-foot freezer. More than a million color-sample chips are filed in the freezer's movable stacks, protected from the distorting effects of heat and light.

At the end of my visit, GE managers talk a bit about their own aesthetic dreams. Already, researchers have figured out how to make plastics feel heavy, for times when heft conveys a tacit sense of quality. Coming soon are joint ventures that will let customers put GE

effects into materials the company doesn't make. Squishy "soft-touch" plastics won't have to look like rubber. Cushy grips will be translucent and sparkle, to coordinate with diamond-effect GE plastics. And somewhere in the aesthetic future are plastics that smell. "I love the smell of suntan lotion," says a manager, laughing at his own enthusiasm, "but that's just me." He imagines sitting in his office in snowy New England with a computer that exudes the faint scent of summer at the beach.

GE is betting real money on such imaginative leaps—on a future that will sparkle like diamonds and smell like summer, that will offer every color that delights the eye and every texture that pleases the touch, on a future of sensory riches. GE believes in an aesthetic age.

This is not a hip San Francisco style shop. These executives don't get their photos in fashion magazines or go to celebrity-filled parties. They don't dress in black, pierce their eyebrows, or wear Euro-style narrow eyeglasses. This is General Electric. Jack Welch's company. Thomas Edison's company. An enterprise dedicated to science, engineering, and ruthless financial expectations. A tough company, macho even. GE doesn't invest in ideas just because they sound cool. When a trend comes to Selkirk, it's no passing fancy.

The twenty-first century isn't what the old movies imagined. We citizens of the future don't wear conformist jumpsuits, live in utilitarian high-rises, or get our food in pills. To the contrary, we are demanding and creating an enticing, stimulating, diverse, and beautiful world. We want our vacuum cleaners and mobile phones to sparkle, our bathroom faucets and desk accessories to express our personalities. We expect every strip mall and city block to offer designer coffee, several different cuisines, a copy shop with do-it-yourself graphics workstations, and a nail salon for manicures on demand. We demand trees in our parking lots, peaked roofs and decorative façades on our supermarkets, auto dealerships as swoopy and stylish as the cars they sell.

Aesthetics has become too important to be left to the aesthetes. To succeed, hard-nosed engineers, real estate developers, and MBAs

must take aesthetic communication, and aesthetic pleasure, seriously. We, their customers, demand it.

"We are by nature—by deep, biological nature—visual, tactile creatures," says David Brown, the former president of the Art Center College of Design in Pasadena, California, and a longtime observer of the design world. That is a quintessential turn-of-our-century statement, a simultaneous affirmation of biological humanity and aesthetic power. Our sensory side is as valid a part of our nature as the capacity to speak or reason, and it is essential to both. Artifacts do not need some other justification for pleasing our visual, tactile, emotional natures. Design, says Brown, is moving from the abstract and ideological—"this is good design"—to the personal and emotional— "I *like* that." In this new age of aesthetics, we are acknowledging, accepting, and even celebrating what a design-museum curator calls our "quirky underside."

This trend doesn't mean that a particular style has triumphed or that we're necessarily living in a period of unprecedented creativity. It doesn't mean everyone or everything is now beautiful, or that people agree on some absolute standard of taste. The issue is not *what* style is used but rather *that* style is used, consciously and conscientiously, even in areas where function used to stand alone. Aesthetics is more pervasive than it used to be—not restricted to a social, economic, or artistic elite, limited to only a few settings or industries, or designed to communicate only power, influence, or wealth. Sensory appeals are everywhere, they are increasingly personalized, and they are intensifying.

Of course, saying that aesthetics is pervasive does not imply that look and feel trump everything else. Other values have not gone away. We may want mobile phones to sparkle, but first we expect them to work. We expect shops to look good, but we also want service and selection. We still care about cost, comfort, and convenience. But on the margin, aesthetics matters more and more. When we decide how next to spend our time, money, or creative effort, aesthetics is increasingly likely to top our priorities.

In this context, "aesthetics" obviously does not refer to the philos-

ophy of art. Aesthetics is the way we communicate through the senses. It is the art of creating reactions without words, through the look and feel of people, places, and things. Hence, aesthetics differs from entertainment that requires cognitive engagement with narrative, word play, or complex, intellectual allusion. While the sound of poetry is arguably aesthetic, the meaning is not. Spectacular special effects and beautiful movie stars enhance box-office success in foreign markets because they offer universal aesthetic pleasure; clever dialogue, which is cognitive and culture-bound, doesn't travel as well. Aesthetics may complement storytelling, but it is not itself narrative.

Aesthetics shows rather than tells, delights rather than instructs. The effects are immediate, perceptual, and emotional. They are not cognitive, although we may analyze them after the fact. As a mid-century industrial designer said of his field, aesthetics is "fundamentally the art of using line, form, tone, color, and texture to arouse an emotional reaction in the beholder."

Whatever information aesthetics conveys is prearticulate—the connotation of the color and shapes of letters, not the meanings of the words they form. Aesthetics conjures meaning in a subliminal, associational way, as our direct sensory experience reminds us of something that is absent, a memory or an idea. Those associations may be universal, the way Disney's big-eyed animals play on the innate human attraction to babies. Or they may change from person to person, place to place, moment to moment.

Although we often equate aesthetics with beauty, that definition is too limited. Depending on what reaction the creator wants, effective presentation may be strikingly ugly, disturbing, even horrifying. The title sequence to *Seven*—whose rough, backlit type, seemingly stuttering film, and unsettling sepia images established a new style for horror films—comes to mind. Or aesthetics may employ novelty, allusion, or humor, rather than beauty, to arouse a positive response. Philippe Starck's fly swatter with a face on it doesn't represent timeless beauty. It's just whimsical fun.

Aesthetic effects begin with universal reactions, but these effects

always operate in a personal and cultural context. We may like weather-beaten paint because it seems rustic, black leather because it makes us feel sexy, or fluffy pop music because it reminds us of our youth. Something novel may be interesting, or something familiar comforting, without regard to ideal beauty. The explosion of tropical colors that hit women's fashion in 2000 was a relief from the black, gray, and beige of the late 1990s, while those neutrals looked calm and sophisticated after the riot of jewel tones that preceded them. Psychologists tell us that human beings perceive changes in sensory inputs—movement, new visual elements, louder or softer sounds, novel smells—more than sustained levels.

Because aesthetics operates at a prerational level, it can be disquieting. We have a love-hate relationship with the whole idea. As consumers, we enjoy sensory appeals but fear manipulation. As producers, we'd rather not work so hard to keep up with the aesthetic competition. As heirs to Plato and the Puritans, we suspect sensory impressions as deceptive, inherently false. Aesthetics is "the power of provocative surfaces," says a critic. It "speaks to the eye's mind, overshadowing matters of quality or substance."

But the eye's mind is identifying something genuinely valuable. Aesthetic pleasure itself has quality and substance. The look and feel of things tap deep human instincts. We are, as Brown says, "visual, tactile creatures." We enjoy enhancing our sensory surroundings. That enjoyment is real. The trick is to appreciate aesthetic pleasure without confusing it with other values.

Theorist Ellen Dissanayake defines art as "making special," a behavior designed to be "sensorily and emotionally gratifying and more than strictly necessary." She argues that the instinct for "making special" is universal and innate, a part of human beings' evolved biological nature. Hers may or may not be an adequate definition of art, but it does offer a useful insight into our aesthetic age. Having spent a century or more focused primarily on other goals—solving manufacturing problems, lowering costs, making goods and services widely available, increasing convenience, saving energy—we are increasingly

engaged in making our world special. More people in more aspects of life are drawing pleasure and meaning from the way their persons, places, and things look and feel. Whenever we have the chance, we're adding sensory, emotional appeal to ordinary function.

"Aesthetics, whether people admit it or not, is why you buy something," says a shopper purchasing a high-style iMac, its flat screen pivoting like a desk lamp on a half-spherical base. He likes the computer's features, but he particularly likes its looks. A computer doesn't have to be a nondescript box. It can express its owner's taste and personality.

"Deciding to buy an IBM instead of a Compaq simply because you prefer black to gray is absolutely fine as long as both machines meet your other significant criteria," a writer advises computer shoppers on the female-oriented iVillage Web site. "Not that color can't or shouldn't be a significant criterion; in truth, the market is filled with enough solid, affordable machines that you finally have the kind of freedom of choice previously reserved only for the likes of footwear." Computers all used to look pretty much the same. Now they, too, can be special.

A Salt Lake City grocery shopper praises her supermarket's makeover. Gone are the gray stucco exterior, harsh fluorescent lighting, and tall, narrow aisles. In their place are warm red brick, spot and track lighting, and low-rise departments of related items. The "crowning glory" is the Starbucks in the front, which provides both a welcoming aroma and a distinctive look and feel. "The experience is a lot more calm, a lot more pleasant," she says, "an extraordinary change, and a welcome one." Grocery shopping is still a chore, but at least now the environment offers something special.

A political writer in Washington, D.C., a city noted for its studied ignorance of style, says he pays much more attention to his clothes than he did ten or fifteen years ago, and enjoys it a lot more. "One thing I try to do is not to wear the same combination of suit, shirt, and tie in a season," he says. "It's another way of saying every day is special." Once seen as an unnecessary luxury, even a suspect indul-

gence, "making special" has become a personal, social, and business imperative.

How we make the world around us special varies widely, and one mark of this new age of aesthetics, as opposed to earlier eras notable for their design creativity, is the coexistence of many different styles. "Good Design is not about the perfect thing anymore, but about helping a lot of different people build their own personal identities," says an influential industrial designer. Modern design was once a value-laden signal a sign of ideology. Now it's just a style, one of many possible forms of personal aesthetic expression. "Form follows emotion" has supplanted "form follows function." Emotion tells you which form you find functional. A chair's purpose is not to express a modernist ideal of "chairness" but to please its owner. "The role of design," a venture capitalist tells a conference of graphic designers, "is to make life enjoyable." The designers generally agree.

If modernist design ideology promised efficiency, rationality, and truth, today's diverse aesthetics offers a different trifecta: freedom, beauty, and pleasure (the brand promise, incidentally, of the rapidly expanding Sephora cosmetics stores). We have replaced "one best way" with "my way, for today," a more personal and far more fluid ideal. Individuals differ, and the same person doesn't always want the same look and feel. Contrary to some assertions, we have not gone from a world in which everything must be smooth to one in which everything must be rough, from an age of only straight edges to an age of only curves, or from industrialism to primitivism. All these styles coexist, sharing equal social status.

Nor are we seeing the triumph of "beauty," defined as a universal standard, although some observers identify the trend that way. They argue that the public is now rejecting both the canons of modernist design and the idea that tastes are personal and subjective. "Beauty is now proclaimed as being at the heart of a universal human nature—even at the core of the order of the universe, and

the essence of life itself," reports *The Washington Post*, declaring, "Beauty is back."

It's true that artists and critics are more willing to talk about beauty than they were a half century ago, and that psychologists have begun to document some aesthetic universals, such as a preference for symmetry in faces. But it's absolutely not true that we've reached some sort of consensus on the one best way to aesthetic pleasure. Quite the contrary. Our aesthetic age is characterized by more variety, not less. Beauty begins with universals, but its manifestations are heterogeneous, subjective, and constantly changing.

Aesthetics offers pleasure, and it signals meaning. It allows personal expression and social communication. It does not provide consensus, coherence, or truth. Indeed, in many cases the rising importance of aesthetics sparks conflicts, since one man's dream house is another's eyesore; one neighbor's naturally beautiful prairie garden is another's patch of weeds. An employer's idea of the dress and hairstyles needed to create the right atmosphere for customers may violate employees' sense of personal identity or practical function. Today's aesthetic imperative represents not the return of a single standard of beauty, but the increased claims of pleasure and self-expression. Beauty in its many forms no longer needs justification beyond the pleasure and meaning it provides. Delighting the senses is enough: "I *like* that" rather than "This is good design."

At the practical level of profit-seeking businesses, the increase in aesthetic pluralism spurs competition to offer increasing variety. "The consumer is a chameleon: one day she's polished, one day she's tribal," says a hair-care-products executive determined to serve both identities. "It is exciting to see not just one look, but people celebrating their individuality." The holy grail of product designers is mass customization. Industrial design guru Hartmut Esslinger (the source of "form follows emotion") imagines modularly designed products that could be recombined "to offer 100,000 individual versions," expressing as many personal styles. "Mass production offered millions of one thing to everybody," writes another design observer, upping the estimate. "Mass customization offers millions of different models to one guy."

This vision is not just a business strategy. It represents a major ideological shift. Designers and other cultural opinion leaders used to believe that a single aesthetic standard was *right*—that style was a manifestation of truth, virtue, even sanity. What if someone didn't like the fixed way in which Walter Gropius had arranged the furniture in a new Harvard dorm? a student reporter once asked the Bauhaus architect. "Then they are a neurotic," Gropius replied. The idea that aesthetics represented truth and virtue was hardly limited to design elites, as those of us old enough to recall the culture wars over men's hair lengths can attest.

Today, buzz cuts and ponytails coexist, without a social consensus and mostly without conflict. Typographers win awards for creating fonts based on such widely varied styles and sources as Renaissance Florentine manuscripts and hand-lettered Latino shop signs. Homeowners mix minimalist contemporary furnishings with antique Persian rugs. Even the gatekeepers of taste acknowledge and embrace aesthetic plenitude. They find the old rigidity strange and a bit embarrassing. "When we started American *Elle*, fashion dictated that a skirt had to be either one inch above the knee or one inch below it," said the magazine's publication director in its fifteenth anniversary issue, published in September 2000. "And if it wasn't, then the woman wearing it was out of it, end of story. The beauty of what's happening now is that you can be bohemian, minimal, sexy, or retro. There are so many options—anything goes."

Maybe not "anything." *Elle*'s list of acceptable diversity is still fairly limited, and it doesn't suggest much mixing and matching across styles. Other style mavens are more eclectic. The smash-hit magazine *Lucky*, launched in December 2000, seeks to offer "fashion options, as opposed to mandates," encouraging readers to combine styles to fit their personal tastes and body types. "I thought there was room for a magazine that took the position that many trends could exist simultaneously," says *Lucky*'s creator, who was inspired by the mix-and-match styles in the 1995 movie *Clueless*.

The once-rigid aesthetic hierarchy has broken down. Individuals do not simply imitate their social betters or seek to differentiate them-

selves from those below them. Personal taste, not an elite imprimatur, is what matters. A furniture executive talks about an environment shaped by customers' "self-assurance." Consumers are willing to mix not only styles but sources. "They have a great sofa or chair," he says, "then build around it with everything from high-end accessories to flea-market finds." Personal expression, personal imagination, personal initiative—form follows instinct.

The French interiors magazine *Maison Française* touts customization as the "reaction to the homogenization of styles and tastes: the desire to personalize our universe. We embroider our jeans, paint our walls, dye our curtains . . . or have others do it for us." The authoritative Larousse dictionary, notes *Maison Française*, traces the word *custom* to Americans personalizing their cars. But, fear not, French designers have given the idea a more ancient and patriotic pedigree. They've reappropriated the dictate of Antoine Lavoisier, the great eighteenth-century chemist: "Nothing is lost, nothing is created, all is transformed."

A sort of chemical transformation through recombination is, in fact, where much of today's aesthetic plenitude comes from. Like atoms bouncing about in a boiling solution, aesthetic elements are bumping into each other, creating new style compounds. We are constantly exposed to new aesthetic material, ripe for recombination, borrowed from other people's traditional cultures or contemporary subcultures. Thanks to media, migration, and cultural pluralism, what once was exotic is now familiar.

Some of these subcultural styles begin with an ethnic base— Indian *mehndi* (temporary henna tattoos), African-American hip-hop styles, New England WASP preppy clothing, Chinese feng shui, the vivid colors of Mexico and the Caribbean, the pervasively influential lines of Japanese art and interiors. Others indicate value-related, voluntary associations, "differences with depth," in the words of cultural anthropologist Grant McCracken. For such subcultures as goths, punks, and skaters, he writes, "Differences of fashion, clothing—the differences of the surface—turned out to indicate differences below, differences of value and perspective."

While subcultures may remain stylistically distinct, elements of their aesthetics get adopted by people who simply like certain looks and may combine them in seemingly contradictory ways. Some of these aesthetic adapters are influential designers or trendsetting celebrities. Others are unknown individuals looking for ways to express their own sense of what is beautiful, interesting, or new. As a result, ethnic styles do not stay in their literal or metaphorical ghettos, nor do they remain pristine and traditional. Value-laden aesthetics, such as punk or goth, spill over into mainstream culture as people outside their subcultures adopt purely aesthetic elements, usually in a less-extreme form. That's how Chanel's reddish-black Vamp nail polish wound up on the hands of stylish women in the mid-nineties, and how pierced ears ceased to indicate anything definite about men's sexual orientation. Those narrow European-style glasses say a lot less about someone today than they did ten years ago.

Ours is a pluralist age, in which styles coexist to please the individuals who choose them. The "return to beauty" classicists confuse today's aesthetic pluralism, which overthrows modernist ideology, with the banishment of modernist aesthetics. But modernism is not dead. It is thriving, enjoying a huge upsurge in interest. Modernist furnishings, from Art Deco to midcentury styles, have become sought-after antiques, and modernist buildings are the latest cause for preservationists. Contemporary designers continue to use modernist motifs, along with many other influences, to create new objects and environments. Some modernist experiments were certainly aesthetic failures, but the modernists created many beautiful things. Their formal breakthroughs continue to inspire delight.

Although clever allusions still have their place, the breakdown of modernist ideology means that it's no longer necessary to hide aesthetic pleasure behind postmodern irony and camp. Even modernism's advocates have abandoned its confining strictures. "Instead of finding a style and adhering to its tenets, modern design allows you to grapple with your own ideas about how you want to live," writes the publisher of *Dwell*, an architecture and interiors magazine first published in 2000.

Dwell's editor in chief preaches a pluralism that would sound strange to her forebears: "We think of ourselves as Modernists, but we are the nice Modernists. One of the things we like best about Modernism—the nice Modernism—is its flexibility." She tweaks the puritanical doctrines of Adolf Loos—"one crabby Modernist"—whose influential 1908 essay "Ornament and Crime" proclaimed decoration degenerate, the amoral indulgence of children and barbarians. To a contemporary reader, Loos sounds like a racist, pleasure-hating totalitarian. In the twenty-first century, ornament is not crime. It is an essential form of human self-expression.

And what an expressive age ours is. The signs are all around us. A few have become cultural clichés: Apple's iMac turns the personal computer from a utilitarian, putty-colored box into curvy, translucent eye candy—blueberry, strawberry, tangerine, grape. Translucent jewel tones spread to staplers and surge protectors, microwaves and mice. Apple reinvents its designs in touchable pearly whites.

Target introduces a line of housewares developed by architect-designer Michael Graves. Few Target customers have heard of Graves, but his playful toaster quickly becomes the chain's most popular, and most expensive, model. A year later, Target doubles the number of Graves offerings, to more than five hundred products. Over time, it adds even more.

Volkswagen reinvents the Beetle. Karim Rashid reinvents the trash can. Oxo reinvents the potato peeler. People will pay an extra five bucks for a little kitchen tool that looks and feels good. Show them something cool or pretty, and they'll replace wastebaskets they've never thought twice about.

For every well-publicized touchstone there are dozens of surprises—credit cards, for instance. Nordstrom issues shiny holographic credit cards to spice up its brand. "The look of the card made it more special," explains a spokeswoman. PayPal, the online payments service, entices customers with see-through Visa cards in five different colors. I present my American Express Blue card at a hotel

and get a common reaction: "Wow. Where did you get it?" The company, proud of its cool card, dubs that response the "clerk double-take."

Reflecting the demand for products that stand out, the number of industrial designers employed in the United States jumps 32 percent in five years. Design schools are so full of students they can hardly find faculty to staff the courses. "We're seeing design creep into everything, *everything*," says the former president of the Industrial Designers Society of America. The post-nineties recession is just a "speed bump" in a long-run trend.

"Kmart goes under," he says, "and all anybody cares about is Martha Stewart. Target doesn't have enough with Michael Graves. They have to hire Philippe Starck, the most famous designer in the world." *Business Week* was wrong to declare the 1990s the age of design. "The nineties were clearly the age of distribution, and Wal-Mart coming to the fore," he says. High-style products like the iMac and Beetle didn't appear until the very end of the decade. "I see 2000 to 2010 as the decade of design."

The San Francisco Museum of Modern Art opens an exhibit of sneakers. Guitars are art in Boston; motorcycles are art in New York. Museums in Miami and La Jolla display household objects, from chairs to salad bowls. To the consternation of critics, an exhibit of Armani couture draws swarms of visitors to the Guggenheim in New York. The definition of "art" has changed. But so has the definition of sneakers and salad bowls. We expect the most mundane products to provide not only function but aesthetic pleasure and meaning. "Design has become the public art of our time," says a curator and designer.

A *Time* cover story hails "The Rebirth of Design," declaring that "America is bowled over by style." Not just America. The new age of aesthetics is a worldwide phenomenon, found throughout the developed nations, most strikingly in the once-plain and pragmatic English-speaking world. "The Style Wars," reads a cover line on the Sydney *Sun-Herald*'s Sunday magazine. "Once upon a time, sofas were for sitting on and kettles were for making tea. But all that's

changed now." Five new Australian home and lifestyle magazines started publishing in 2000 alone, bringing the total there to more than twenty.

Aesthetic creativity is as vital, and as indicative of economic and social progress, as technological innovation. In Turkey, interior design is flourishing; the number of magazines on the subject has jumped from one to forty in a decade. Young people are recovering Ottoman artifacts and aesthetics, fusing them with Asian and Western influences. Istanbul, says a Turkish architect who returned there from New York, is "very dynamic, and hungry for progress. Hungry to catch up with London and New York as a capital of design."

Japan, whose traditional styles have long been a source of aesthetic inspiration worldwide, is fast becoming "the real international capital of fashion," writes Amy Spindler, the influential style editor of *The New York Times Magazine*. It's the place where aesthetic change for its own sake dominates popular culture. "Unlike with the London punks and mods, or the New York rappers who so inspire dress in the streets of Japan's capital, there are no politics behind the Tokyo fashion movements. The punk movement, when it came, was only about fashion. The hip-hop movement has nothing to do with rebellion. . . . As central as fashion is to life here, all it really says is that the person wearing it loves fashion." Along with the clothing styles that attract New York editors, Japan exports new aesthetic concepts through animation and industrial design.

As recently as 1970, Japan had no design schools. Neither did South Korea or Singapore, which have also become centers of design. Today, Japan has at least nine design schools, South Korea at least ten, and Singapore at least four. To boost the country's industrial design capacity, the South Korean government is establishing more specialized schools and design departments within existing universities. Even Italy, by many measures a design superpower, offered no degrees in design, as opposed to architecture, before Domus Academy opened in 1983. Today, at least twenty-three schools grant design degrees. Since 1995, more than forty design and architecture

magazines (excluding graphic design publications) have begun publishing worldwide.

Graphic design has grown along with product and environmental design. In the early seventies, the American Institute of Graphic Arts, the professional association for graphic designers, had 1,700 members. "And 1,350 lived or worked between Fourteenth Street and Eighty-fifth Street in Manhattan," says a longtime member. Now there are 15,000 members—double the number in 1995—and dozens of chapters all over the country. That growth in part reflects organizational vitality, but the profession as a whole is indeed flourishing. There are about 150,000 graphic designers in the country, estimates the AIGA's executive director. A generation ago, he says, his counterparts would have optimistically told a reporter there were 30,000 and "believed there were only 15,000." Worldwide, at least fifty graphic design magazines publish regularly; in 1970, there were three.

Demand for professional graphic design has increased along with do-it-yourself capability. Word processors and PowerPoint are teaching everyone about typefaces and bullet points. Digital cameras, low-cost scanners, and ink-jet printers make four-color illustrated documents cheap and easy. In 1999, Kinko's launched a $40 million campaign to convince customers that everyday communication requires polished graphics: "Sometimes it's not just what you say, but how you say it." Maids looking for housecleaning jobs hand out flyers that feature attractive layouts, clip art, and typefaces once reserved for design professionals. Staid law firms hire graphic designers to create a unique and consistent look and feel for everything from stationery to Web sites, including such once-unthinkable elements as corporate logos. The plain typed résumé or company newsletter is as obsolete as carbon paper. "There's no such thing as an undesigned graphic object anymore," says graphic designer Michael Bierut, former president of the AIGA board, "and there used to be."

Contrary to *Time*, it's misleading to call the trend "design." Designers worry as much about function as about form, and they stubbornly resist being treated as mere "stylists." Yet when a GE Plastics executive says that "aesthetics, or styling, has become an

accepted unique selling point," he is not talking about recent break-throughs in the cleaning power of toothbrush-bristle arrangements or the ergonomics of desk chairs. Nor is he addressing the ideological meanings that designers invoke in the manifestos that bring prestige within their profession. He's saying that surfaces matter, in and of themselves.

Talking about "design" also inevitably focuses attention on products, with occasional nods to hotel interiors. Even graphic design usually gets left out. The *Time* cover story is illustrated with pictures of housewares and electronic gizmos. Every single person it quotes, except boutique hotelier Ian Schrager, is in the business of designing, displaying, or selling *objects*. That's what "design" means to most people—cars, computers, toothbrushes, housewares, clothes, furniture.

The boom in product design is just one sign of the increasing importance of sensory content in every aspect of life. Real estate agents hire "stagers" to redecorate homes for sale. New home owners can then use "move-in coordinators" to unpack and arrange their things in a visually appealing way. Aesthetically ambitious suburbanites engage professionals to adorn their houses for Christmas. Busy professional couples hire chefs to come in and make dinner, providing not only good food but the textures and smells of home cooking. Business executives enlist Hollywood stylists to dress them. Making people, places, and things look good is a growth business.

Or consider the change observed by Pierluigi Zappacosta, a founder of Logitech, the computer peripherals company best known for its mice. Zappacosta has his own place in design history; by hiring Hartmut Esslinger's design firm, frog, to create Logitech's product and packaging designs, he injected a playful, distinctive style into the dull world of computer peripherals. But the most vivid stories Zappacosta tells about aesthetics have nothing to do with computers. They're about food.

When he came to Palo Alto from Italy in 1976, Zappacosta was baffled by American meals—no good bread, no good cheese, no good coffee. "It seemed like something was fundamentally wrong," he

says. If the food was bad, the atmosphere of restaurants was even weirder. "You could not eat, except in the dark," he says, recalling going from the blinding sun into pitch-dark business lunches. "I don't know how much it has to do with food and how much it has to do with the concept of décor. But if it was a nice restaurant, you couldn't see what you were eating."

All that has changed. Just as competition from Microsoft spurred Logitech to beautify its mouse, so grocery and restaurant entrepreneurs have pushed up standards for food and restaurant design. Some were immigrants re-creating the good taste of their homelands. Others were American-born innovators, creating such oddities as "California roll" sushi and barbecue-chicken pizza. Today, marvels Zappacosta, you not only can get good bread in Silicon Valley, but a local grocery has a thirty-foot-long aisle filled with cheeses from all over the world—far more variety than you'd find in an Italian market. Dark restaurants aren't classy but old-fashioned.

Our generic standards have ratcheted up from Pizza Hut to California Pizza Kitchen, from TGI Friday's as trendy urban innovator in the 1970s to TGI Friday's as everyday suburban fare. "Black-Eyed Pea used to be a high-design restaurant," says an architect who specializes in restaurant design. The chain, which serves home-style Southern food, was one of the first to hire professionals to create its atmosphere. "It used to be unique and kind of fashion-forward. People would talk about, 'Have you seen the Black-Eyed Pea?' That's not the case anymore." Design that was once cutting edge is now a minimum standard, taken for granted by customers.

Contrary to all the stories about product design, a better indicator of our aesthetic age than the splashily designed objects on store shelves is the evolution of the *environments* that surround them, and us. Industrial design is unquestionably enjoying a new golden age, but the look and feel of at least some leading products has been important since the late 1920s. As a widespread phenomenon, meticulous attention to environments is much newer. "Design is everywhere, and

everywhere is now designed," says David Brown, the former Art Center president, with only a little exaggeration.

With its carefully conceived mix of colors and textures, aromas and music, Starbucks is more indicative of our era than the iMac. It is to the age of aesthetics what McDonald's was to the age of convenience or Ford was to the age of mass production—the touchstone success story, the exemplar of all that is good and bad about the aesthetic imperative. Hotels, shopping malls, libraries, even churches seek to emulate Starbucks. Curmudgeons may grouse about the price of its coffee, but Starbucks isn't just selling beverages. It's delivering a multisensory aesthetic experience, for which customers are willing to pay several times what coffee costs at a purely functional Formica-and-linoleum coffee shop (much less a 7-Eleven or Dunkin' Donuts). The company employs scores of designers to keep its stores' "design language"—color palettes, upholstery textures, light fixtures, brochure paper, graphic motifs—fresh and distinctive.

"Every Starbucks store is carefully designed to enhance the quality of everything the customers see, touch, hear, smell, or taste," writes CEO Howard Schultz. "All the sensory signals have to appeal to the same high standards. The artwork, the music, the aromas, the surfaces all have to send the same subliminal message as the flavor of the coffee: *Everything here is best-of-class*." (Emphasis in the original.)

Starbucks has a specific look and feel. But it's not alone in either the message it wants to send or the sensory techniques it uses to send it. Within a generation, the floors of shopping malls have gone from concrete to tile to marble. Truck stops and turnpike rest areas are hiring architects to create airy, light oases. Designer bathrooms have become de rigueur in upscale restaurants. Once windowless boxes, new self-storage centers look like antebellum plantation homes or luxury hotels. Factories incorporate more open space and natural light, and businesses make relocation decisions based in part on aesthetic amenities. Muzak has dumped its infamous elevator music in favor of recordings by original artists, with programs crafted to produce just the right atmosphere for a customer's environment.

Trade show booths today emulate theme parks and World's Fairs,

striving to be "immersive environments" rather than mere product displays. Lighting, sound, and textures convey not only information but the right mood. The goal, writes an exhibit designer, is to create "a complete environment—one that gets inside the minds of the attendees and triggers the right feelings." Form follows, and leads, emotion.

People have always decorated their homes. But the aesthetic quality and variety of home interiors have increased dramatically. Furnishings once reserved for rich aficionados are now the stuff of middle-class life. In the early 1990s, when Pottery Barn launched its interiors-oriented catalog, American home owners could not buy a wrought-iron curtain rod without hiring an interior designer. "We had to go to a little iron shop in Wisconsin and teach them how to make a curtain rod," recalls Hilary Billings, who turned the Pottery Barn catalog into a home-furnishings source for the aesthetically aspiring middle class, a niche that rival Crate and Barrel also filled. Now such once-exotic offerings can be found in discount stores. "Crate and Barrel changed the world," says Brown, "and then Target changed it again."

In a 1976 *Vogue* article, a designer praised a Manhattan high-rise for millionaire jet-setters by saying, "Luxury of the bathroom is terrific—marble floor and walls and nicely designed chrome fixtures." Twenty-five years later, new tract-home bathrooms come with marble floors, and do-it-yourselfers replace ho-hum designer chrome with brushed-nickel faucets once restricted "to the trade." Large home builders open design centers where buyers can choose from hundreds of porcelain, stone, and marble tiles, dozens of different sinks, and well over a thousand carpets, customizing their mass-produced homes.

Home-improvement shows are booming on television, offering not just do-it-yourself handyman advice but designers' aesthetic expertise. Seventy million U.S. households get Home & Garden Television, "the CNN of its niche," which also runs in Canada, Japan, Australia, Thailand, and the Philippines. The Learning Channel's *Trading Spaces* room-makeover show, a knockoff of the British hit *Changing Rooms*, draws 3 million to 5 million viewers a week, sets

audience records for the networks, usually placing among cable's top ten shows. Producers get between three hundred and five hundred unsolicited applications a day from home owners who'd like to participate. The shows keep proliferating. BBC designers now redo gardens on *Ground Force* and, using only what residents already have on hand, make over entire homes on *House Invaders*. On TLC's *While Your Were Out* and its sister Discovery Channel's *Surprise by Design,* spouses and friends surprise a home owner with a redecorated room. MTV makes over teens' rooms in rock-star style on *Crib Crashers.*

"Home-improvement television has gone from being an oddity very much on the fringe to being very mainstream," says a veteran host. "Our society's willingness to spend our time and money on homes is much greater, whether it's a condominium or a house on the water." Membership in the American Society of Interior Designers has more than doubled since 1992, rising to about twenty thousand from nine thousand.

A new art market has developed: upscale wall décor. Artists and art collectors have long mocked the idea that someone might purchase a work to go with a couch—an insult to serious art. Perhaps as a result, the wall décor industry has been the home of generic, clichéd prints. But not all visually sophisticated consumers want art to impress their friends, hobnob with the gallery crowd, or make money as an investment. Some just want a more attractive living room. In response, an unsnobbish middle market is offering prints and photographs to go with stylish furniture.

Many of the featured artists are well-known modern or contemporary names. Eyestorm, which started as a specialized Web site and branched out into stores, offers limited-edition prints by Damien Hirst at $3,000 each, and a photo of Andy Warhol by Dennis Hopper for $500. Serving the same need, Crate and Barrel sells framed reproductions of Mark Rothko paintings for $499. Sales are growing at double-digit rates. Customers are "buying for aesthetics, not collecting," says an Eyestorm executive. They're treating art not as an investment or status symbol but simply as a way to create a beautiful home environment.

As aesthetic standards rise in private homes, public places feel pressure to upgrade their own look and feel. Elaborating on the techniques of one-of-a-kind boutique hotels, Starwood Hotels & Resorts has adopted a strategy of "winning by design." Its upscale W chain gets the most attention, but the big news is in the midmarket. Starwood is ridding Sheraton and Westin rooms of cheesy floral bedspreads, plastic veneer furniture, and tacky ice buckets. It, too, is buying better art. "If you wouldn't have it in your house, why should we give it to a guest?" is the motto, and the hotelier's design choices reflect rising standards at home. Bathroom mirrors get frames, and countertops go granite. Sheraton rooms feature sleigh beds and accent walls. Three customers a day ask, unsolicited, how they can buy Westin's all-white, ultracomfortable "heavenly bed."

Airport terminals are remodeling with skylights, panoramic views, art galleys, custom carpeting or terrazzo floors, and high-end shops. Wolfgang Puck Cafes and Starbucks have replaced hot dogs and stale coffee. New airport spas offer manicures and massages to travelers with time to kill. At La Guardia, the Figs restaurant serves such gourmet dishes as Italian panini sandwiches and fig-and-prosciutto flatbread pizza. At Chicago's O'Hare, travelers changing concourses walk beneath a 744-foot neon-light sculpture, its colors rippling in sync with music. At art-filled Albany airport, which opened its remodeled terminal in 1998, the security checkpoints match the café chairs—blond and cherry woods with a decorative grid of brushed stainless steel and copper-colored backing. Only the actual conveyor belt would look out of place in a Starbucks. "If Americans are going to spend more time in airports, it's incumbent upon us to make them attractive places," says the former mayor of Philadelphia, who made upgrading the city's airport a major project. And that was before added security precautions extended airport waits.

Shopping malls, once designed to be functional and convenient, with little attention to atmosphere, are turning to aesthetics to try to hold customers who might otherwise prefer drive-up "lifestyle centers." New malls have "grand portals" and attractive landscaping on

the outside, soft seating and decorative lighting fixtures on the inside. Older malls are remodeling. "The original shopping centers were extremely durable but not necessarily the kind of places you'd like to linger in," says the chief designer at a large mall developer. As recently as the 1980s, he explains, malls "were rational and functional designs that were to be convenient and efficient. They were more or less 'machines for shopping.'"

Not so today. At the Beverly Center, a twenty-year-old mall in Los Angeles, the new central court features a backlit, three-story "shoji screen" with panels in subtle blues and yellows representing the colors of the California landscape and sky. A new patio off the food court gives visitors a view of the Hollywood Hills, while sofas and chairs throughout the corridors invite people to linger. The goal, says the mall's general manager, was to create a place "where people would spend the day, not come in on their mission and turn around and go somewhere else for their social environment."

The most dramatic indicators of the new aesthetic age relate not to product design or environments, but to personal appearance—the crossroads of individual expression, social expectations, and universal aesthetic standards. In a 2001 report titled *Looking Good, Sounding Right: Style Counselling in the New Economy*, a British consulting and research group writes that employees' looks are no longer simply an advantage to their personal careers but "a highly marketable asset for employers." The importance of "aesthetic skills" has grown along with lifestyle-oriented service businesses, in which aesthetic environments attract customers and good-looking employees function as "human hardware," enhancing the company image.

A British boutique hotel chain, for instance, hires only attractive employees (with good personalities). It then gives each new staff member ten days of grooming and deportment training, including individual makeovers and shaving lessons. In today's economy, argues the report, training programs for the unemployed need to emphasize aesthetics as much as other skills: "Why should the middle class, profes-

sionals, and politicians be the only ones to make use of the image-makers?" Following that logic, StyleWorks, a New York–based non-profit group, uses volunteer hairstylists, makeup artists, and image consultants to provide "a fresh new look for a fresh new start" to women moving from welfare to work. Founded in 1999, StyleWorks gave makeovers and style counseling to about one thousand clients in its first two years.

As recent elections demonstrate, the politicians also need their image makers. From Al Gore's earth-tone suits to Florida Secretary of State Katherine Harris's heavy makeup, coverage of the 2000 U.S. presidential race seemed obsessed with appearances. For the first time ever, the Gallup Organization polled people on which presidential candidate was better looking (Gore won, 44 percent to 24 percent). The question was worth asking because the answer wasn't obvious. Both candidates were way above average. Contemplating the politics of cuteness, a *Washington Post* writer declared, "Presidentially, the United States is now in a place called Hunksville."

In her Senate-race victory speech, Hillary Clinton gave credit to her "six black pants suits." When she showed up on Capitol Hill looking plump and frumpy, critics opined that she'd hit a "glamour spiral." When Gore reemerged on the political scene in August 2001, all pundits could talk about was his salt-and-pepper beard. Speculation about 2004 Democratic contenders inevitably mentions the good looks of Senators John Kerry and John Edwards. *People* magazine even dubbed Edwards the nation's "sexiest politician."

The 2001 British election concentrated even more blatantly on the candidates' looks. "The underlying topic of the General Election," wrote a Tory commentator, "was not tax and spend, boom or bust, saving the pound and snatching Britain from the gaping, salivating maw of Europe, but hair, and [Tory candidate William] Hague's distressing lack of it." Hague's looks were universally declared a major political problem, before and after he was trounced by Tony Blair. "The general view is that he looks a lot like a fetus in a suit," said an old friend and ally. Shortly after becoming Hague's successor as Tory leader, the equally bald Iain Duncan Smith proceeded to attack Blair

on the hair issue. "He's losing it pretty rapidly and brushes it like a teased Weetabix," he said. "If having a head of hair is the qualification for being Premier, we'll have to rule out the current PM in a year's time."

Good hair, by contrast, is a political asset. Japanese prime minister Junichiro Koizumi's permed "Lion King" mane boosted his popularity and helped reinforce his image as an iconoclastic reformer. German chancellor Gerhard Schroeder, whose thick brown hair gives him a youthful appearance, actually went to court over a published allegation that he dyes his hair to keep out the gray. He won an injunction against future hair-coloring claims. With dramatic costuming sense and the right headgear, however, even a bald politician can win style plaudits. "The chic-est man on earth," according to fashion designer Tom Ford, is Afghan leader Hamid Karzai.

Handsome political leaders reflect a more general phenomenon. Spared not only the disfiguring diseases and malnutrition of earlier centuries but the crooked teeth, acne scars, and gray hair of our parents and grandparents, the people of the industrialized countries are arguably the best-looking people in history. We live less physically demanding lives, which can lead to obesity but also keeps us young. It's no longer the case, as a nineteenth-century visitor wrote, that "the bloom of an American lady is gone" at twenty-one and by thirty "the whole fabric is in decay." Baby boomers expect to look young and attractive well into their fifties, and many do.

While only the genetically blessed can be extraordinary beauties, more and more of us qualify as what historian Arthur Marwick calls "personable"—generally good-looking if we care to be. At the same time, we have the chance to see many more truly beautiful people than our ancestors, thanks to a combination of media, travel, and population density. An hour watching television, flipping through magazines, or driving down billboard-lined streets exposes us to more beautiful people, of more different types, than most of our forebears would have seen in a lifetime. That means we make more exacting judgments, about ourselves as well as others. "Only when people have the opportunity to make choices and comparisons can

they make a genuine evaluation of personal appearance," writes Marwick.

Those judgments extend to areas where personal appearance was once considered irrelevant, even unseemly, to call attention to. Authors on both sides of the Atlantic are starting to notice, and sometimes complain, that their looks are almost as important as their writing. "Looks sell books," reports *The Washington Post*. "It's a closed-door secret in contemporary American publishing, but the word is leaking out. Not that you have to resemble Denzel Washington or Cameron Diaz, but if you can write well *and* you possess the haute cheekbones of Susan Minot, the delicate mien of Amy Tan or the brooding ruggedness of Sebastian Junger, your chances are much greater."

In Britain, publishers aren't as shy about admitting the importance of the "gorge factor"—How gorgeous is the writer?—especially for new authors. Acclaimed young novelist Zadie Smith, author of *White Teeth*, even underwent a publisher-pleasing makeover, changing her hairstyle and getting rid of her glasses. "I didn't see too many *White Teeth* reviews without a photograph," says the company's publishing director. "Looks do make a difference, we all know that."

If all this emphasis on appearance represents bad news for those of us who'd just as soon be judged on other criteria, the good news is that the same influences have led to a broader definition of attractiveness. Exposure to the way many different people look raises beauty standards, but it also teaches us that beauty, while a recognizable universal, comes in different types—variations of build, skin color, hair color, and so on. On top of the natural variations, we add artificial ones, matters of style that imitate or expand on nature. The result of higher beauty standards and more stylistic variety is an explosion of activity designed to produce better-looking, or more aesthetically interesting, people. Here, too, ornament is no longer a crime.

The number of nail salons in the United States has nearly doubled in a decade, while the number of manicurists has tripled. The market for skin-care "beauty therapists" and aestheticians, long strong on the European continent, is booming in the United States and Britain.

Tattoos have ceased to be taboo. Hair coloring is virtually mandatory. Nearly three-quarters of middle-aged women (ages forty-five to fifty-four) polled by the American Association of Retired Persons say they dye their hair to cover gray. So do 13 percent of middle-aged men. U.S. hair coloring sales topped $1.1 billion in 2001, up 34 percent since 1997.

The trend is international. Sixty percent of the women in Japan and South Korea color their hair, between 30 percent and 40 percent in Singapore, Hong Kong, and Taiwan. In 2002, Japan Airlines changed its policies to allow flight attendants to have subtly colored hair; previously only naturally black hair was allowed. "Nowadays if you don't color your hair, you're the one who's different," says a Singapore fashion-magazine editor.

"Hair-dyeing used to be driven by negative motivations like hiding gray hair," says a hair-coloring executive in Japan, where sales doubled from 1991 to 2001. "But today, people have come to view hair coloring as a form of self-expression." A Tokyo business analyst compares the rapid adoption of hair coloring to a more widely recognized Japanese trend: "The two biggest changes in the Japanese market in the last decade have been mobile phones and the color of Japanese hair."

Coloring adds depth and highlights to dull hair and makes artificial blondness so common it has become, in the words of one fashion critic, "just one of the many attractive ways to adorn dark hair." Clairol aims its Herbal Essences True Intense Color at men and women ages eighteen to thirty-four. Young people, says an executive, tend to be "very experimental" and "want to express themselves and their own individuality."

When L'Oreal launched its Féria line of hair colors in the summer of 1998, it showcased a blond shade on a youthful model with a short Afro and milk-chocolate complexion. Even more audaciously, a Clairol ad shows two black-clad redheads, one with pale skin, the other deep brown: "Believe it or not—we're the same color," reads the headline, ostensibly referring to the Clairol product. What once would have been a problematic statement about race is now purely

aesthetic. And artificiality is no longer suspect. Does she or doesn't she? Of course she does. In the next ad, she'll have yet another hair color. "The brand is about breaking the rules of hair color and using it like a cosmetic," a L'Oreal executive says of Féria.

Young men constitute a rapidly growing market for hair coloring, with U.S. sales up 25 percent in five years. Teen boys in the United States spend about 5 percent of their income on hair color. "If you have the fashion, you have the girls," says a teenager whose mother helps him keep his hair tipped blond. Too young to worry about gray, young men are looking for excitement and self-expression. "I have this mousy brown hair, and I never felt it represented who I was," says a twenty-six-year-old Canadian man, whose hair color has ranged from jet black to champagne blond. "I see myself as more colorful and more interesting." A Brisbane, Australia, salon owner reports that twenty to thirty men a week come in for hair color, many inspired by pop star Ricky Martin's tinted locks. "In the old days, you didn't color your hair," he says. "Now it's just being fashion-conscious."

Since the 1980s, we've also experienced what cultural critic Jonathan Rauch dubs the "Buff Revolution." For the first time in centuries, it has become respectable for people in Anglo-American countries to pay attention to men's bodies. "Suddenly," writes Rauch, "there were half a dozen physique magazines on every 7-Eleven newsstand. Suddenly buses prowled through the cities bearing ads in which, for no discernible reason, a barechested young man with a chiseled and tanned and shaved-down torso displayed a microwave oven (a microwave oven?)."

Rauch finds this revolution generally a good thing, despite some excesses. Others worry that men's growing concern with their looks is, to quote a magazine headline, "Turning Boys into Girls." Feminist Susan Faludi assails "ornamental culture" for its baleful effects on men's self-esteem. Books with titles like *The Adonis Complex* and *Looking Good* fret that men are hurting their physical and psychological health in pursuit of their aesthetic ideals.

For both men and women, the boundary between health and

beauty, medicine and cosmetics, is melting away. Pharmaceuticals promise to grow hair on men's heads and slow its growth on women's upper lips. "Enjoy beautiful eye color change even if your vision is perfect," suggests an ad for contact lenses. From 1992 to 2001, the number of patients having cosmetic medical procedures in the United States nearly quintupled, from 413,000 to 1.9 million. Sixty percent of American women and 35 percent of men say they'd have cosmetic surgery if it were safe, free, and undetectable; younger people are more likely to say yes, suggesting a generational shift in attitudes.

Having prevented or cured most tooth diseases, dentists now bombard prospective patients with mailers selling cosmetic services— bonding and whitening for younger-looking smiles. U.S. and Canadian orthodontists claimed 5 million patients in 2000, up from 3.5 million in 1989. "The dental profession's traditional domain, centered around the eradication of disease, now finds itself on the threshold of uncharted territory: the enhancement of appearance," declares a cover article in *The Journal of the American Dental Association*. A journalist evaluating tooth-whiteners notes that the products "are primed to be the next deodorant: a once-optional form of personal hygiene that's now simply an obligation. It's only a matter of time because the more of us who get whitened, the grungier your unwhitened teeth will appear in contrast."

Dermatologists zap age spots with lasers and prevent acne with drugs. Doctors declare teenage acne scars a thing of the past, as unnecessary as measles or crooked teeth. In 2001, more than 111,000 Americans under eighteen availed themselves of chemical peels, while another 55,000 submitted to microdermabrasion. Such skin treatments also raise beauty standards. With new preventive drugs and remedies available, says a teenager, "Now, if you have some bad acne, it really stands out."

While all this activity has been going on in the economic and social world, two big waves of scholarship have directed intellectual attention toward aesthetics. Scholars in the relatively new field of "mate-

rial culture" study the interactions among style, commerce, and personal identity. This research reflects what Grant McCracken calls "the long-standing anthropological conviction that material culture makes culture material, i.e., that the expressions of a lifestyle are more than mere reflections of it; that, in some cases, they are its substance, and that, in all cases, they give it substance." The material—and hence the aesthetic—matters to people's sense of self. It isn't just surface and illusion. And it is worthy of serious study.

Feminist historians are uncovering and analyzing women's beauty culture and domestic taste, challenging the twentieth-century dogmas that declared ornamentation inherently decadent, corrupt, or manipulative, and markets inherently exploitive. "Why were there no serious books on refrigerators and cars?" Penny Sparke, a design historian, recalls wondering. "Why was there so much work available about architecture and so little about interiors? . . . Feminine culture, linked with the everyday, the commercial and the aesthetically 'impure,' had been relegated to the margins." That's no longer true, as Sparke's own work demonstrates.

Journals with names like *Fashion Theory* (first published in 1997) and *Journal of Design History* engage these topics, among others. Academic presses publish works on the history and meaning of dress and of dishes. Art museums are beefing up their design and clothes collections, and scholars are analyzing the culture and history of fashion. Books on the evolution of shopping and store environments, pro and con, are increasingly common. *Enterprise & Society*, a business-history journal founded in 2000, devoted one of its first issues to "beauty and business," focusing on commerce and personal appearance.

One result of this new inquiry, quips a reviewer, is that "the new term for an overflowing wardrobe is 'archive'; rummaging through your cast-offs has become a form of research, and, if you have shopped wisely, your archive may deserve an exhibition of its own." In 2000, a New York professor did in fact donate her collection of Perry Ellis clothing to the Fashion Institute of Technology's museum.

Many natural and social scientists, meanwhile, are increasingly

interested in the nature of aesthetic universals. While the material-culture scholars ponder the value and social creation of aesthetic meaning, these researchers want to understand the biological origins of aesthetic pleasure. Their scholarship challenges the received academic wisdom that tastes are as different as languages, that the art of one culture is incomprehensible to the previously unexposed people of another. In fact, languages themselves begin with universals. So, apparently, do aesthetic responses. As a result, aesthetic elements can spread relatively easily from culture to culture. Although context and meaning can vary widely, and specific tastes may differ from individual to individual, human beings don't have that much trouble appreciating the pleasures of otherwise foreign aesthetics.

Psychologists have found patterns of symmetry and proportion, consistency and surprise, that cross cultures and ages. Even infants, they've discovered, distinguish between attractive and unattractive faces. Across fields and in different countries, good-looking people earn more, report economists, and good looks are at least as important economically for men as for women. "Musics cross-culturally are very different from one another," says Denis Dutton, a professor of aesthetics with a particular interest in the relation between biology and art. "But musics depend on sounds, on pitch, on harmonies, on iterations—getting tired of something, being surprised. Novelty, surprise, echoing effects, repeating of themes, variations of themes—in all developed musics you find these things happening." Languages differ in how finely they distinguish colors, but some categories are found just about everywhere: the "focal colors" of white, black, red, green, yellow, and blue. No culture names only orange and puce. The combinations vary, but the component building blocks are universal.

Evolutionary theorists postulate explanations for these patterns, based on survival and sexual selection. "Our response to beauty is hard-wired—governed by circuits in the brain shaped by natural selection," writes psychologist Nancy Etcoff. "We love smooth skin, symmetrical bodies, thick shiny hair, a woman's curved waist and a man's sculpted pectorals, because in the course of evolution the people who noticed these signals had more reproductive success. We are

their descendants." Of course, biology also differs somewhat from individual to individual, which may explain why I prefer brunets while you like blonds—a preference for exogamy has positive genetic effects—or why I respond strongly to bright colors while you prefer pastels. Within the universal patterns are individual variations. In addition, the universal patterns of novelty and surprise lead to different results depending on what a particular person is already accustomed to.

The analysts of ephemeral material culture and the seekers of biologically based universals often seem at odds. But they in fact complement each other. Both are necessary to fully understand the role of aesthetics in human life, to explain both pleasure and meaning. Together, they tell us that aesthetics is neither a natural absolute nor a complete social construct. It interweaves nature and culture. The evolution of taste operates on timescales that range from gene-shaping eons to fad-and-fashion seasons. Aesthetics begins with the body, but it does not end there. Human beings are indeed visual, tactile creatures; we are also social, pattern-making, tool-using creatures. We remember, innovate, experiment, teach, and improve. "Making special" is a complex discovery process—a search through trial and error, experimentation and response, for sensory elements that move or delight.

The prophets who forecast a sterile, uniform future were wrong, because they imagined a society shaped by impersonal laws of history and technology, divorced from individuality, pleasure, and imagination. But economics, technology, and culture are not purely impersonal forces ruled by deterministic laws. They are dynamic, emergent processes that begin in the personal—in individual action, individual creativity, and individual desire. And, in our era, they are accelerating aesthetic discovery.

TWO

THE RISE OF
LOOK AND FEEL

In 1927, the influential adman
Earnest Elmo Calkins published an article in *The Atlantic Monthly*
titled "Beauty the New Business Tool." He argued that manufacturers could no longer be content with functional but ugly products.
"We are just on the threshold of creating a new world on top of our
modern industrial efficiency," wrote Calkins, "a world in which it is
possible through the much criticized machines to replace the beauty
that the machines displaced."

Under competitive pressure, Calkins declared, automobiles,
phonographs, packaged goods, shops, lighting fixtures, kitchens, and
bathrooms were all getting better looking. Consumers were no longer
satisfied just to have cheap goods and hygienic homes. "We demand
beauty with our utility, beauty with our amusement, beauty in the
things with which we live," he wrote. Henry Ford's obstinate insis-

tence on homely black cars had put his company at a competitive disadvantage, and even General Electric had created a "committee on beauty, with a representative from each department."

Calkins's thesis sounds eerily familiar, a lot like the first chapter of this book. His analysis of the way competition can stimulate aesthetic improvements was sound. But Calkins was exaggerating an incipient trend in hopes of spurring it on. The typical American of his day did not live in the luxury of classic movies or enjoy the Art Deco furnishings of today's museum exhibits. Bathroom fixtures may have been getting more decorative in the late twenties, but bathrooms themselves were still relatively rare; only half of American homes had the full complement of hot and cold running water, a bathtub or shower, and an indoor toilet. Ordinary people had more access to aesthetic goods than in the past, but practicality still ruled.

Consider clothes. In the late twenties and early thirties, a typical office clerk in the San Francisco area owned just three suits, eight shirts, and one extra pair of pants, while his wife had nine dresses. That was it—all their outer garments, for work and play, summer and winter, leisure and formality. These were not impoverished, unemployed, or rural people; they were the white-collar urban middle class. Yet they replaced their clothes only when the garments wore out—once a year for house dresses and every four years for men's suits—and their small wardrobes offered little opportunity for aesthetic variety or stylistic playfulness. "The more expensive items of clothing must have been worn until they were fairly shabby," concluded contemporary researchers, adding that "these families did not buy extravagant amounts of clothing, nor did they pay high prices. Their expenditures must have allowed little attention to fashion and certainly no ostentation in dress."

To say that the 1920s were an age of aesthetics is true in some sense, just as it is true that the 1850s were an age of telecommunications, thanks to the telegraph, and the early 1960s an era of computers, thanks to the mainframe. But everyday life feels very different when such developments are still mostly the province of a knowledgeable or wealthy elite. Pervasiveness matters. To most people of

the 1920s, what seemed new was not the look and feel of products but being able for the first time to buy radios, washing machines, or automobiles *at all*. Mass production, falling prices, and new forms of distribution and credit, not improved aesthetics, were the era's most notable economic developments. (The most important aesthetic trend was the boom in moviegoing, which boosted interest in fashion and personal appearance.)

This pattern held for most of the twentieth century. The broad public enjoyed the expanding benefits of standardization, convenience, and mass distribution, with much less emphasis on look and feel than on other sources of value. In the age of Wonder Bread and Holiday Inn, the big story was not the rise of aesthetics but the spread of predictable standards of minimum quality. After crowded city apartments and isolated, bathroom-free rural homes, little houses made of ticky-tacky looked awfully good. A chain hotel room might lack the charm of an ideal country inn, but it wouldn't be a roach-infested dump either. Packaged foods were not only convenient but reliable and slow to spoil.

"The best surprise is no surprise," the slogan Holiday Inn adopted in 1975, summed up several decades of economic progress. Americans were more concerned with avoiding below-par experiences than achieving unique or extraordinary ones. This preference expressed both prevailing cultural attitudes and available business skills. Delivering basic comfort and convenience to a vast middle class was, in itself, a huge achievement. Unlike Europe, where markets were still fragmented by national barriers, the United States provided a huge free-trade zone for anyone who could produce and distribute goods with wide appeal.

But the economics of mass production, mass marketing, and mass distribution exacted an aesthetic cost. The lowest common denominator determined what got made. Decorative household items, such as dishes, that had once offered a lot of aesthetic variety became more uniform; brides whose immigrant mothers had happily furnished their tables with unmatched open-stock dishes turned to the "convenience and correctness" of prepackaged matching sets, while man-

ufacturers moved from versatile batch production to more homogeneous output. Even goods that had great style tended to be made of cheesy materials, and many aesthetic niches went unserved. The rich could not be as different as they might like to be. With the broad middle class providing such a lucrative market, writes design historian Thomas Hine, affluent consumers "could not buy the materials and craftsmanship to which they had been accustomed."

Even in the stylistically exuberant period that Hine dubs the decade of "Populuxe," from 1954 to 1964, aesthetics was most important for textile-based fashions—the first fruits of the industrial revolution—and for a few mature industrial goods, such as cars and furniture, that had already become widespread. The design establishment, secure in the high-modernist conviction that ornament was crime, scorned the Populuxe styles that the public embraced. Social critics denounced "styling" as form without content, not a source of value but a tool of deception and manipulation. Cultural authorities considered adornment at best a frivolous, feminine concern, inferior to the real stuff of material progress. In the technocratic era of the one best way, correct taste was a matter of rational expertise ("this is good design") not personal pleasure ("I *like* this").

To twentieth-century design theorists, "rationality meant efficiency, professionalism and skill," notes feminist design historian Penny Sparke,

> all of which mitigated against an emphasis upon the aesthetic component of home-making, which had emphasised the roles of intuition, instinct and amateurism. This is not to say, of course, that women did not carry on exercising their taste in their homes and continue to enjoy arranging flowers, polishing furniture, fluffing up cushions and arranging knick-knacks on surfaces. What it did mean, however, is that none of this was any longer openly encouraged and, more importantly, no longer openly valued by society at large.

Embodying this "rational" or "ethical" view of design, Britain's

wartime Utility scheme dictated mass-produced furniture designs that eliminated craftsmanship and ornament. Rationing rules treated bookcases as essential and dressing tables and upholstered easy chairs as unnecessary. The goal was not merely to conserve materials for the war effort but to alter public tastes. "We believe the utility furniture scheme has done much to accustom the public to a better standard of design," concluded the Board of Trade's design advisers in 1946. Although consumers and furniture sellers were eager to return to varied and ornate offerings, price controls and punitive taxes continued to discourage "irrational" designs until 1952. Aesthetic authorities even dismissed the public's enthusiasm for midcentury modern furniture, which young couples embraced for the wrong reasons. Without concern for ideological purity, "they see the 'contemporary style' merely as fashion," sniffed a furniture designer.

In the United States, the Museum of Modern Art's industrial design curator used his platform to campaign against streamlining—the smooth, "aerodynamic" look characteristic of American industrial design, beginning in the 1930s. In this "design cliché" equating speed and progress, he wrote, "the teardrop swelled, divided and multiplied, became garnished with ribbons of chrome and elevated on an altar of sales, while statistical Magnificats were sung in its honor." He condemned streamlining as "the Jazz of the drawing board," too commercial and removed from its sources to be good, authentic art.

While the general public might have sometimes ignored authorities' prescriptions for proper taste, the era's conformist ideals extended to mass culture. The stylistic diversity we now take for granted was inconceivable. A yearbook from the 1950s shows row after row of students with the same hairdos, regardless of their natural hair textures, often wearing identical outfits for their portraits. Photographs of commuter rail stations at rush hour depict crowds of men in what appear to be identical gray suits and hats. In 1945, a *New York Times Magazine* reporter speculated on whether returning servicemen would rebel against military uniforms by adopting bright colors and individualistic styles. Her sources' consensus foretold the conformist

material culture of the next two decades: "Our conservative men are conservative primarily because they insist on wearing what other men wear. It's a pretty sure guess that if our manufacturers as a group decided to manufacture lavender topcoats and emerald green street suits, American man would put them on his back and wear them home—*if every one else did too!*"

Cultural homogeneity famously began to break down in the 1960s, but that breakdown is easy to exaggerate. In the late 1970s and early '80s, aspiring professionals were snapping up the male and female versions of *Dress for Success*, lest their clothes be insufficiently conformist. And not until the mid-1980s did businesses begin to master the fast production changes and supply-chain management necessary to deliver affordable product diversity. Now, says a design expert, "there's less groupthink among consumer products companies, less of a stampede towards 'streamlining,' say, or 'fins.' More segmentation and mass customization [are] possible." Car companies make fewer major model changes from year to year, but more models exist simultaneously.

We are now at a tipping point. Small economic advances that have built bit by bit for more than a century are reaching critical mass, realizing Calkins's dream. At the same time, recent cultural, business, and technological changes are reinforcing the prominence of aesthetics and the value of personal expression. Each new development feeds others. The result feels less like the culmination of a historical trend than the beginning of a new economic and cultural moment, in which look and feel matter more than ever.

It's Memorial Day weekend in Dallas, and the heirs of the San Francisco clerks and Populuxe Levittowners, young families with run-of-the-mill white-collar jobs, are shopping for home improvements. Khaki-wearing couples push their toddlers through displays of shower stalls and vanities. "Look, look," exclaims a two-year-old, excited by the unexpected abundance of a familiar form, "*potties*." A mother-daughter team oohs at the cuteness of candleholders.

Another mocks the foot-high reproductions of Greek statues. Little kids bounce on the piles of samples displayed in the rug department. Others wave balloon animals, a present from the clown by the store's door.

This is The Great Indoors, Sears for the age of aesthetics, a free-standing division of the giant retailer. A one-stop celebration of sensory profusion and plenitude, the store sells ornaments for the home, everything from ranges and refrigerators to stemware and framed prints, along with design and installation to make aesthetic achievement easy. The appliances and bathroom fixtures pledge to work, of course, but mostly they promise to delight. You don't need brushed stainless steel to get the dishes clean, fourteen silk and velvet throw pillows to sleep at night, or embroidered towels to dry your hands. You don't need a choice of 250 lavatory faucets.

And you don't need to shop for faucets in an environment as carefully designed as any of its contents, with a Starbucks in front and slatelike tile on the bathroom walls. Look carefully, and you can see that the 122,000-square-foot building is a generic warehouse whose cream-colored ceiling is corrugated metal and whose bright, warm lights drop from girders. But few shoppers notice. A peaked façade, patios, and show windows keep the storefront from looking like a big box. Inside, below the lights, the store's designers have created a world of open horizons and aesthetically appealing abundance.

The colors marking the walls of each department are sophisticated: brick and dark salmon checks for "great kitchens" (the lowercase letters are graphically au courant), gray-green diamonds for "great rooms." The durable tile floors are polished to a marble sheen. Nothing is stacked beyond a comfortable reach, which means there are no shelves blocking the vistas. Goods are clumped in still lifes, mixing textures and colors and breaking business boundaries, as hard "home improvement" products mingle with soft "home furnishing" items. "There's only one type of kitchen I want help with. One that's totally mine," reads a decorative sign on the wall, a graphic frieze in contemporary type. The Great Indoors feels nothing like a warehouse store or, for that matter, like good old utilitarian Sears.

To take one measure of aesthetic abundance, The Great Indoors sells more than fifteen hundred different styles of drawer pulls: unruly twists of wrought iron, satin nickel curves sliced from Möbius strips, scrolls of beaten copper, icy teal wedges of translucent glass, Art Nouveau dragonflies, lizards in oxidized copper, bright chrome rails with brass accents, pewter ovoids, wrought-iron question marks, pipe-playing petroglyph figures dancing in relief, delicate wreaths embossed in brass patina, antique-silver dinosaurs, Frank Lloyd Wright–style geometrics, knobs like polished hematite, chrome cacti, seashell collages in nickel, unadorned bridges of chrome or brass, purple hippos for the kids.

Row after row, drawer upon drawer. Rough and smooth, straight and curved, traditional and modern, refined and kitschy. Drawer pulls from China, from Germany, from Spain. Something for every taste, every age, every room.

Nothing like this existed in the twenties or the fifties or the famously opulent eighties. The first Great Indoors opened in 1998; its nearest competitor started only a few years before. By 2002, there were twenty Great Indoors locations; the company estimates that between one hundred and one hundred fifty U.S. communities have enough people and money to support future stores. The venture has been good to Sears, bringing in sales of about $50 million a store, at least $375 per square foot, compared to $325 in its mainstay department stores. Profits are reportedly higher too: 32 percent gross margins, compared to 26 percent at Sears stores.

The customers spending all that money aren't society ladies, specialized aesthetes, or guilt-stricken ex-hippies looking to make political statements with their throw rugs and bathroom tiles. They're pretty ordinary Americans, mostly female suburban home owners who consider themselves middle class. Something has changed to make a store like The Great Indoors possible. A lot of things have.

The most obvious sources of today's aesthetic abundance are rising incomes and falling prices. After correcting for inflation, the median U.S. household income has more than doubled since 1955, and jumped 29 percent since 1975—even as families have shrunk, giving

them yet more income per person. We can afford more aesthetic goods, from faucet sets to sweater sets, because we can afford more of everything. To take one example, a woman's cashmere turtleneck that would have cost the average factory worker thirteen hours of work in 1975 now takes fewer than six (and, if bought on sale, fewer than three). Thanks in large measure to wives with professional salaries, upper-income families have seen their incomes rise even faster.

"I am not buying you another top," says a mother in Target to her preteen daughter. "You must already have about thirty." Thirty tops! What riches that wardrobe would have represented to a kid in the 1970s—let alone the 1950s or the 1920s. The average American woman owns seven pairs of jeans, clothes she probably can't even wear to work, and the average teenager owns even more. The tiny, single-rod closets of decades gone by have been replaced by "pantries for clothes," spawning a whole industry of closet organizers.

More efficient methods of distribution and new product sources— some of them far from obvious—have made aesthetic goods cheaper and more plentiful. Granite countertops and marble floors aren't more common just because we're richer. Inexpensive, high-quality stone slabs now come from China and India, while portable edging machines developed in the mid-nineties let fabricators open new businesses with minimal investment. As a result, says an industry watcher, natural stone is "no longer a material just for the upper class."

As for distribution, Wal-Mart's ugly stores may seem like the antithesis of the age of aesthetics, but by driving down prices, Wal-Mart's hyperefficient management techniques, which other retailers have copied, have made aesthetic goods available and affordable to many more people. Consider Christmas lights. Home owners today put on light displays that would have made theme-park news a generation ago. Some use professional light installers. Others program computers to control animated sequences. These trends attract media coverage. But even ordinary, do-it-yourself displays have gotten more elaborate and more common.

"It is easy and inexpensive to put up a tasteful display, and not

much more cost or effort to try and humiliate your weak-willed neighbors," says David VanderMolen, who's been tracking the cost of Christmas lights since he was a teenager in the mid-1980s. Back then, his job was to buy and install holiday lights for his family's Charlotte, Michigan, home. Each year his parents would give him $10, enough for two 35-light strings, each twenty feet long, from Kmart. If the weather wasn't too bad during the Christmas season, a string of lights would last about three years. After a few years, VanderMolen built up a collection of 350 miniature lights, enough to make his house the most elaborately decorated in the neighborhood.

Today, that display would be nothing special. You can buy a 100-light string, nearly fifty feet long, for $2.44 at Wal-Mart. Even without adjusting for inflation, VanderMolen's old $10 annual budget would cover more lights in a single year than he could accumulate over several years in the 1980s. Today's cheaper lights, mostly made in China, also last longer. "The stuff now is so well made that you can put it up in November before it gets too cold or wet, and leave it up until a January thaw, and it doesn't all fall apart," says VanderMolen.

New accessories, including various specialized clips, make installing the lights much easier, and the variety of lights has expanded. "The now ubiquitous 'icicle' lights put 350 lights in seventeen feet for $6.74," he notes. "There are chasing lights, 'garland' lights that put 350 lights in the same length as the 100-light set, tube lights, spotlights, projection lights, [and] the old-fashioned C7 and C9 ceramic bulbs." With lights so inexpensive, easily installed, and varied, home owners are beginning to expand the holiday light tradition to Halloween and the Fourth of July.

Rising incomes and falling prices mean we can buy more of everything, including aesthetics. But that's obviously not the whole story, since look and feel are also growing more important relative to other goods—something that has not always been the case. The connection between today's rising incomes and the increasing demand for aesthetics confuses many otherwise astute analysts. We often hear that

rising wealth inevitably leads to an increase in the relative importance of aesthetics. But that wasn't true for much of the nineteenth and twentieth centuries. Even those who do consider that history sometimes suggests that aesthetics isn't important to most people until societies or individuals reach some income threshold. It's an appealing explanation, but it's incorrect.

"Aesthetics is a luxury," quips a friend in response to this book's thesis. "Maslow said so." Abraham Maslow's seminal writings on psychology argue that humans have a "hierarchy of needs" and will obtain the essentials, such as food and shelter, before moving on to less vital items, including aesthetics. "We should never have the desire to compose music or create mathematical systems, or to adorn our homes, or to be well dressed if our stomachs were empty most of the time," he wrote. Maslow was primarily interested in what makes people psychologically healthy in affluent societies, where true deprivation and danger are rare, and he qualified even his strongest statements about basic needs, contrasting starvation with mere appetite, for instance. But a less nuanced version of his model, portrayed graphically as a simple pyramid, often leads to a false conclusion: that aesthetics is a luxury that human beings care about only when they're wealthy.

Analysts sometimes write as if no one but the very wealthy paid any attention to aesthetics before the mid-1990s. "Experiential and aesthetic needs are higher-order needs, which individuals seek only when basic needs have been satisfied," explain management professors Bernd Schmitt and Alex Simonson in *Marketing Aesthetics*. Now that consumers have fulfilled their basic needs, these scholars argue, businesses should concentrate on satisfying customers' aesthetic desires—sound advice based on a faulty, or misstated, premise.

Human beings do not wait for aesthetics until they have full stomachs and a roof that doesn't leak. They do not pursue aesthetic needs "only when basic needs have been satisfied." Given a modicum of stability and sustenance, people enrich the look and feel of their lives through ritual, personal adornment, and decorated objects. Poor people create the body decoration that illustrates *National Geographic*.

Poor people built the cathedrals of Europe and developed the sand paintings of Tibet. Poor people turned baskets and pottery into decorative art. Poor people invented paints and dyes, jewelry and cosmetics. Five thousand years ago, unimaginably poor Stone Age weavers living in Swiss swamps worked intricate, multicolored patterns into their textiles, using fruit pits as beads, work that archaeologists have found preserved in the alkaline mud. These artifacts do not reflect societies focused only on "lower-order" needs. Aesthetics is not a luxury, but a universal human desire. Those anticapitalists who criticize markets for luring consumers into wanting more than their basic needs, and those capitalists who scoff at aesthetics for detracting from serious work, are missing a fundamental fact of human nature.

With its emphasis on shifting relative prices, microeconomics is a clearer guide than Maslow to understanding the increasing value of aesthetics. In a subtle variation on Maslow, the value of the *next increment* of what we consume changes depending on what we already have. It's the ever-changing mix that matters, not a hierarchical checklist. There is no pyramid of needs, where each layer depends on completely satisfying the need under it. Rather, the marginal value of some characteristics, such as nutrition or shelter, is high initially—we don't want to starve or freeze to death in a snowstorm—but that value drops off faster than the marginal value of other characteristics, including aesthetics.

The relative costs and benefits of different goods rise and fall as circumstances change. Consider what has happened with cars, among the first industrial goods for which aesthetics became important. In the 1950s and 1960s, automotive design and manufacturing seemed mature—cost and quality fell into predictable niches—so car buyers focused on looks, giving rise to the famous tail fins of the Populuxe era. In the 1970s, however, the trade-offs changed, even though incomes continued to rise. Gasoline shortages made fuel efficiency more important, and Japanese and German competitors entered the U.S. market in a big way, offering significantly higher reliability. Suddenly, the relative costs of aesthetics, fuel efficiency, and reliability shifted, making aesthetics less important on the margin.

Today, by contrast, quality is high throughout the auto market, gasoline is plentiful and relatively cheap, and aesthetics has again become decisive. Baby boomers are fueling a market for "road candy"—striking cars designed for fun, from convertibles to the retro PT Cruiser. About 20 percent of middle-aged car buyers, estimates one marketing expert, are less interested in performance or reliability than in "stylish fun." The cars they buy, often the third or fourth in the family fleet, have aesthetic personalities that express the drivers' identities. And younger car buyers are, if anything, even more aesthetically oriented, forcing companies like Honda to rethink their designs. "If you put out an automotive appliance, no one under thirty-five will buy it," explains an industry observer. On the margin, look and feel are more likely to determine value.

Rather than progressing up a simple Maslovian hierarchy, then, we move back and forth among the available options, making the best trade-offs we can. The trade-offs we choose depend on what resources we have. They also depend on what options are available, at what cost. So the relative importance of aesthetics waxes and wanes over time. Technology and economic development affect the relative costs of equally valuable goods. To a peasant in a subsistence economy, significantly better housing or faster transportation might require more than a lifetime's income, while a bit of decorative carving or an elaborately braided hairstyle takes only time, skill, and minimal expense. In this instance, someone will choose aesthetics over more "basic" goods.

The industrial revolution changed those relative prices. When mass production and distribution first made functional products cheap, consumers often chose function over form. This effect was particularly pronounced in the United States, because its populous continental market offered great economies of scale. The preference for function over form gave rise to the common critique that industrial capitalism had made the world ugly, not just because factories were unpleasant but because, given the costs and benefits they faced, the masses were mostly interested in making their lives healthier, easier, more comfortable, and more exciting rather than beautiful. "The

public, tickled to get so many things so cheaply, accepted them without question," lamented Calkins, "and thus we had a depressing period when, in New York City, brownstone houses were built literally by the mile." And he hadn't seen Levittown.

In some areas of life, people did enjoy more aesthetics than their ancestors, thanks to such advances as cut glass, synthetic dyes, or colorful Formica. On the margin, however, they were more likely to choose such newly affordable benefits as convenience, hygiene, mobility, and living space. Once these goods were widespread, those who grew up with them could take them for granted and go in search of additional sources of value. In the past few decades, that search has become easier and easier.

People who think about aesthetics for a living often marvel at how much the world has changed in a generation. What was once exotic is now commonplace. What was expensive is now affordable, sometimes even cheap. Back in the 1970s, recalls an industrial designer, "a wonderfully designed product—designed with [aesthetics] in mind—was the venue for very sophisticated buyers and very upscale markets. Products were very hard to find and they were pretty much unavailable. You really had to know where to go get them." Braun coffeemakers were as hard to come by as contemporary furniture. And once you'd located what you wanted, say, a beautiful piece of furniture, buying it was a major financial commitment, "like a mortgage for a house." Aesthetics, in its many forms, was a specialized good, available mostly in a few large urban markets.

Making more things special requires making markets bigger. That may sound paradoxical, since we associate mass markets with boring, homogenized products. But contrary to popular assumptions, there is a major difference between *mass* markets and *large* markets. Because the expansion of markets in the nineteenth and twentieth centuries happened at the same time as the development of mass-production techniques, many people equate the two. But they're different, with different aesthetic implications. Mass markets spread the

fixed cost of producing the same good over a lot of different buyers. Large markets simply have a lot of people in them. A large population can transform formerly unprofitable niches into profitable mass markets. The bigger the market, the more varied the goods.

Adam Smith noticed this phenomenon back in the eighteenth century. A woodworker could specialize in barrels or cabinetry if he lived in London; in a small town, to fill his working hours, he had to be a generalist. The division of labor (and its equivalent, the specialization of goods), observed Smith, "is limited by the extent of the market." By expanding markets to include more buyers and sellers, trade makes greater specialization possible. What was true of eighteenth-century woodworkers is true of aesthetic businesses today. If you want to succeed making drawer pulls that look like Art Nouveau dragonflies, rather than same-for-everyone functional hardware, you've got to find the equivalent of a large city.

Trade helps, of course, just as Smith said. From the 1950s to the 1990s, trade barrier after trade barrier fell, allowing suppliers from Europe to China to sell their wares in the United States and vice versa. This market expansion not only increased supplies and lowered prices. It also enriched the aesthetic mix, bringing together formerly scattered design traditions. "When industrial products are exported, a glimpse into the cultural identity of their country goes with them," writes a German industrial designer to his American counterparts. As styles have spread beyond their former borders, well-traveled critics sometimes complain that every place looks like every other place, since the old stylistic ghettos that once made for unique experiences have been disappearing. To a given person in a given place, however, the intermingled world offers not less aesthetic choice but more. Even stylistically consistent chains such as Starbucks or Crate and Barrel add to the overall aesthetic variety in the areas they enter. There may be less variation from place to place, but each place features a wider range of styles. Through recombination, the possibilities for new styles and new niches continue to expand.

Domestic growth has been just as important. Over the past half

century, the U.S. population nearly doubled, and the country—like many others—became more urban, with more and more people clustered in the densely populated places that support lots of niches. In 1950, only fourteen U.S. metropolitan areas had more than a million residents, accounting for less than a third of the country's total population. In 1990, there were thirty-nine places with more than a million people, slightly more than half the country. Ten years later, fifty metro areas had more than a million residents, for a total of 164 million people, or 58 percent of all Americans. More and more of us live in big local markets.

By the 1990s, when the age of aesthetics really became apparent, all 75 million baby boomers—the equivalent of ten New York Cities—were in their prime earning years, and the equally large echo boom of the boomers' children was reaching adulthood. With so many new consumers, it was possible to turn once-tiny niches into profitable specialized markets, making variety feasible where homogeneity once reigned. This enormous new demand combined with higher incomes to support new supply. The Great Indoors, says its president, is possible in part because middle-aged baby boomers are "starting to feather their nests" and are flush both with their own earnings and with wealth "cascading from their parents to them."

While cities can support places like The Great Indoors, you no longer have to live in a major metropolitan area to get access to aesthetic quality and variety. Since the 1970s, new technologies and business institutions have allowed aesthetic merchants to bring their wares to people just about anywhere. This trend didn't begin with the World Wide Web. "It was the advent of the credit card that really did it," says Roger Horchow, who launched the first catalog selling luxury gifts and furniture in 1971.

Horchow's venture would have been impossible a decade earlier. The bank cards that became Visa and MasterCard meant that customers could order from an unknown company like his and not fear they'd lose their money. Horchow could fill the orders without worrying about deadbeats. Unlike big catalog operations like Sears and Spiegel, he could concentrate on finding interesting products and let

the banks handle billing and collections. The Horchow Collection didn't have to develop its own credit operation.

Equally important was the computerized database. By 1971, Horchow could get, and use, the names and addresses of a million potential customers, something that couldn't have happened a decade or two earlier. As more and more catalogs developed, the databases grew, adding not only names but more and more information that suggested what those customers might like—what catalogs they bought from, what magazines they read. The extent of the virtual market expanded, and so did the possibilities for serving specialized niches, not only with goods but with new "lifestyle" magazines covering interiors, fashion, and design.

Those magazines, in turn, whetted readers' appetites for more aesthetic surroundings. By the early 1990s, the home magazines "were gaining terrific traction and great circulation," recalls Hilary Billings, who turned Pottery Barn's mail-order operations into a popular source for high-style home décor. These magazines, she says, "were seducing you with these beautiful, wonderful homes that you could only get access to if you were able to hire an interior designer and go to the trade." Many magazine readers wanted to emulate the styles they saw, but they were in no financial position to hire a designer and pay a premium for "to the trade" furnishings. That frustration fueled more catalogs, including Billings's for Pottery Barn.

By the 1990s, there were scores of lifestyle magazines and hundreds of different catalogs, carving out niches by product (food, clothing, furniture, gadgets), style, and demographics. Horchow goes through his mail to document the trend. There's a catalog called *Wine and Jazz* and another promising *Charleston Gardens*. "Here's a whole catalog of wooden outdoor furniture," he says, "where before you saw a couple of chairs in a catalog." Instead of finding the lowest common denominator, as 1950s-style market research tried to do, the analysis behind direct mail made it easier to offer goods and catalog graphics tailored to customers' personal preferences. Behind this spread of aesthetic choice was that familiar business story: the clever use of ever-cheaper, ever-faster computer technology.

In the late nineties, the Sony Vaio and Apple iMac changed the look and feel of computers, transforming dull tools into sources of visual, tactile pleasure. "I can't help patting them," Sony designer Teiyu Goto says of the "thin and groovy" lavender and silver notebooks he created. The iMac, says a design museum curator, "made people look at computing in a different way. They suddenly said, 'Oh, the computer is not just a machine but a decorative object in my home. Why can't it look as good as the house I live in?'" What was true of hotels and restaurants was suddenly true for computers—new standards had emerged. Price and performance were no longer enough to satisfy customers, who expected aesthetic upgrades to accompany faster chips. Even the most practical, corporate-oriented computer makers scurried to hire designers who could give their products some style.

Earnest Calkins would have predicted as much. He believed that ugly industrial technologies would come to have beautiful shells, as the phonograph had been converted into a wood cabinet for the living room and the locomotive had "begun to adorn itself to appeal to a more sensitive public." As computer makers use color, form, and texture to compete, or cellular phones offer easy-to-change faceplates, they're following that well-established pattern. But more is going on with the high technology of our day than Calkins ever imagined in his.

For starters, the gears and levers of old-style machinery are disappearing, their functions buried in the infinitesimal etchings of computer chips. No longer subject to the constraints of internal mechanisms, product surfaces have enormous freedom to follow their owners' pleasures. Your phone can look like a football or a green neon Slinky; a Web camera may resemble a whimsical little creature or a *War of the Worlds* spaceship; a wristwatch can be just about any size, shape, color, or material. Thanks to new engine designs, even cars have much more flexibility to take on new shapes. "The old Beetle had to look that way," says a longtime observer of the design world. "The new Beetle doesn't."

Industrial designers used to complain that manufacturers gave them products to decorate after all the serious design had been done by engineers. Now designers' aesthetic function, once scorned as "mere styling," is the key to defining their products' personality, and hence their value. "We think that aesthetics is just the name of the game right now," says a GE Plastics spokesman, "and if designers are going to differentiate their products in the marketplace it's going to be because of finish and color."

More shocking still is what has happened to the *function* of such technologies as computers, lasers, and fiber optics. They're no longer just the hard, "practical" technologies of old science-fiction visions, to be employed exclusively for such serious business as cutting metal, analyzing data, or fighting wars. Nor are they simply objects with a look and feel of their own. They are aesthetic tools. Just as trains, planes, and automobiles were not industrial goods consumed for their own sakes but sources of transportation services, so high-tech machines are increasingly vehicles to provide aesthetics. The number-crunching logic machines and amplified light beams of practical imaginations have become the playthings of artists and designers, expanding the possibilities of sensory expression. Although no one intended it, today's high technology is particularly friendly to aesthetic applications.

Lasers scan photos, play music, cut fabric, print graphics, resurface skin, and zap away unwanted hair. Trade show booths incorporate touchscreens and virtual-reality goggles. Digitized video makes editing easy, permitting MTV-style quick cuts. Fiber optic–based endoscopes guide plastic surgeons as they restructure forehead tissues. Starbucks designers use 3-D animation software to demonstrate how layouts, materials, lighting, and artwork will look in real stores. Software adapted from pilot-training flight simulators lets real estate developers show potential buyers and land-use regulators exactly how new houses will fit into the landscape. On the GE Plastics Web site, customers can specify, display, and order any of 35,000 colors—no description necessary, just point and click.

From Frank Gehry's curve-fitting architecture to George Lucas's

imaginary worlds, computers make the once-impossible possible, the always-possible easier, and the hard-to-articulate clearer. Gehry says the CATIA software program, which his firm adapted from the aerospace industry, allows an architect to "demystify the shapes for the contractor and make them to within several decimal points of accuracy," leading to much tighter cost control even as it permits wildly innovative design. Computer-aided design breaks down the wall between imagination and execution, reducing the chances that designers will develop something that can't be made. "The technology allows a designer to manipulate cyberspace and create a form and hand that model to an engineer—it's defined, it's surfaced, it's a solid maybe—and the engineer can manipulate it further," says an industrial designer. Coming next: realistic three-dimensional holograms that will let designers "feel" and revise their models using special gloves.

Even the oldest products of the industrial revolution are enjoying the aesthetic benefits of new technological powers. To embed her intricate textile-design concepts in expert-system software, Jhane Barnes employs two mathematicians as full-time consultants. Some patterns she couldn't create without computer assistance; the rules are too complex to graph or remember. Others would require a week of tedious charting to record what she now creates in just an hour. These specialized software tools have given Barnes many more design options, and much more time to explore them.

"The design process is much faster," says Barnes, who uses her textile designs in menswear, upholstery fabrics, and carpets. "So that means my collection can be larger, and that means business can grow. Also, I'm more prolific. That means I can be a better designer, because I can throw away things that didn't take so long to design and say, 'Oh, I can do another one in a short amount of time, so let me just make it better.'" Coming up with a new season's collection takes as long as it ever did. The computer just allows more iterations. "If I know I have a month to finish fall," Barnes says, "even though with the computer I could finish it in a week and take a three-week vacation, I'm having too much fun—I take the whole month. So the line is better than if I had to do it the long way."

Of all design fields, the personal computer has probably had the most immediate and radical effect on graphics—making new designs possible, creating new niches, popularizing once-esoteric know-how, and generally calling people's attention to the value of visual communication. What has happened in graphic design is a harbinger of broader trends, the sort of pattern we can expect in many other fields. Technology has made improving look and feel much easier, giving us a more attractive and varied aesthetic world.

Consider how the daily newspaper has changed. Journalism professor Carl Sessions Stepp compared the design and contents of ten midsized newspapers from 1963 with comparable weeks in 1998 and 1999. The old papers, he reports, "cram fifteen or more stories into eight gray columns" on their front pages, with tiny photos and hardly any white space. Inside, "stories wrap out from under their headlines and frequently end in mid-sentence (a common problem in those hot-type days)." Today's layouts, by contrast, feature modular stories, abundant white space, and ample illustrations, courtesy of computerized composition, digitized wire-service photos, and computer-generated graphics. And, of course, newspapers are more likely to have color. The better design hasn't come at the expense of written content, which has increased; when you're richer, and the cost of aesthetics is falling, you can have more of everything.

What was polished enough a decade or two ago is no longer acceptable. That doesn't mean everything looks the same. To the contrary, aesthetics-friendly tools have simultaneously raised expectations and encouraged stylistic plenitude. The universal appeal of thoughtful, well-balanced graphics coexists with the demand for novelty, variety, emotional resonance, and personal expression.

Twenty years ago, typefaces traveled on film and required special equipment and expert hand manipulation to be turned into printable text. A modest commercial typesetter would carry no more fonts than could be displayed on a single sheet of typing paper. "There were probably about twenty serif and maybe eight sans serif fonts on that sheet," recalls a graphic designer. "And everyone always used Palatino." Not so today. The digital revolution means typeface design

is no longer a capital-intensive business but something any graphic designer can experiment with. The result is a vast expansion of the supply of fonts, a profusion of choices. Phil's Fonts, a six-employee Maryland company, offers more than thirty thousand electronic fonts from typeface designers all over the world. Customers range from ad agencies and design houses to soccer moms making flyers and couples personalizing their wedding invitations.

Not all personalized expression looks good to other people, of course. Especially in the early days of desktop publishing, a lot of amateurs went in for the multifont ransom-note look. PowerPoint presentations are still often hard to read or cluttered with clichéd clip art, and the Web is full of ugly sites. But, on the whole, the computer-driven democratization of design has made more people sensitive to graphic quality. Bit by bit, the general public has learned the literal and metaphorical language of graphic design. Carried by computers, aesthetics has spread to places and professions that were formerly off-limits to any such frivolity.

Ten years ago, a prestigious law firm never would have put bullet points or different sizes of type in a client newsletter, lest the document look like advertising. Today, lawyers have seen too many PowerPoint presentations to scorn the power of graphic communication. Now, says a bemused graphic designer, "lawyers are giving clients two forms of material—conventional narratives and documents that look like *Good Night Moon*. They look like children's stories: giant words on a page, things in a box, action items, bullet points, no transitions. . . . It's good to have people finding the ideas of graphic design accessible. It's a little tragic that we have to go through this phase where so many people are doing it badly, but they'll get over it."

What's true for graphics is true for aesthetics in general. Expanded supply creates expanded demand, which in turn feeds even more supply. Over time, people learn. They discover more about what's aesthetically possible and more about what they like. Exposure changes tastes.

The age of aesthetics, in all its pervasiveness and plenitude, has come to bathroom cleaning. Every day, all over the world, designers are working to make a better, prettier, more expressive toilet brush for every taste and every budget. The lowliest household tool has become an object of color, texture, personality, whimsy, even elegance. Dozens, probably hundreds, of distinctively designed toilet-brush sets are available—functional, flamboyant, modern, mahogany.

For about five bucks, you can buy Rubbermaid's basic plastic bowl brush with a caddy, which comes in seven different colors, to hide the bristles and keep the drips off the floor. For $8 you can take home a Michael Graves brush from Target, with a rounded blue handle and translucent white container. At $14, you can have an Oxo brush, sleek and modern in a hard, shiny white plastic holder that opens as smoothly as the bay door on a science-fiction spaceship. For $32, you can order Philippe Starck's Excalibur brush, whose hilt-like handle creates a lid when sheathed in its caddy. If your tastes don't run to trendy designers, for around the same price you can get a brush that hides in a ceramic cowboy boot. At $55, there's Stefano Giovannoni's Merdolino brush for Alessi, its bright green T-shaped handle sprouting like a cartoon plant from a red, yellow, or blue plastic pot. Cross the $100 barrier, and you can find all sorts of chrome and crystal, brushed nickel and gold, ranging as high as $400.

Like many variety increases, the profusion of designer toilet brushes required new forms of distribution. But better-looking brush sets were a predictable outcome of a competitive marketplace, in which customer-pleasing innovations reap rewards. "We take it for granted that there will be change and progress, that there's some sort of teleological drive in technology," says David Brown, the former president of Art Center College of Design. "There's that drive in manufacturing, there's that drive in engineering, to better and better and better, safer and safer and safer, less and less costly to manufacture. Why shouldn't we assume that there's a similar mechanism in terms of people's aesthetic expression? Why shouldn't there be a reasonable expectation that a toilet brush today would function better

and look better and cost less than a toilet brush from five years ago?" In this regard, aesthetics is no different from computing power. What was acceptable yesterday isn't today. Expectations increase, and tastes evolve.

The toilet brush is an unusually pure example of aesthetic demands. Who can seriously ascribe the desire for a pleasing brush caddy to the status-craving drive to impress the neighbors? Stainless-steel appliances, beautifully tailored clothes, or cool cars may (or may not) mask such other-directed motivations. But a brush hidden in the corner of the bathroom, a bathroom your neighbor will quite likely never see, is surely just a brush, an object acquired for its own sake. And what sort of prestige could possibly accrue to a tool for cleaning toilets, however lovely or expensive its case might be? The look and feel of your toilet brush are just that—sensory pleasures, expressions of what you find appealing.

How, then, do people come to believe that their lives would be a little better, their surroundings a bit more enjoyable, if they could store their cleaning tools in an attractive or expressive case? Toilet brushes are, after all, rarely advertised. They have to speak for themselves, with no talking frogs or pop tunes to promote them. Toilet brushes are usually minor purchases made without deep analysis, and each brush cleans pretty much as well as the next. So the immediate sensory appeal of the brush set on the shelf is decisive. We buy aesthetic models because we like what we see and feel. Exposure, not manipulation, creates demand.

This is a clue to changing tastes: We've seen more and more improvements. There's a ratchet effect. If you're used to a neat, attractive toilet-brush holder, you won't be happy throwing a bare brush under your sink. If you've become accustomed to memos and résumés with proportional typesetting, you won't think old-fashioned Courier typewriter type looks polished or professional. When Scott McNealy, the CEO of Sun Microsystems, tried to ban PowerPoint and require handwritten slides, his employees refused to give up their slick graphics, sometimes employing devious techniques. "We've handled this prohibition by doing our slides in Blueprint or Comic

Sans," one wrote to me after I mentioned the ban in an article, "two fonts which *look* like hand lettering."

Once people get used to a certain level of conscientious aesthetics, they don't want to go back—and they don't have to, even when times get tough. Fierce competition is making aesthetic products cheaper and more available, to the chagrin of executives whose companies once enjoyed near monopolies. Until recently, retailer Chiasso could charge just about anything for the high-design housewares and furnishings it sells through mall stores and a catalog and Web site. Managers never even held a pricing-strategy meeting until late 2002. But just as the company's stores were getting hammered by the post–September 11 drop in tourism and mall traffic, customers started to get more and more offers elsewhere.

"DWR is coming on strong," says Chiasso's chief executive, referring to Design Within Reach, a major competitor founded in 1999 to sell reasonably priced, immediately available modern furniture. Now DWR also sells the sorts of accessories Chiasso is known for, and it has expanded from a catalog and Web site to roll out retail stores in hip urban neighborhoods. Meanwhile, at the lower end of the market, Target continues to add to its high-design offerings. Williams-Sonoma, which owns Pottery Barn and Restoration Hardware, opened a high-style, low-cost catalog division called West Elm in early 2002. All this competition is great news for aesthetics-conscious consumers and terrible news for style pioneers like Chiasso. The company filed for Chapter 11 bankruptcy protection in early 2003 and closed all but four of its stores to focus on its direct marketing operations. Consumers now expect good design *and* a good price.

Aesthetic experience leads to greater self-confidence and more definite opinions. People feel qualified to judge the look and feel of their surroundings. "Design is being democratized," notes star designer Karim Rashid, who is most famous for his best-selling trash cans. "Our entire physical landscape has improved, and that makes people more critical as an audience."

That critical audience can seem quite tyrannical to those who have to please it. As a home developer remarked to me, it must have been

nice in the good old days when just offering a yard and some bathrooms was enough to impress customers. Nowadays, the bathrooms have to be bigger and better, ever more luxurious; so do the house and the yard and, indeed, the whole neighborhood. What's true of homes is true of more personal aesthetics. Exposure creates escalating demands. I get my fingernails sculpted and my eyebrows waxed because nail salons and day spas sprouted in my old neighborhood. When action-movie stars buffed out, so did many men in the ticket lines. A friend tells me that his wife had always been a "naturalist" who scorned plastic surgery—until one of her friends got a face-lift and looked just great. Now she's contemplating surgery too.

Individuals adopt all sorts of styles, and particular fashions come and go, but attention to appearance and personal grooming seems to be ever-rising. An academic who splits her time between Princeton and London observes the effects as new grooming standards travel east across the Atlantic. "Last year it was all about manicures," she says. "All the nail bars went up," and women began to fret about their fingernails: "How could you go around with your plain old hands?" Now London women have added tooth whitening and bikini waxes to their grooming routines. "You begin to feel self-conscious about things that otherwise you would never give a thought to."

As she was applying various potions to my skin, a facialist asked about my work. I told her about my research and mentioned all those toilet brushes. She did not approve. Leaving your toilet brush on display, she observed, "would really interfere with your feng shui." How does a Texas facialist come to have an opinion on the ancient Chinese art of interior arrangement? This conversation would not have taken place twenty years ago, and not just because people like me didn't get facials.

Travel, media, immigration, and education have increased the flow of aesthetic ideas. From 1980 to 2000, the Chinese population of the United States tripled, making feng shui important to West Coast real estate sales years before it spread to the more general culture.

America's first popular feng shui manual appeared in 1983, written by a young journalist who'd learned about the practice while on a fellowship in Hong Kong. "It was similar to discovering a lost treasure in a grandparent's attic, something that had existed for a long time but that no one—at least in the West—had noticed or valued," she recalls. Today, feng shui advice fills several shelves of the interior design section in most U.S. bookstores, inspiring home and office arrangements even for those who do not buy the system's more mystical claims.

Rising incomes, falling prices, and new supplies would be enough all by themselves to increase aesthetic exposure and change tastes. But these factors aren't operating in isolation. The great social and cultural shifts of the late twentieth century have also made aesthetics more important, more legitimate, and more varied, shaping the aesthetic age as surely as any technical or business innovation.

Along with media and immigration, the most obvious cultural influence is feminism. Whether married or single, women with independent incomes feel freer to spend their money on the aesthetic goods that traditionally appeal to women. That has predictable results, including stores like The Great Indoors, and unexpected ones, such as the spread of nail salons and the boom in plastic surgery. But the effects go beyond women's personal consumption. More female business travelers affect the design of hotels and restaurants. Later marriages and more divorces mean women and men live on their own longer, which means more single men must furnish their own homes and develop their own tastes. A more competitive marriage market for both men and women heightens the importance of looking good personally and of creating a home environment that appeals to the opposite sex. More working mothers mean teenage boys are more likely to do their own clothes shopping, enhancing their sense of personal style.

At the same time, the merging of the traditional "separate spheres"—the aesthetic, feminine home and the functional, masculine workplace—has diminished the assumption that style is an intrinsically female concern. When *Men's Journal* devoted its

September 1999 edition to design, it became the best-selling issue ever, and an annual event. Today's corporate chieftains are more likely to insist on having a hand in designing their own home environments, rather than delegating that task to their wives or to professional experts. "More and more what we are going to see are people who want building designs that make *their* vision," says Harvard Business School professor Michael Maccoby, an expert on executive temperaments.

"Ten years ago, it wasn't cool for a guy to be into design," says the Chiasso CEO. But particularly among younger men, paying attention to aesthetics is not just acceptable but expected. "If I'd dressed like kids today, I'd have gotten beat up in the locker room," he says, noting that many of the boys in his seventh-grade daughter's class dye their hair. Twenty-seven percent of males ages sixteen to nineteen say they "try to stay on the cutting edge of fashion," a sharp jump from 16 percent in 1994, according to surveys for Cotton Inc., the cotton-promoting trade group. The pervasive visuals of video games and music videos also teach young men to expect and interpret careful design.

Still, a gender gap persists, making the presence of female decision makers all the more important to aesthetic businesses. Even Chiasso's decidedly unfrilly contemporary styles appeal primarily to female customers, who outnumber males about two to one. When the company began looking for mall locations in the mid-1990s, it had a hard time getting space. The old boys' network of leasing agents didn't understand the idea of a store devoted to fun, museum-quality objects for the home. "Is it like Spencer Gifts?" asked one, referring to the purveyor of off-color gag gifts and black-light décor. Many malls refused Chiasso's business. As shopping centers hired female agents, Chiasso found a more receptive market. But, says the company's CEO, "the only way we got into our first two malls in 1996 was a gay leasing agent."

The mainstreaming of gay culture has itself altered tastes. In some cases, formerly gay styles such as earrings on men have spread to heterosexuals. The "Buff Revolution," while it has other sources as well,

was clearly influenced by gay men's emphasis on bodybuilding. Equally important, as the stigma of being thought gay has diminished, paying attention to aesthetics has become less costly and more appealing for heterosexual men. "A lot of people think I'm gay because I like to dress well, to look my best," says a young banker in a *New York* magazine article on men's new devotion to personal appearance. "But it's important. You need to stand out, whether at work or with women." Better to look good and be thought gay than to look straight and be thought sloppy, ignorant, ugly, or old. It's easy enough to correct a misconception about one's sexual orientation. But an aesthetic first impression might reveal an unappealing truth.

Opposing aesthetics and function, aesthetics and business, or aesthetics and masculinity is not universal. These contrasts are the culture-bound products of Puritan restraint, nineteenth-century romanticism, and twentieth-century technocracy. Not surprisingly, many of the commercial innovations that have overturned these assumptions come directly or indirectly from cultures that put a high value on aesthetics, particularly Italy and Japan. These cultures take look and feel as seriously as any other source of value. David Brown, the former design school president, notes that more than 40 percent of his college's students were Asian or Asian American. "These kids were coming from backgrounds in which design and visual arts carried a high degree of prestige," he says.

Within the United States, many subcultures, notably African Americans, have always seen personal style as an important expression of accomplishment and self-respect. Against the degradation of slavery and segregation, explains a history of African Americans in fashion, "Style represented a challenge to nonexistence . . . Style said I am. No matter what." Creating a striking appearance was a skill to be practiced, not an indulgence to be shunned. "Black style was not about breathlessly aspiring to an impossibly grand life but about confidently, proudly, spreading around the knowledge and polish we already possessed." With the end of racial segregation, that view has become increasingly part of the cultural mainstream, carried not only by individual encounters but by the media images of popular athletes,

musicians, and actors. Those teenage boys who want to be on the cutting edge of fashion are in many cases emulating black role models who make conscious style a marker of masculine achievement.

The civil rights revolution has had other, more subtle aesthetic effects. With the legal equality of black Americans (and of women) have come new social attitudes toward cultural minorities, conformity, and individualism. Treating everyone equally now means acknowledging the right to be oneself, including a broad freedom to follow one's own tastes. Personal expression, including signs of group affiliation, generally trumps orthodox social norms. When blacks claim the right to wear African-inspired clothes or hairstyles, they succeed not so much because of increased racial tolerance per se as because of increased tolerance in general. Instead of upholding a single stylistic mainstream, the social norm has shifted to dictate diversity.

The profusion of styles we see is thus not just a matter of information and technology but of the spread of certain values. The mere knowledge of aesthetic concepts does not guarantee their adoption. In the 1950s, a London art-school student found inspiration for a dress-design assignment in the pages of *National Geographic*, where "there were a number of exciting and colorful photographs of New Guinea tribal warriors in full war paint, resplendent in feathers and shell adornments." The way he adapted those motifs into mass-market dresses, however, did not meet with professorial approval. The teacher, he recalls, "was not amused and went so far as to say that if I lived to be a hundred, I would never see such tribal ways influencing Western styles of dress, adornment, and beauty. How wrong he was."

Until relatively recently, social convention restricted the aesthetic play of imagination and technology. Forget hip-hop flamboyance and punk transgression. In the 1960s, nice girls didn't dye their hair or get their ears pierced. Michael Jordan's tailored but body- and fashion-conscious dress (not to mention his earring) would have been too conspicuous, a reminder that black men took unseemly pride in their personal style. As recently as 1983, a leading fashion critic could describe Armani suits as representing "a style that is decidedly homosexual," and thus of limited appeal to mainstream professional men,

who feared being thought effeminate unless they chose clothes that "go unnoticed."

The extension of liberal individualism—the primacy of self-definition over hierarchy and inherited, group-determined status—has changed our aesthetic universe. This doesn't mean people don't have strong opinions about other people's aesthetic choices. The breakdown of unified standards can, in fact, lead to greater conflict, and in some cases, such as employer dress codes, one aesthetic identity (the company's look and feel) may clash with another (the employee's personal style). Compared to earlier periods, though, tolerance is both a social norm and a stylistic reality.

When served by an open marketplace, individualist culture continually multiplies the stylistic possibilities available to any given person. Popularity also tends to tame formerly outré styles, turning symbolism into pure form. "Nose ring time," goes a song parody. "Every new rebellion becomes another annoying trend." If not just anything goes, that is more because of individual tastes, including the desire to associate with others with similar preferences, than because of external pressures. The one best way is dead as an ideal.

Instead of a single dominant standard, then, we see aesthetic fluidity. Individuals recombine styles that please them, and those combinations in turn create ever more ideas and categories that can be further recombined. Consider a Web site called Gothic Martha Stewart, inspired by the cheeky question, "What if Martha Stewart was a goth?" The site's creator says she established it after noticing that her goth friends were as devoted to do-it-yourself décor as the queen of WASP domesticity. They just used a different palette toward different expressive goals.

"Many of our projects," she writes, "were direct adaptations of Martha's Good Things—except we used scraps of black velvet, vintage lace, purple satin ribbons, dried bloodred roses, and other typically goth things we had around the house. Little did Martha realize how easily her elegant eggshell blues and seafoam greens could be turned to black and burgundy!" Goth itself is not a single category but a universe of proliferating motifs. To inspire the do-it-yourselfer

with a taste for dark romanticism, the site lists eight different types: Victorian, Medieval, Techno-Modern, Cemetery, Fairy, Asian, Egyptian, and Punk DIY. No wonder observers use words like *dizzying* to describe the aesthetic variety of our day.

Whether goth Good Things, "road candy" cars, or brightly colored Alessi toilet brushes, something about that dizzying variety inspires individuals to devote their time, money, and attention to look and feel—to affirm by their actions that aesthetics has value. Superficial though they are, the sensory qualities of people, places, and things matter to us. But the nature and sources of that value and, indeed, its very legitimacy, are deeply contested. Not everyone believes that surface has genuine worth.

Three

SURFACE AND SUBSTANCE

To the chagrin of designers, it's hard to measure the value of aesthetics, even in a straightforward business context. Often look and feel change at the same time as other factors, making the specific advantages of each new characteristic hard to isolate. Some companies, such as Apple Computer, are good at design but less adept at other business operations, muffling whatever success their fine styling might bring. And in many markets, competition tends to wipe out any hope of direct gain; the benefits of aesthetic investment go to consumers, not producers. In these cases, spending on aesthetics is just a cost of staying in business, not a profit-increasing investment.

We know that people generally don't want something that's otherwise worthless just because it comes in a pretty package and, conversely, that valuable goods and services are worth even more in attractive wrappings. Beyond these generalities, it's often hard to tell exactly how surface and substance interact. Occasionally, how-

ever, we get a fairly pure example of how much people value aesthetics.

In the early 1990s, Motorola came out with an updated version of its most popular pager. The new version had enhanced features, but what really made it special was the pager's colorful face. Managers bored with the old look had replaced basic black with bright green, making the new-and-improved pager unlike anything on the market in those pre-iMac days. Buyers thought the green pager was cool, and they were willing to pay a premium to get it. "The moral of the story, which I repeat many, many times to engineers, is that all the fancy-ass technological engineering in the world couldn't get us a nickel more for the product," says the former head of Motorola's pager division. "But squirt-gun green plastic, which actually cost us nothing, could get us fifteen bucks extra per unit."

Is this anecdote an innocent example of creativity in action, with a few laughs at the expense of technologically earnest, aesthetically clueless geeks? Or does the story provide a glimpse at just what's wrong with an age of look and feel—an era in which a bright plastic face is as important as real technological improvements? Should the success of the squirt-gun green pager give us the creeps?

An appealing pager face may delight customers, but it upsets many critics, who question the value of form without function. Surface and substance are opposites, they believe. Surface is irrelevant at best and often downright deceptive. If people pay more for mere aesthetics, goes the reasoning, then those consumers are being tricked. A squirt-gun green pager is simply not worth more than a black one. The two pagers have the same features! Paying more for green plastic is stupid, and only a dupe would do it. Function, not form, creates legitimate value.

The idea that surface itself has genuine value, for which consumers willingly pay extra when other characteristics are the same, appalls these critics. They "see that view as tantamount to advocating cannibalism of infants or something," says graphic designer Michael Bierut. In one such case, he recalls, a critic berated a conference of designers "for creating meaningless distinctions between identical

products like Coke and Pepsi. After some back and forth I asked him whether there was any inherent virtue in variety and beauty for their own sake. He sort of fumbled around and then more or less said that things could not exist 'for their own sake' and then invoked the example of Leni Riefenstahl's work for Hitler. That was as quick a ride from Pepsi to Nazis as I've had in a long time."

To such critics, form is dangerously seductive, because it allows the sensory to override the rational. An appealing package can make you believe that Nazis are good, or that colas are distinguishable. The very power of aesthetics makes its value suspect. "In advertising, packaging, product design, and corporate *identity*, the power of provocative surfaces speaks to the eye's mind, overshadowing matters of quality or substance," writes Stuart Ewen, the critic with whom Bierut sparred. "Provocative surfaces" have no legitimate value of their own, he suggests, and they inevitably hide the truth. Contemplating the rise of streamlining in the 1930s, Ewen declares that "a century that began with a heady vision of moving beyond the ornament and uncovering the beauty of essential truth had rediscovered the lie." Aesthetics, in this view, is nothing more than a tool for manipulation and deceit.

Ewen is not alone. Sociologist Daniel Bell, in the twentieth-anniversary edition of his influential book *The Cultural Contradictions of Capitalism*, points to the prominence of cosmetics in department stores as a sign of the pervasive falsehood oiling "the machinery of gratification and instant desire" that is contemporary capitalism. Women's fashion and fashion photography exemplify for Bell the same falsehood as advertising: "this task of selling illusions, the persuasions of the witches' craft," which he deems one of the contradictions that will ultimately bring down capitalism by eroding its Puritan foundation. To Bell, consumers are too susceptible to illusion and luxury, embracing hedonistic values that undermine bourgeois virtue. "The world of hedonism," he writes, "is the world of fashion, photography, advertising, television, travel. It is a world of make-believe."

Informing many such critiques is a naïve mid-twentieth-century

view of how business operates: that producers can simply decree what consumers will buy, in a foolproof "circle of manipulation and retroactive need," as the Frankfurt School Marxists Theodor Adorno and Max Horkheimer put it in an influential 1944 essay. In commercial products at least, such critics see ornament and variety not as goods that we value for their own sakes but as tools for creating false desire. Where the gullible public finds pleasure and meaning, the expert observer perceives deception. "That the difference between the Chrysler range and General Motors products is basically illusory strikes every child with a keen interest in varieties," declare Adorno and Horkheimer. "What connoisseurs discuss as good or bad points serve only to perpetuate the semblance of competition and range of choice."

In this view, modern commerce, because it appeals to consumers as visual, tactile creatures, is deceptive and decadent. The claim is unfalsifiable, since the more we try to proclaim the real value we attach to look and feel, the more we demonstrate just how duped we are. Legitimate value must come from objective characteristics—the taste (or, preferably, the nutritional value) of colas, the fuel-efficiency and power of cars, the cooking quality of toasters, the warmth of clothing—not through the associations and pleasures added by graphic imagery, streamlining, or fashionable cuts.

Although tinged with Marxism, this analysis is not all that different from the engineering vision of archcapitalist Scott McNealy of Sun Microsystems, who declared PowerPoint presentations wasteful because they consume more computer memory than handwritten slides—even though memory is abundant and virtually free. Hardheaded realists have no patience for the triviality of surfaces. If "content," rather than "packaging," is the only real value, then any attention to aesthetics furthers a lie, and resources spent on aesthetics are obviously wasted. This reasoning combines the oversimplified Maslovian idea, "aesthetics is a luxury," with a puritanical conviction that luxury is waste.

Just as the aesthetic imperative is not something only businesses feel, the fear that surfaces dissemble, distract, and distort is not limited

to commerce and its critics. A conservative minister worries that evangelical churches, in their efforts to attract and hold members, have sacrificed the substance of preaching and prayer for mere spectacle. Today's services feature giant video screens, professionally lit stages, and high-energy rock bands. "The worship of God is increasingly presented as a spectator event of visual and sensory power rather than a verbal event in which we engage in a deep soul dialogue with the Triune God," he writes, adding that "Aesthetics, be they artistic or musical, are given a priority over holiness. More and more is seen, less and less is heard. There is a sensory feast but a famine of hearing. . . . Now there must be color, movement, audiovisual effects, or God cannot be known, loved, praised and trusted for his own sake."

Here, the "sensory feast" is less a lie than a distraction, diverting worshipers' attention and ministers' efforts from more important matters. As aesthetic expectations rise, in this view, congregants too easily forget the purpose of the spectacle. They become addicted to sensory stimulus, losing the ability to worship without it. They come to expect an experience of "color, movement, [and] audiovisual effects," an immersive environment rather than a cognitive exchange. As the aesthetic overrides the verbal, the feeling of worship overwhelms the message.

This critique reflects the widespread fear that surface and substance cannot coexist, that artifice inevitably detracts from truth. It is a fitting argument for a traditional Calvinist minister, whose dissenting forebears stripped churches of many of their aesthetic trappings. Before ornament was crime, it was idolatry. The whitewashed Puritan meetinghouse is as devoid of decoration as any modernist box.

You don't have to be a religious leader to worry that the spectacular may cancel out the verbal. The same anxieties arise even for pure entertainment. One sign of the "age of falsification," writes a critic, is "the blockbuster movie in which story line and plausibility are sacrificed to digital effects and Dolby Sound." In this pessimistic vision, substance—"story line and plausibility"—will not survive the rise of

surface. We cannot have movies that have both good stories and special effects. Our love of sensory delights is crowding out more cognitive pleasures. And it is creating a world of falsehoods.

Even worse, we fear, the aesthetic imperative is disguising who we really are. From Loos to Bell, and for centuries before them, critics of ornament have aimed some of their sharpest attacks at bodily decoration—at all the ways in which individuals create "false" selves and at the temptation to judge people by their appearances. In the seventeenth century, writers and preachers warned against women's makeup, which "takes the pencill out of God's hand," defying nature and divine will. "What a contempt of God is this, to preferre the worke of thine owne finger to the worke of God?" exclaimed one writer condemning cosmetics.

The idea that unadorned faces and bodies are more virtuous and real than those touched by artifice persists to this day, usually in a secular, often political, form. In *The Beauty Myth*, Naomi Wolf advocates "civil rights for women that will entitle a woman to say that she'd rather look like herself than some 'beautiful' young stranger." Wolf praises the "female identity" affirmed by women who refuse to alter their appearance with makeup, hair dye, or cosmetic surgery: "a woman's determination to show her loyalty—in the face of a beauty myth as powerful as myths about white supremacy—to her age, her shape, her self, her life." Except those born with exceptional natural beauty, authenticity and aesthetics are, in this vision, inevitably at odds. Remaining true to oneself means eschewing artifice.

The preachers—secular and religious, contemporary and historical—tell us that surfaces are meaningless, misleading distractions of no genuine value. But our experience and intuition suggest otherwise. Viscerally, if not intellectually, we're convinced that style does matter, that look and feel add something important to our lives. We ignore the preachers and behave as if aesthetics does have real value. We cherish streamlined artifacts, unconcerned that they do not really move through space. We find spiritual uplift in pageantry and music. We prefer PowerPoint typefaces and color to plain, handwritten

transparencies. We define our real selves as the ones wearing makeup and high heels. We judge people, places, and things at least in part by how they look. We care about surfaces.

But we are not only aesthetic consumers. We are also producers, subject to the critical eyes of others. And that makes us worry.

We worry that other people will judge us by our flawed appearances, rather than our best selves. We worry that minding our looks will detract from more important, or more enjoyable, pursuits. We worry that we will lack the gifts or skills to measure up. And we worry that our stylistic choices will be misinterpreted. Businesses making pagers, creating sales brochures, and designing trade show booths face all the same problems, but without the emotional anguish that comes when the surface and substance are personal.

"If you look like you spend too much time on your clothes, there are people who will assume that you haven't put enough energy into your mind," says an English professor who advises aspiring humanities scholars on their appearance and manners. Still, she warns that the wrong clothes can be catastrophic: "If you don't know how to dress, then what else don't you know? Do you know how to advise students or grade papers? The clothes *are* part of the judgment of the mind." Even to people ostensibly concerned only with substance, surface matters. And getting it right is hard.

Speaking to Yale University's 2001 graduating class, Hillary Rodham Clinton, just a few months into her first term as a U.S. senator, bundled these anxieties into a bitter joke. "The most important thing that I have to say today is that hair matters," she said. "This is a life lesson my family did not teach me, Wellesley and Yale failed to instill in me: the importance of your hair. Your hair will send very important messages to those around you. It will tell people who you are and what you stand for. What hopes and dreams you have for the world . . . and especially what hopes and dreams you have for your hair. Likewise, your shoes. But really, more your hair. So, to sum up. Pay attention to your hair. Because everyone else will."

Beneath the humor is a sense of betrayal. *Why are you so obsessed with my hair? Why won't you take me seriously?* It wasn't supposed to

be this way, not for ambitious public women. Hair is just surface stuff. And surfaces aren't supposed to be important, at least not in a postfeminist era in which women can be more than decorators and decoration. Yet Hillary Clinton's hair is so famous that there used to be a Web site, hillaryshair.com, devoted to its many changing styles. Countless column inches and television minutes have chronicled her various hairdos and probed their meaning, seeking those "very important messages." Clinton is a polarizing figure, so her enemies and her allies have identified radically different messages. But both camps have opined about the meaning of her hair.

Taken literally, Clinton's joke offers another reading, equally marked by betrayal. *Somebody should have warned me. My education ripped me off.* Looks matter, and Wellesley and Yale and the Rodham family sent Hillary into the world without teaching her how to manage her appearance. They instead told her that serious people, especially serious women, don't waste precious attention on anything as trivial as hair. Inculcated with the idea that surfaces are false and unimportant, she lacked the presentation skills for an aesthetic age and had to learn them in public.

The joke simultaneously expresses three contradictory beliefs: that appearance matters and should be given due attention (the unironic reading); that appearance shouldn't matter (the ironic reading); and that appearance matters for its own aesthetic pleasures rather than for any message it sends ("what hopes and dreams you have for your hair"). These sentiments are hardly original or unique to Hillary Clinton. Most of us hold all three views at least some of the time. Untangling them—figuring out when each is true and how they relate to each other—is essential to understanding how to live in our age of look and feel.

As emotionally satisfying as it may sometimes be, declaring surfaces false and worthless is merely another form of deception. That sort of cheap dismissal not only ignores obvious realities. It also makes us a little crazy. Rather than deny that aesthetics conveys both pleasure and meaning—and, thus, has value to human beings—we need to better understand how pleasure and meaning

relate to each other and to other, nonaesthetic values. What is the substance of surface?

When they aren't denouncing surfaces as lies and illusion, cultural critics typically have one explanation for why we devote time, attention, and, most of all, money to aesthetics: It's all about status. The intrinsic pleasures of look and feel are irrelevant. We're simply attracted to anything that helps us compete for recognition and dominance.

In *Luxury Fever*, a self-described "book about waste," economist Robert Frank treats the aesthetic ratchet effect as entirely status-driven. We want ever-more appealing things because our neighbors have them. True enough. But in Frank's world, finding out that our neighbors are enjoying some new luxury functions only as a competitive spur, not as information about what's possible. We aren't happy for the neighbors. We don't want to share the same pleasures. We don't identify with them and want to imitate their taste. We just want to show them up. To Frank, rising expectations reflect only a desperate struggle to keep up with the Joneses.

Larger, better appointed homes are not, in this view, an enjoyable effect of prosperity but the outcome of a race to have the biggest and best on the block—a race that can have only one winner. We buy fancy clothes and luxury furnishings because we want to "stand out from the crowd," not because we like these things. Hence Frank's argument that "if, within each social group, everyone were to spend a little less on shoes, the same people who stand out from the crowd now would continue to do so. And because that outcome would free up resources to spend in other ways, people would have good reasons to prefer it."

The argument depends on the conviction that we do not want those expensive shoes or large homes because of any intrinsic qualities. Frank assumes that we do not value the luxuries themselves— the soft leather of the shoes, the smooth granite countertop, the sculptural lines of the car, the drape and fit of the jacket—but just

want to stand out, or at least not look bad, compared to other people. He also imagines only rivalry, not identification, a desire to stand out from the crowd, never to fit in with our friends. In Frank's world, aesthetics provides no pleasure and only the most desiccated and anti-social meaning.

Not surprisingly, he sees aesthetic competition as almost entirely wasteful, making everyone worse off. "If I buy a custom-tailored suit for my job interview," Frank writes, "I reduce the likelihood that others will land the same job; and in the process, I create an incentive for them to spend more than they planned on their own interview suits. . . . In situations like these, individual spending decisions are the seeds of a contagious process." In this view, we would all benefit if men could agree to wear cheap, ugly suits and spend their money on more important, more substantial things—a vision of fashion not unlike the British Utility scheme that took the ornament out of furniture and declared bookcases more essential than easy chairs.

Why, then, is the process contagious? Frank thinks it's just a matter of status-oriented one-upmanship, focused almost entirely on how much things cost. But consider why Frank's ideal world would require a cartel, in which everyone agreed to follow a drab standard. What would happen if every restaurant looked like a functional school cafeteria—but one establishment started to decorate with colored paint and table linens, background music, and special lighting? What if every product came in a plain black-and-white box—but one company invested in graphics and color? What if everyone wore drab Mao suits—but one person dressed with color, tailoring, and flair? People would, of course, be drawn to the aesthetic deviant, even though that nonconformity might well offend the reigning status hierarchy.

This thought experiment suggests something at work besides status and one-upmanship. Sensory pleasure works to commercial and personal advantage because aesthetics has intrinsic value. People seek it out, they reward those who offer new-and-improved pleasures, and they identify with those who share their tastes. If a nice suit helps someone win a job, that's because the interviewer finds it more enjoy-

able to talk with someone dressed that way. The aesthetic ratchet effect, whether it demands deodorant and clean hair or well-cut clothes and attractive shoes, rewards what we find pleasing to the senses. But there's more at work than Frank's money-oriented status pursuit. If you show up for an interview in a custom-tailored suit only to find your prospective boss wearing khakis and a polo shirt, the mismatch in aesthetic identities will cancel out any imagined status gains. You and the boss obviously have different ideas of what's enjoyable and appropriate.

Status competition is part of human life, of course. But cultural analysts like Frank are so determined to see status as the only possible value, and money as the only source of status, that they often ignore the very evidence they cite. Frank writes that "the status symbol of the 1990s has been the restaurant stove." Fancy stoves are, in his opinion, entirely about keeping up with the neighbors' kitchens. To bolster his argument, he quotes a woman who owns a $7,000 stove, despite rarely cooking at home. Does she say she felt social pressure to buy an overpriced appliance? Does she say she wanted to stand out from the crowd? No, she describes the stove as a *work of art*: "You think of it as a painting that makes the kitchen look good." The supposedly damning quotation demonstrates the opposite of what Frank maintains: The woman sees the stove primarily not as a status symbol but as an aesthetic pleasure.

The manufacturers intended as much. "I was convinced that if I built something beautiful and powerful and safe, there were people out there who'd buy it," says the founder of the Viking Range Corp. The company admits that most buyers are "look, don't cook" customers. Even an employee who was given a range says she never uses it, preferring to microwave something quick. "But I love looking at my Viking," she says. "Sometimes, I turn it on just to feel its power." Obviously the stoves serve something besides functional needs. But that "something" is more complex and sensual than status, combining a vision of an ideal life of home cooking with the immediate pleasures of beauty and power. Whatever status a fancy range conveys comes less from its cost than from its ability to show off the owner's discerning eye.

Even analysts who do not view luxury goods as waste do not necessarily credit the goods' intrinsic sensory appeal. In *Living It Up,* a mostly sympathetic analysis of what he calls "opuluxe," James Twitchell examines the spread of luxury goods, which he describes as "objects as rich in meaning as they are low in utility." Opuluxe demonstrates the openness of today's social structure, he argues. Anyone can buy into the signs of wealth, so "making it" is no longer a matter of joining a socially exclusive club. Twitchell thus sees the profusion of luxury goods as tacky but benign.

Like Frank, however, Twitchell has a hard time noticing any qualities beyond status badges and advertising-created brand personas. And, like Frank, he unconsciously offers clues that more is going on. He tells us, for instance, that in the Beverly Hills Armani store, "I saw something I hadn't seen before. I saw customers patting the clothes, fondling the fabrics, touching the buttons. . . . It was like being in a petting zoo." People pet Armani clothes because the fabrics feel so good. Those clothes attract us as visual, tactile creatures, not because they are "rich in meaning" but because they are rich in pleasure. The garments' utility includes the way they look and feel.

Twitchell's twenty-two-year-old daughter, Liz, accompanies him on his tour of Rodeo Drive, pretending to be a spoiled daddy's girl being bribed with presents to stay in college. This false persona reflects Twitchell's preconceptions about why people buy luxury goods, and what sort of people those buyers are. Only a superficial young woman, he assumes, would be wowed by luxury, not his intellectual Liz.

After a day at the act, however, Liz finally breaks down in tears, forcing the pair to make an abrupt exit from Tiffany. She explains why: "I believe myself to be everything the woman in Tiffany thought I wasn't: intelligent, self-sufficient, not given over to the whimsical spending of large amounts of money." But Liz is sucked in. She wants the stuff her father is pretending he might buy for her. And she wants it not so she can impress anyone else or feel affiliated with prestigious brands. She wants those luxuries because they are aesthetically appealing, because they are, in a word, *beautiful.*

"Watching the woman in Armani try on the $20,000 beaded dress, I was momentarily entranced—and more than slightly jealous," she writes after the experiment collapses.

The stuff was just so BEAUTIFUL, and when I looked down at my Old Navy sweater, I couldn't help but feel a bit wanting. . . . I wanted to leave Rodeo Drive for the same reason I often avoid fashion magazines: not because I don't care about such trivial stuff, but because I DO care, and when I look at these beautiful things, I'm left with an aching feeling of desire and a slight dissatisfaction with my current life. Luxury is incredibly powerful, and it gets to almost all of us, even when we're told it's meaningless.

The status critique does not actually say luxury is meaningless. To the contrary, the critics' usual argument is that such goods are *only* about meaning; they are "objects as rich in meaning as they are low in utility." The status critique sees only two possible sources of value: function and meaning; and it reduces meaning to a single idea: "I'm better than you." It denies the existence or importance of aesthetic pleasure and the many meanings and associations that can flow from that pleasure.

Luxuries, in this view, offer no intrinsic appeal beyond their social signals. But only superficial people, filled with status-anxiety and insecure about their own worth, would care about those meanings. By circular reasoning, then, to be attracted to such goods is to be a superficial person. So a serious young woman like Liz must avoid contact with fashion magazines and luxurious clothes—not simply because she would ache at the unattainable, but because wanting those things would call her identity into question. Her desire would imply that she's the sort of superficial, insecure person who cares about "such trivial stuff." To affirm that she's a young woman of substance, she must ignore the appeal of surfaces.

If surfaces are "trivial stuff," surfaces that change for no good reason are even less worthy. Hence, those who see aesthetics as "illusion" and "make-believe" are particularly vitriolic toward fashion. *Fashion* in this sense applies not just to clothing and related products but to anything whose aesthetic form evolves continuously, from typefaces and car bodies to musical styles and popular colors. Fashion is the process by which form seems exhausted and then refreshed, without regard to functional improvements.

Critics often portray fashion as entirely the product of commercial manipulation. "Typewriters and telephones came out in a wide range of colors in 1956, presumably to make owners dissatisfied with their plain old black models," sniffed the influential social critic Vance Packard in his 1957 book *The Hidden Persuaders*. Nearly a half century later, many people still imagine that the world works the way Packard portrayed it. Aesthetic changes, in his view, were merely forms of deception, ways of creating artificial obsolescence. Packard offered no evidence that the colorful typewriters and telephones performed any worse than the plain old black models; rather, he objected to purely aesthetic upgrades, deeming them wasteful.

Today an engineer similarly condemns the latest iMac for using behind-the-curve chips and mocks buyers who've "been seduced by the case plastic":

> *After people get over the* oh, cool! *and start really looking at this, the only real reason for getting it will be to impress people, just as was the case with the Cube, because what is* really *innovative about this is the case. And you can't actually get any work done with a fancy case.*

Missing the effects of the technological progress he sees as legitimate innovation, the engineer doesn't consider the trade-offs. For a long time, ever-greater computing power was indeed what people looked for in a new machine. But computers are so capable these days that most customers don't need the absolutely fastest chip. To some-

one who doesn't plan to tax the machine's processing speed, a beautiful case may be worth more than cutting-edge technology, not just for status ("to impress people") but for personal enjoyment. At a given price, adding style will be more valuable, at least to some people, than adding power. True, you can't get any more work done with a fancy case, but you can enjoy the same work more.

From the buyer's point of view, greater aesthetic variety in an equally functional product is an unequivocal improvement, possibly (as with the green pager) one for which consumers will gladly pay a premium. If the goal is happiness rather than expert-determined "efficiency," form is itself a function. Pleasure is as real as meaning or usefulness, and its value is as subjective. Of course, aesthetic experimentation does not preclude other improvements. A new pager may have both enhanced features and a stylish face.

Fashion exists because novelty is itself an aesthetic pleasure. Even when the general form of something has reached an enduring ideal—the layout of book pages, the composition of men's suits, the structure of automobiles, the shapes of knives, forks, and spoons—we crave variation within that classic type. Colors and shapes that looked great a couple of years ago begin to seem dull. We're attracted to fresher, newer forms. The same never-ending tinkering that gives us more functional, better-looking toilet brushes also gives us new looks to replace the old.

The changes are usually incremental, moving gradually in one direction over a long period until that form's aesthetic possibilities are exhausted and something new suddenly feels right. That new look has often evolved without much notice, also building slowly, so that what seems like an abrupt shift actually represents a switch from one incremental process to another.

Consider a story told by Anne Bass, a wealthy patron of the arts and haute couture. She describes her taste in clothes as classic, not "so much embellishment as beautiful lines, beautiful tailoring, things that are constructed in clever ways." In the flamboyant 1980s, her fashion choices were relatively restrained, but she did buy evening clothes "that had a bit of the 'costume' about them." Bass recalls the

moment when those clothes suddenly felt obsolete. In August 1989, she attended a Paris fashion show and dinner given by Giorgio Armani:

> *I remember wearing a Saint Laurent evening suit that paired a heavily embroidered jacket with a tangerine charmeuse sarong, and that was the last time I recall putting on something that made that kind of statement. Because, suddenly, that night, it felt completely wrong. It felt like Armani was modern, was what was happening. Before that night, I didn't really get Armani. I thought he was a nonevent. But I remember that evening, that party, as the end of an era. . . . I don't think it was long afterward that I opened my closet in New York, and noticed that everything was either beige or black.*

The shift Bass observed had been going on for some time. Otherwise no one would have been interested in attending an Armani event in the first place. The designer had in fact come to prominence in the early 1980s. But Bass and her fashion-savvy friends could not have known in advance when one man's vision of what clothes should look like would go from a stylistic "nonevent" to a newly dominant aesthetic. Exactly what sort of variation will seem appealing at a given time is uncertain and can be discovered only through trial and error.

The fashion process is not mechanical but contingent; which changes will fit the moment depends on a host of unarticulated desires and unnoticed influences, making shifts hard to predict. A fashion writer refers to "fashion's X-factor, the unknown quantity that makes an item seem hot to a consumer." The decrees of would-be style makers—that mauve is back but in a "more sophisticated" form, that gray is the "new black," that velvet furniture is in again—suggest a sort of dictatorial authority. But this rhetoric is just a combination of bravado and best guesses. The sales racks are full of aesthetic experiments that failed to capture the public imagination, and every such item is an argument against the notion that authorities can dictate style. Now more than ever, that is not how fashion works.

Besides, there is more to fashion than profit-seeking "built-in obsolescence." We find fashion patterns in goods for which there is no commercial market. Historian Anne Hollander notes that fashion in clothing has existed for eight hundred years, centuries longer than the apparel business. "The shifty character of what looks right is not new, and was never a thing deliberately created to impose male will on females, or capitalist will on the population, or designers' will on public taste," she writes. "Long before the days of industrialized fashion, stylistic motion in Western dress was enjoying a profound emotional importance, giving a dynamically poetic visual cast to people's lives, and making Western fashion hugely compelling all over the world." Pleasure, not manipulation, drives changes in look and feel.

Even intangible, noncommercial "goods" exhibit similar patterns. Sociologist Stanley Lieberson has studied how tastes in children's names change over time. Nobody runs ads to convince parents to choose *Emily* or *Joshua* for their newborns. No magazine editors authoritatively dictate that "*Ryan* is the new *Michael*." But names still shift according to fashion. Name choices, like clothing choices, are influenced by the desire to be different but not too different; the ideal balance varies from person to person. Like designers experimenting with new ideas in ignorance of what their competitors are trying, parents have to choose their babies' names without knowing exactly what other parents are choosing. The result is a complex, often surprising, dynamic. Parents frequently find that the name they "just liked" is suddenly widely popular, expressing aesthetic preferences that are somehow in the air. Contrary to common assumptions about how fashion works, Lieberson finds that names don't trickle down in a simple way from high-income, well-educated parents to lower-income, less-educated parents. Newly popular names tend to catch on with everyone at about the same time.

External influences, such as the names of celebrities or fictional characters, do play a role in what's popular. But cause and effect are complicated. Fictional characters don't just publicize possible names; their creators, like new parents, select those names from the current milieu. And whether a famous name spreads partly depends on inter-

nal, purely aesthetic factors. Harrison Ford, Arnold Schwarzenegger, and Wesley Snipes are all action stars, but their stardom hasn't translated into millions of little Harrisons, Arnolds, or Wesleys—in part because their names just don't *sound* all that appealing.

What does sound appealing itself changes over time, as particular phonemes go in and out of style. In recent years, for instance, the ending *schwa* sound has been popular for girls' names, such as Hannah, Samantha, Sarah, and Jessica; in the era of Susan and Kimberly other endings seemed equally feminine. African-American parents are more likely than whites to invent completely new names for their babies; those unique names follow clear patterns that indicate gender, and they show fashion cycles in the popularity of component syllables. *La-* used to be a popular first syllable for black girls' names. Now *-eisha* is a popular ending. Names associated with living old people often seem dated, like out-of-style clothing; popular names from generations who have passed on, by contrast, may seem classic and resonant, like vintage fashion. Even in this completely noncommercial context, we see fashion cycles of distinctiveness, popularity, and obsolescence, driven by the quest for aesthetic satisfaction. That satisfaction combines purely sensory components with meaningful associations.

Whether for names or clothes, fashion reflects the primacy of individual taste over inherited custom. The freer people feel to choose names they like, rather than, say, names of relatives or saints, the more rapidly baby names go through fashion cycles. As Hollander observes, "Fashion has its own manifest virtue, not unconnected with the virtues of individual freedom and uncensored imagination that still underlie democratic ideals." Fashion pervades open, dynamic societies. Through markets, media, and migration, such societies offer more outlets for creativity, more sources of new aesthetic ideas, and more chances for individuals to find and adopt the forms that please them. Our age of look and feel reflects the increasing openness of our social and economic life, which both enhances and takes advantage of aesthetic abundance. As a result, we see fashion appearing in new areas, with much greater fluidity of form. The more

influence accorded individual preferences, the greater the importance of fashion—and, in many cases, the more accelerated its pace.

This dynamic perturbs critics. Static, customary forms, they suggest, are more authentic. Thus Daniel Bell worries about the rise of syncretism, "the jumbling of styles in modern art, which absorbs African masks or Japanese prints into its modes of depicting spatial perceptions; or the merging of Oriental and Western religions, detached from their histories, in a modern meditative consciousness. Modern culture is defined by this extraordinary freedom to ransack the world storehouse and to engorge any and every style it comes upon." And Ewen, again equating style with illusion, writes that "modern style speaks to a world where change is the rule of the day, where one's place in the social order is a matter of perception, the product of diligently assembled illusions." Although he might recoil from the implications, Ewen seems to assume that "one's place in the social order" would be more valid if it were determined not by perception and individual effort but by something more impersonal and objective—bloodlines, perhaps, or skin color.

Even when he cites the advantages of the shift to a more open society, Ewen casts it in terms of false identity: "On the one hand, style speaks for the rise of a democratic society, in which who one wishes to become is often seen as more consequential than who one is. On the other hand, style speaks for a society in which coherent meaning has fled to the hills, and in which drift has provided a context of continual discontent." This analysis scorns the search for individual satisfaction and self-definition—the pursuit of happiness—as no more than a source of "continual discontent." The traditionalist conservative argument against the disruptions of an open social and economic order has transmogrified into a left-wing attack on fashion.

Genuine value, such critics suggest, ought to reflect something more permanent and substantial than ever-shifting tastes. The ephemeral nature of style, in this view, confirms its fundamental falsehood. "As style reached out to a more broadly defined 'middle class' of consumers" in the nineteenth century, Ewen complains,

the value of objects was less and less associated with workman-ship, material quality, and rarity, and more and more derived from the abstract and increasingly malleable factor of aesthetic appeal. Durable signs of style were being displaced by signs that were ephemeral: shoddy goods with elaborately embossed surfaces, adver-tising cards, product labels. If style had once been a device by which individuals tried to surround themselves with symbols of perpetuity, now it was becoming something of the moment, to be employed for effect, and then displaced by a new device of impression.

Value in this view should approximate static, universal standards instead of fluctuating with fickle individual preferences. Hence Ewen's dislike of the "abstract and malleable factor of aesthetic appeal," which is all too subjective and personal.

The old "symbols of perpetuity" were in fact products of a tradi-tional, fairly static social order. These goods demonstrated inherited social position; only a family that had maintained wealth and rank over generations would possess homes, portraits, furnishings, or sil-verware with the patina of age. You could show off your grandfa-ther's portrait or your great-grandmother's silver only if your family was in fact one of long-standing status. Surface patina demonstrated social substance. As anthropologist Grant McCracken notes, "The patina of an object allows it to serve as the medium for a vitally important status message. The purpose of this message is not to claim status. It is to verify status claims." Arrivistes could be identi-fied by the shine of their possessions, avoiding the sixteenth-century fear of the "tailor or barber [who] in the excess of apparel [would] counterfeit and be like a gentleman." (Clothes, rather than acquir-ing patina, wear out over time; that's why they're more subject to fashion and why status-oriented societies try to impose sumptuary laws.)

The ephemeral nineteenth-century merchandise that Ewen con-demns spread new aesthetic pleasures to people of limited means. Made possible by new forms of production and distribution, these goods were cheap in both senses of the word. Embossed paper doo-

dads might be short-lived, but they were also accessible and fun. They had little to do with social status and much to do with personal enjoyment. A world of pretty product labels is more delightful than a world of generic barrels, and it is a world in which style no longer belongs only to an elite. These new and shifting forms of aesthetic pleasure befit a fluid social order.

Fashion itself can, of course, be a source of status. As anyone who has been a teenager knows, the right style can determine who's in, while the wrong look can mean social oblivion. Early-twentieth-century social critics worried about the social pressures created by newly affordable ready-to-wear clothes when respectability depended greatly on the proper appearance. Writing in 1929, one essayist complained that "crops may fail, silk-worms suffer blight, weavers may strike, tariffs may hamper, but the mass-gesture of the feminine neck bending to the yoke of each new season's fashion goes on." Garment makers, she complained, made sure "that last year's wardrobe shall annually be made as obsolete as possible," placing a severe financial burden on poor women who wanted to look current. Here is an earlier version of the Packard and Ewen critiques: Fashion represents the tyranny of commercial manipulation.

Such critics exaggerated both year-to-year fashion shifts and the response of consumers; as we know from survey data, families with moderate incomes did not own large or frequently changing wardrobes. But these criticisms expressed genuine anxiety. By making fashionable clothes available to people who a generation earlier would have had no such choice, the apparel industry increased not just pleasure but aspiration. And with aspiration came, inevitably, the disappointment of limits. In industrialized countries, working women had access to new forms of self-expression and adornment, the sorts of aesthetic pleasures once reserved for the social elite. But, like Liz Twitchell in Beverly Hills, they would also ache for the unattainable.

We do not know, of course, that traditional peasant women experienced no such pangs. Folktales like "Cinderella" suggest that they did. What was different by the nineteenth century was that social critics cared, and that fashionable attire had taken on symbolic

importance for average people. Dressing in style was a new sort of personal achievement, especially if you weren't rich enough to buy someone else's good taste, and it was a source of social prestige. Self-presentation had become a valuable skill, at all social levels.

That is all the more true today, and the task is far more difficult. Although the financial cost of putting on a good appearance has dropped, the trickiness of the challenge has increased. As Hillary Clinton can testify, the more technological and social choices we have about how we look, the more ways we can go wrong—and the more meaning people are likely to read into our choices. The challenges of fashion have also spread to previously fashion-free areas of life. When law firms eschewed graphic design and followed long-standing customs, no one judged them by their letterhead. Now they have to think about the connotations of typefaces and logos; sticking to the plain old style is itself an indicative choice. "Fashion," observes Hollander, "is a perpetual test of character and self-knowledge, as well as taste, whereas traditional dress"—or any other custom-bound aesthetic expression—"is not."

The "character" Hollander sees tested by fashion's demands is not moral character but a combination of self-awareness, confidence, taste, and affiliation. How we deal with fashion's flux suggests something about our inner life. Can we enjoy its pleasures, using them to create an aesthetic identity that reflects who we are, including what we enjoy? Can we find a happy balance between look and feel and other values? Or do we feel compelled either to subordinate the rest of our life to appearance or to ignore appearance altogether—to treat look and feel either as the ultimate value or as entirely without value?

Much of the rhetoric surrounding appearance offers this false choice. From well-intended mothers to scathing social commentators, authorities tell us that surfaces are "meaningless." That might be true if they meant that the value of aesthetics lies in its own pleasures, not in what it says about something else. But that's not at all what they intend. Authorities call aesthetics "meaningless" to suggest that it is

worthless and unimportant, that it doesn't matter. Thus, Liz Twitchell says she's been taught that luxury is "meaningless," so its pleasures shouldn't affect her. Ewen excoriates graphic designers for creating "meaningless distinctions" between products, denying the value of aesthetic pleasures and associations. "I try to help her not judge herself against the prevailing criteria of how she's supposed to be," says a father whose thirteen-year-old daughter thinks she's too skinny. "I tell her all this is meaningless."

When a father tells his teenage daughter that looks are "meaningless," he is not assuring her that she's attractive or will become so over time. He is saying that she's loved and valued for her other traits, regardless of how she looks—a loving but irrelevant affirmation. Her looks do mean something important to her. They don't match her sense of who she is or would like to be. By changing the subject, her father is inadvertently agreeing that she looks bad, exacerbating her sense of failure. We do not respond similarly to teenagers who wish they were stronger, more musical, or better in school; we coach them on how to build on their natural gifts. Yet somehow we believe that looks are different, that appearance must be worth either everything or nothing.

Denying that we care about appearance for its own sake leads us to exaggerate its deeper significance, in order to justify our natural interest. Consider some of the commentary surrounding the 2000 election. When Florida Secretary of State Katherine Harris appeared with heavy makeup, wags compared her to a drag queen and Cruella De Vil. Al Gore got similar treatment after he wore bad makeup in his first debate with George W. Bush. Commentators called him, among other things, "Herman Munster doing a bad Ronald Reagan impression" and "a big, orange, waxy, wickless candle."

In both cases, commentators appealed to their readers' interest in how other people look. To give their criticisms a respectable mask, however, many pundits treated these cosmetic problems as symbols of more serious flaws. One interpreted Harris's blue eye shadow as evidence that "she failed to think for herself" and declared that "one wonders how this Republican woman, who can't even use restraint

when she's wielding a mascara wand, will manage to use it and make sound decisions in this game of partisan one-upmanship." Amid the Florida recount, a Gore critic harked back to his excessive makeup to suggest that he was a phony: "While Gore yammered about [the voters'] 'will,' it was clear to my houseplants that the man who looks like he raids Katherine Harris' pancake makeup supply was really gloating about the Florida Supreme Court decision in his favor."

These commentators went well beyond the idea that self-presentation may say something about the "judgment of the mind," reflecting a person's self-awareness and taste. They damned Harris and Gore not for bad judgment but for bad character. They invoked the old tradition that equates cosmetics with deception and decadence. Someone who wears a lot of makeup, they suggested, is not to be trusted.

In fact, someone who wears a lot of makeup may just have a sunburn (Gore) or out-of-date style (Harris). Surface may not say much at all about substance. Being able to separate the two is the first step toward avoiding the deception that critics of aesthetics so fear. But to do so we have to admit that aesthetics has value in and of itself instead of pretending that it is "meaningless" or trying to justify our interest in looks by freighting them with unwarranted symbolism. All other things being equal, we prefer beauty, just as we prefer intelligence, charm, eloquence, or talent. But beauty can coexist with stupidity, rudeness, or cruelty. All other things may not be equal. What's true for people is true for places and things. All other things being equal, we prefer attractive computers. That does not mean, as Apple discovered with its beautiful Cube, that we will ignore price and performance to get aesthetics.

The challenge is to learn to accept that aesthetic pleasure is an autonomous good, not the highest or the best but one of many plural, sometimes conflicting, and frequently unconnected sources of value. Not all sources of value, including aesthetic and moral worth, line up in one-to-one correspondence. Rhetoric that treats aesthetic quality as a mark of goodness and truth—or as a sign of evil and deception—is profoundly misleading.

The values of design itself—function, meaning, and pleasure—

can exist independently of each other. It's incorrect to argue in defense of Wal-Mart's big-box stores that "a Wal-Mart is 'ugly' only because we either ignore or devalue what it does best." The value of Wal-Mart's design comes from its function. Ugliness diminishes pleasure, a different good. Function may coexist with pleasure, and increasingly it does, but it does not have to. Saying a store is ugly does not mean it has no value, only that its value must lie outside aesthetics. Just as we may value a green pager more highly than a black one entirely because of its looks, we may value Wal-Mart for its convenience and efficiency, while acknowledging that it's ugly. And we can tell nothing about the moral worth of either the green pager or the store by judging its looks.

A bad person can be beautiful or create beautiful things. A good person can be ugly or make bad art. Goodness does not create or equal beauty. The problem with Leni Riefenstahl's films is not that they're aesthetically powerful—that achievement is, considered in isolation, valuable. But aesthetic quality does not trump or cancel out other considerations. Beauty is not a moral defense, merely an autonomous value. Just as a plain face does not make a young woman bad, so artistic achievement does not justify serving an evil cause. Aesthetic pleasure and moral virtue are independent goods. They may complement or contradict each other, or operate entirely independently. Colas are neither good nor evil, and neither is their packaging. The packaging design adds pleasure and meaning, and thus value, to morally neutral products.

When evil deeds come to be associated with otherwise attractive images, the images lose their attraction. Meaning arises from association, in this case canceling out pleasure. A black swastika in a circle of white on a red background may be graphically appealing, but we do not evaluate its form independently of its historic meaning. For two generations after Hitler, well-muscled Nordic men looked like villains, not Adonises. Only recently, under the influence of gay aesthetics, has that ideal of masculine beauty begun to lose its Nazi connotations. Riefenstahl's artistic achievements, and her images, are permanently polluted by the cause she served. Film students may

study her techniques, but they do not forget or forgive her moral failings. Form has its own power and worth, but it does not inevitably trump content. Aesthetics is not a psychological superweapon, capable of blinding us to all other values.

When terrorists slammed two passenger jets into the World Trade Center on September 11, 2001, Michael Bierut had his own moment of Nazis-to-Pepsi self-doubt. He was in London and returned home to Manhattan a few days after the attack. "As a designer," he wrote me, "I am still reeling from the images of 9/11." The act had been horrifying, but the images it created could not have been better designed: "The timing of the collisions, the angle of the second plane, the colors of the explosions, the slow-motion collapsing of the towers: could the terrorists ever dream how nightmarishly vivid this would be to the vast viewing audience?"

Amid the trauma of mid-September, this terrible juxtaposition—striking images in the service of death—recalled all the attacks ever made on surface for its own sake, and on the designers who create surface appeal. If an event so awful could look so vivid, even beautiful in a purely formal sense, how could we trust aesthetic pleasure? How could designers like Bierut justify their work, except when surface serves some grander substance? The attack, wrote Bierut, "makes me think about all the times I've worked on purposeless assignments and put meaningless content into beautiful packages. I will not approach my work the same way from now on."

He knew better. The destruction of the World Trade Center was not a carefully composed movie scene, designed to arouse pity and terror within the safe frame of fiction. It was the all-too-real murder of thousands. It was entirely substance. The attack was not packaging, not surface, not performance art. It had both meaning and political purpose. The striking images produced led viewers not to praise but to condemn the attackers who created them. Only those who embraced the murderers' cause rejoiced in those images. Aesthetics did not prove a superweapon, justifying slaughter. To the contrary, the media images that followed were attempts to capture the events—and the horror and grief—of the day. Those images were

valuable because they could say more than words. But the images were not the act itself.

In the horror of the moment, Bierut had forgotten the meaning and value of his work, falling into the puritanical mind-set that denies the value of aesthetic pleasure and seeks always to link it with evil. To wrap meaningless, as opposed to vicious, content in beautiful packaging does no harm. To the contrary, such creativity enriches the world and affirms the worth of the individuals whose pleasure it serves. Colas are not genocide.

Bierut soon had second thoughts. "One of the signatures of any repressive regime," he wrote the following day, "is their need to control not just meaningful differences—the voices of dissent, for instance—but ostensibly 'meaningless' ones as well, like dress. It will take some time for people to realize that creating the difference between Coke and Pepsi is not just an empty pastime but one of many signs of life in a free society." The Afghan women who risked the Taliban's prisons to paint their faces and style their hair in underground beauty shops, and who celebrated the liberation of Kabul by coloring their nails with once-forbidden polish, would agree. Surface may take on meaning, but it has a value all its own.

Four

MEANINGFUL LOOKS

It's Saturday afternoon at the Shops at Willow Bend in Plano, Texas, a fast-growing suburb about twenty miles north of Dallas. The new mall is a richly detailed monument to today's aesthetic imperative, a Prairie Style–attempt to create something more enticing than a "machine for shopping." Soft leather seating encourages people to linger, while materials like ash and cherry, copper and etched glass, provide a sense of luxury. The octagonal food court is topped by a dramatic skylight and ringed with a bas relief of stylized shapes—gears and patchwork stars, mountain peaks and cacti. Willows appear throughout the décor, from an arching mural painted above the main entrance to stone leaves inlaid in the polished limestone floors.

But on this particular Saturday, barely six weeks after its grand opening, Willow Bend's most striking aesthetic element has nothing to do with its designers' careful choices. The mall's unifying motif is its customers' clothes. Everybody seems to be wearing Tommy

Hilfiger and Ralph Lauren: pullovers and polo shirts in red, white, and blue.

It is September 15, 2001.

The stores have not had time to stock up on patriotic wares. Instead, all these people have looked in their closets, skipped past the blacks, browns, oranges, aquas, and pinks, and converged on the same color scheme. Patterns that a week earlier were bold blocks of primary colors, with only a hint of Americana, have suddenly become symbols of solidarity, grief, pride, anger, defiance, patriotism. For the many South Asian immigrants in this high-tech suburb, the clothes convey an added meaning: *I am one of us, not one of them*.

Human beings are not only visual, tactile creatures. We are also social, cognitive creatures, drawn to pattern making and informed by memory. We use form to communicate, and we infer meaning from familiar aesthetic elements. Graphic design, writes a teacher and practitioner, "is a visual language uniting harmony and balance, color and light, scale and tension, form and content. But it is also an idiomatic language, a language of cues and puns and symbols and allusions, of cultural references and perceptual inferences that challenge both the intellect and the eye."

On this day, the social significance of red, white, and blue is understood through recent shared experience. Just as we assume that the colors are meaningful, not simply expressions of taste, we don't mistake them for the colors of Texas or of nearby Southern Methodist University, much less of Britain or France or the Confederate States of America. We know they refer to the American flag. And what does that flag, a graphic object, mean? Even that association is not quite the same on September 15 as it was on September 1.

Although tastes vary from individual to individual, aesthetic pleasure generally operates within a range of responses set by biological universals. Meaning has no such anchor. It is completely subjective, arising from experience and association. The same form may signify different things—or nothing at all—to different audiences or in different circumstances. To an ancient Roman, blue was the color of weakness and barbarism, the war paint of the uncivilized tribes of

Northern Europe. To a Christian in the late Middle Ages, blue was the color of the Virgin Mary. In twelfth-century France, blue represented the monarchy; six centuries later, blue symbolized the Revolution. To Europeans today, blue signifies conservative political parties, while U.S. newscasters use blue to indicate states that vote Democratic. As a color on the spectrum, blue is meaningless. Embedded in a cultural context, blue can mean all sorts of things, from IBM to the United Nations. Blue has historical and cultural significance, but it has no "authentic" meaning.

For critics who believe legitimate value must come from such objective criteria as "workmanship, material quality, and rarity," rather than from the subjective preferences of individuals, the shifting meaning of look and feel is as disturbing as their ephemeral pleasures. Meaning is clearly a source of aesthetic value, but how can that value be genuine if it doesn't endure or if we can't determine it in advance? Surely there must be some objective measure of authentic meaning and, hence, authentic worth.

Yet aesthetic meaning won't hold still. Indeed, much of the value of aesthetics lies in its pliability, in our ability to direct the joys of form to new meanings or to strip form of its connotations and enjoy aesthetics for its own sake, often leading to new associations. Just as once-neutral forms can take on new or recovered meanings, so elements that were once meaningful can evolve through use and popularity into primarily formal motifs, with little significance beyond the pleasure they bring. Pleasure tends to suck the symbolism out of aesthetic elements, but new connections are always emerging.

What's true for color is true for other aesthetic elements, even those originally created with a particular meaning in mind. Their connotations shift over time. To the British Victorians who revived Gothic architecture, the return to medieval styles represented a rejection of bourgeois, industrial life. Some advocates emphasized the imagined religious and social harmony of medieval villages; others, the authenticity and expressiveness of hand craftsmanship. Regardless of emphasis or details, Gothic revival architecture embodied an intellectual critique that damned nineteenth-century economic,

social, scientific, and technological trends. It was an outward and visible sign of an ideological commitment.

Within decades, however, the style had come to indicate little more than a general respect for history and scholarship, along with an appreciation for high-class architectural fashion. "By the simple device of building our new buildings in the Tudor Gothic style," said Woodrow Wilson, then president of Princeton University, in 1902, "we seem to have added to Princeton the age of Oxford and Cambridge; we have added a thousand years to the history of Princeton by merely putting those lines in our buildings which point every man's imagination to the historic traditions of learning in the English-speaking race."

More flexible than previously dominant classical styles, Gothic revival architecture suited the era's expanding colleges and was even used for scientific laboratories on both sides of the Atlantic. Although Princeton's primary early-twentieth-century architect embraced the ideological symbolism of Gothic architecture, that association was belied by the university's most prominent Collegiate Gothic building. Blair Hall not only greeted arriving trains, the epitome of industrial technology, but was named for the railroad entrepreneur who donated the funds to build it. Ambitious new universities like Duke and Chicago, similarly built with money from nineteenth-century industrialists, adopted neo-Gothic architecture to represent their status as places of serious learning. Their architectural choices in no way condemned their benefactors' enterprises or the dynamism of turn-of-the-century America.

Nowadays, the sight of Gothic revival buildings suggests higher education, with no particular reference to medieval ideals. Only an allusion to scholarly or, in the case of churches, religious contemplation still attaches to this architecture. The form draws its meaning not from its original intent but from the activities that have come to surround it. If neo-Gothic architecture hadn't suited the work of early-twentieth-century universities, and if those institutions hadn't had the resources to erect lots of buildings during the height of its fashion, the style never would have come to represent elite scholarship in the pub-

lic mind. It would have been nothing more than a passing nostalgic fad or an esoteric symbol of reactionary traditionalism. Experience, not predetermined ideology, gave the style its looser, more enduring, meaning.

Something similar is happening with the revival and spread of dreadlocks. First adopted as an outré religious symbol, the mark of the subversive, even scary Rastafarians (hence the "dread" that conservative Jamaicans attached to the style), dreadlocks became over time an emblem of reggae music, Afrocentrism, or nonsectarian (as opposed to Rastafarian) spirituality. Over the past decade, the increasing popularity of dreadlocks has eroded even this symbolism. Just as neo-Gothic buildings suggest only a general idea of "scholarship," so dreadlocks increasingly connote only a general sense of creativity, individuality, and stylishness. Casting and costume directors put dreadlocked actors in roles calling for cutting-edge intelligence (the clever lab tech, the early adopter) or romantic exoticism (the soap opera leading man). Like narrow-framed glasses and black clothing, dreadlocks are affected by writers, artists, and ad executives.

"Recently, I visited a large record company, and half the staff must have had them: graphic designers sitting behind computers, A&R people, account executives. Not so long ago, you couldn't get a job if you had dreadlocks. Now you probably could run for mayor," says an artist who originally adopted the style as a sign of "rebellion and respect." The spread of dreadlocks, she laments, has removed much of the style's meaning: "In American cities, so many different citizens from different cultures now carry dreads that some of the spiritual reasons behind them have been lost."

That loss would be just fine with people who wear the style mostly for its looks and ease of care, not its symbolism. Writer Veronica Chambers is both amused and aggravated by the misunderstandings her locks engender: "Over the last eight years that I have worn dreadlocks, [the style] has conferred on me the following roles: rebel child, Rasta mama, Nubian princess, drug dealer, unemployed artist, rock star, world-famous comedienne and nature chick. None of which are really true. It has occurred to me on more than one occasion that my

hair is a whole lot more interesting than I am." Chambers is not "wild," as some assume. She doesn't smoke pot, and her tastes run to Calvin Klein, not dashikis. Yet she agrees with a friend who concluded, after Chambers surprised him in a straight bob wig, "Those dreads are really you." However misleading their original symbolism, the locks have become integral to her identity, just as neo-Gothic architecture is a part of Princeton's. Their value is personal and subjective but nonetheless genuine.

Chambers adopted her hairstyle because she was inspired by a photo of Alice Walker, "her locks flowing with all the majesty of a Southern American Cleopatra." Walker, in turn, was inspired by Bob Marley and Peter Tosh, imagining "what a person dreamed about at night, with hair like that spread across the pillow. And, even more intriguing, what it would be like to make love to someone with hair on your head like that, and to be made love to by someone with hair on his or her head like that." Whatever cultural significance dreadlocks may have had to Chambers and Walker, their initial reactions were not cognitive but visceral—beauty and sex. The meaning came after the pleasure, through a combination of cultural associations and personal experience.

The cultural significance was nevertheless important to the spread of dreadlocks, freeing people to wear dreads in the face of potential embarrassment. Consider the costs and benefits of adopting an unusual style. At first, someone who has no reason beyond taste to embrace a hitherto unpopular look won't be likely to accept the risk of social ostracism (or the added expense). Only those with a strong ideological or religious commitment—those who want to make a statement—will incur the cost. These early adopters, however, spread the idea, attracting people who like the look and share some cultural affinity with those who've adopted it for ideological reasons. The style becomes a signal of solidarity, not only for those who embrace all the early adopters' beliefs, but for those who admire their conviction, sympathize with some of their ideas, or want a sign of iconoclasm.

Less alienated from the general culture but still acting on convic-

tion, this second wave of adopters can articulate a dissident, but more respectable, meaning for the style: an affirmation of black pride, for instance, rather than a belief that Haile Selassie is God. The new aesthetic brings praise from a small but growing group, diffusing the style further, even as it remains outside the mainstream. The look goes from culturally marginal—strange—to culturally nonconformist in a more positive sense. That's one reason second-wave adopters are often artists whose social identities already have a romantic element of rebellion. This pattern holds true not only for personal appearance but for graphic design, architecture, and interiors.

Second adopters, in turn, reduce the risks of the look for those with less commitment to a particular meaning. (Later adopters may also drop some of a style's more extreme or costly elements, creating neater dreadlocks or eliminating gargoyles.) Over time, as more and more people embrace the style, the cost of using it falls, while the pleasurable benefits remain. Remnants of the original symbolism may survive, creating confusion in some cases, adding value in others, but meaning becomes primarily personal and particular: *Those dreads are you*, not *Those dreads are the authentic black experience*.

In the age of look and feel, this aesthetic cycle appears to have accelerated, heightening the tension between meaning and pleasure and between social and personal meaning. As we see more aesthetic possibilities, and feel less pressure to conform to a single "correct" or consistent look, we turn formerly meaningful styles into sources of personal pleasure. At the same time, we seek to convey something about ourselves (or our products or places) not only through verbal declarations but through look and feel, creating, in the process, new connections between surface and substance, form and meaning. We want to show as well as tell, and the increasing variety of aesthetic options permits more complex or differentiated meanings, a more specific match between outward form and inward identity.

Today's aesthetic imperative overturns the simplistic dichotomy between "rebellion" and "conformity," or "individual" and "mass." The result is *selective* conformity, an implicit or explicit drive for finer and finer gradations and the looks that identify them. Rather than

choose between standing out and fitting in, we conform in some ways
and diverge in others, choosing (consciously or unconsciously) a mix
of meaning and pleasure, of group affiliation and individual taste.
Friends develop what zoologist and author Desmond Morris calls
"costume echo," adopting similar conventions of dress and carriage.
Morris first identified the phenomenon when he "noticed two
women walking down the street who dressed so similarly, they could
have been in uniform."

Costume echoes apply to all sorts of surfaces, not just personal
appearance. They can exist anywhere, including among organiza-
tions, and theyr create new meanings through association. Consider
all the late-1990s companies, particularly dot-com start-ups, that
adopted logos with swooshes in them. "When in doubt, add one. Or
two, or three," quipped a design consultant. The hopeful symbol of
forward thinking even made it into the Gore-Lieberman campaign
logo designed by Al Gore. Whatever its early adopters may have
intended, the swoosh came to signify its era—not "the future" but
"the late 1990s."

While costume echoes are probably as old as adornment, today's
proliferation of cultural and stylistic options provides the opportuni-
ty for more, and finer, distinctions. "Even if you engage in some kind
of radical piercing, like encasing both eyebrows in tight rows of small
rings, and by this means emphatically announce to the world that you
are not employed in middle management at a Fortune 500 company,
you are hardly doing something unprecedented," writes Luc Sante in
a wry essay, concluding, "Perhaps, then, you are not proclaiming your
individuality so much as establishing your kinship with others of the
same micropersuasion." Just so, and it's not a matter of self-delusion.

But interpretation can be difficult. Is the pierced eyebrow really a
sign of rebellion, or does the wearer just think it looks cool? As a
symbol of affiliation, how different is it from the costume echoes of
an "urban tribe" of Chicago women defined by "manicured nails,
blowout-straightened hair, and Sears Tower–inspired stilettos"?
While the pain involved in eyebrow piercing limits its appeal, thus
preserving some of its original meaning, the same can't be said of

other formerly "rebellious" looks. Teenagers who adopt skater or hip-hop styles often bristle when adults take their clothes as signs of anti-social attitudes rather than fashion sense or group affiliation. Especially when change is easy, the aesthetic cycle—the process of moving from meaning to pleasure, or between social and personal meaning—constantly shifts the connotations of look and feel.

The proliferation of aesthetic choices reduces the chances that pleasure, personal meaning, and social meaning will be in sync, making interpretation difficult. Only rarely do we have the sort of universally shared knowledge that enabled us to interpret red, white, and blue clothing after the September 11 attacks. Lacking that knowledge, we are prone, as Chambers recounts, to read too much meaning into some aesthetic signals and perhaps too little into others. Even when meanings are consciously intended and properly understood, they tend to be general associations, not clearly symbolic one-to-one correspondences. The social meaning of particular styles gradually dissipates—from Rastafarian to Afrocentric to "spiritual" to artistic to just a bit nonconformist—even as the personal meaning grows. *I like that* merges into *I'm like that*. Identity prevails.

When Hillary Clinton warned Yale graduates that "your hair will send very important messages to those around you. It will tell people who you are and what you stand for," she was joking. But she was also drawing a painful lesson from her experience as first lady. Because she kept changing her hairstyle, never settling comfortably into an aesthetic persona, she exacerbated the public's distrust. Her shifting hairstyles may have indicated nothing more than stylistic cluelessness. But to a public accustomed to political figures with settled looks, the constant makeovers suggested that the authentic Hillary either did not exist or was deliberately hiding from view. After all, the first lady gave no signs of aesthetic playfulness, no hint that she was experimenting with different styles for her own pleasure.

Rather, she seemed either not to know who she was or to be reshaping herself to fit whatever temporary image would suit her

husband's political needs. As first lady, she failed what Anne Hollander calls fashion's "perpetual test of character and self-knowledge." Only when she ran for Senate did Clinton adopt a consistent look, including a neat and flattering hairstyle favored by female executives. Only then did she seem to say *I like that*—black pantsuits and vividly colored shawls—and thus to confirm, *I'm like that*. Only by implicitly affirming certain tastes did she end the constant swirl of meanings around her stylistic persona.

Identity is the meaning of surface. Before we say anything with words, we declare ourselves through look and feel: *Here I am. I'm like this. I'm not like that. I associate with these others. I don't associate with those.* A college student explains how the aesthetic signals worked as she dropped the fashions of her preppy upbringing and joined the punk scene: "I cut my hair very short and wore black clothes constantly. (Wearing black made it easy to spot my friends and be spotted by them. . . .) While I was rebelling against society in general, being the nonconformist in that sense, I was also conforming with the smaller group of people that became my friends."

Aesthetic identity is both personal and social, an expression both of who we are and with whom we want, or expect, to be grouped. Aesthetic signals of identity may be as simple, and their origins as obvious, as the green, white, and red bands on an Italian restaurant's sign. They may be as hard to explain as the style of an Ian Schrager hotel or as subtle as the shape of a pants leg or the ratios of a typeface. Sometimes those statements of identity are inadvertent, and occasionally they are false. But in an age of aesthetics, they are inescapable.

"Should a guy buy new glasses if the prescription is still current, but they're out of style?" asks a correspondent, wondering how far the aesthetic imperative extends. The question has no right answer, but the choice has symbolic consequences. Defining glasses as purely functional, rather than fashion items, is itself a telltale decision. It identifies the wearer as one sort of person and associates him with others who make the same choice. Do you want to be thought of as a practical, frugal person who sees fashion accessories as frivolous and

vain (or perhaps a person who'd rather put his aesthetic dollars into his car or furniture)? Or do you want to seem like someone who pays attention to every detail, including personal appearance? Either way, you'll tend to attract the like-minded while alienating those who disagree.

The more choices we have, the more responsibility we face—whether or not we want it—to define ourselves aesthetically. Because others make similar selections, for similar reasons, *I like this* becomes *I'm like this*. "All choices of clothing, particularly the quick and simple ones, involve allying oneself in the eyes of spectators with others who have made the same kind of choices, usually for the same reason," observes Anne Hollander.

> *If you always buy Brooks Brothers button-down shirts whenever you do buy shirts, if your income permits it, you will be associated with everyone else who does the same, whether that is what you intend or not. . . . Going once a year to Brooks Brothers usually indicates that in order to keep shopping easy and safe you associate yourself with other safe, conservative Brooks Brothers shirt wearers and, further, that you do not wish to avoid being associated with them.*

The same pattern holds true for stationery or office design, for church buildings or company logos. What seems right to you associates you with others who make the same choices. The implied associations may be desirable, or they may create a sense of false identity, leading you to adjust your aesthetic signals. But there are no truly safe havens, no aesthetic defaults we can adopt without fear of interpretation. "I like that," a statement of taste alone, is meaningful in itself.

For places and things, as for people, the most basic function of aesthetics is to say, "Here I am," signaling the identity of the thing itself. Look and feel communicate more quickly than literacy alone. Tide comes in an orange box. McDonald's has golden arches. Viagra is a blue pill; Prilosec and Nexium are purple. A Porsche looks sportier than a Mercedes. The job of graphic design "is to make something

that distinguishes itself when you see it in context," says Stephen Doyle, a prominent designer. A good magazine cover looks distinctive not only in isolation but on the newsstand, among other magazines, including competitors in the same category.

In the aisles of Kmart, the Martha Stewart Everyday products, for which Doyle designs packaging, both fit in and stand out. The packaging styles and colors vary by product, so the sheets and towels look like linens, the pans and spatulas like kitchen gadgets, the seeds, fertilizers, and bug sprays like gardening supplies. At the same time, the sans serif typefaces, sophisticated colors, and vivid photographs all say "Martha Stewart." Those graphic elements attract buyers who want to combine modernity with do-it-yourself homeyness—a distinctive personal identity and aspiration.

Effective surfaces, whether for people, places, or things, reveal layers of identity and association while preserving a fundamental sense of self. A graphic identity, says Doyle, "is like a personality. You need to be able to take the same person to a black tie dinner and then see them at a barbecue, and then hang out in front of the [television] with them in their socks. It's still the same personality, but adapted for different occasions." The days of the unvarying stand-alone trademark and the single corporate color are over—too impersonal, inflexible, and monotonous for the age of look and feel. The challenge for designers, as for individuals, is to be true to the "self" of underlying identity while still allowing appearance to vary with time, place, and circumstance.

Every Starbucks looks like Starbucks, yet every Starbucks is unique, combining in a singular way elements of the company's language of colors, finishes, materials, lighting, and music. "People are amazed that we have stores across the street from each other," says the company's director of business development. "But they're different stores." The Starbucks design language does more than allow stores to accommodate different spaces or traffic patterns. Following the aesthetic imperative, different store environments offer novelty— a change of pace for regular customers—and personalization. If the color of one store "reminds you of something from your childhood

that you intensely dislike, you can go three stores down to a different Starbucks and say, 'I like this better. I just feel better here,'" she explains. By developing mix-and-match elements, Starbucks maintains its aesthetic personality while still suiting different tastes.

In some cases, a brand's aesthetic identity is so distinctive and emotionally resonant that fans are inspired to imitate it. Apple Computer lovers use 3-D rendering software and graphics packages to create imaginary "mock-up Macs," displaying "photos" of their creations on Web sites. Some of these fantasy products are clearly jokes—the iWok, for instance—while others are credible enough to spark rumors of forthcoming Apple releases. A high school student's rendition of the "G5 Sphere" was so realistic that Apple lawyers told him to take it off the Web. While real Apple products look different depending on how they're used and who's expected to buy them, those products nonetheless share an underlying identity, a continuing personality expressed through look and feel. And many Apple users see important aspects of their own identities reflected in that inanimate personality.

The idea that commercial products and places might have personalities disturbs critics of consumer culture. Hence Stuart Ewen's sarcastic italics when he writes, "In advertising, packaging, product design, and corporate *identity*, the power of provocative surfaces speaks to the eye's mind, overshadowing matters of quality or substance." Naomi Klein in *No Logo* uses the very existence of brands as a sinister sign of corporate power and manipulation.

Leaving aside the importance of aesthetic pleasure for its own sake, inanimate objects and public environments are in fact more valuable when they offer distinctive aesthetic identities. A world of undifferentiated products and places would not only be less pleasant; it would be more alienating and more confusing. Without aesthetic signals, it would be harder to find what we wanted or to complement our own personalities. The same sorts of critics who detest suburbs with identical houses and celebrate personal nonconformity somehow believe that every detergent box and restaurant should look like every other one, with no helpful aesthetic signals and no accounting for taste.

These inanimate aesthetic personalities don't just identify products and places themselves. They give individuals the ingredients with which to create or affirm our own aesthetic personas, to experience and express something about who we are. By appealing to different tastes and personalities and evoking different associations, style differences add value to commercial experiences. This value is more complex than the one-dimensional hierarchy assumed by status-obsessed social critics: I'm better than you, because I have the most up-to-date or the most expensive or the most difficult-to-obtain style, because my silverware has patina, my furniture is antique, my business card uses elegant paper, and my suit is custom-made. Most aesthetic signals have nothing to do with status hierarchy. They establish horizontal differences, not vertical ones. The same khakis or white button-down shirt worn different ways can identify a teenager as a "prep," "goth," or "hippie"—signs of affiliation, not prestige.

Or consider two chains owned by Starwood Hotels: Westin and Sheraton. They cater to business travelers with similar expense budgets. But business travelers are a much more diverse group than they once were, and the two chains attract different customers. When the company overhauled its hotel rooms to make them more aesthetically appealing, designers kept those differences in mind, reinforcing the existing brand identities. Westin rooms, which serve somewhat younger travelers and many more women, got contemporary furnishings, with black-and-white photos of urban scenes on the wall and all-white linens on the beds. For Sheraton rooms, by contrast, designers selected furniture in traditional forms, including a sleigh bed, and they used pin-striped bedspreads and accent walls to create a "wow factor" with a masculine feel.

Do the new rooms appeal to the eye's mind? Most definitely. The pleasures of a white comforter or a blue accent wall don't lie in the feature's "rational" function. But these provocative surfaces aren't deceptive. To the contrary, they are themselves the quality and substance of the experience, the difference between this hotel room and a traditionally generic one. What you see is what you get. The bed-

spread won't change from pinstripes into a stain-hiding floral pattern while you sleep.

The rooms' distinctive aesthetic identities do reflect a commercial calculation: that travelers will come back to hotels that make them feel at home. Market critics sneer at such reasoning, less interested in the hotels' desire to please than in the profit motive behind it. For hotel guests, however, the results are what count. No one can feel at home in a place with no aesthetic identity. A generic, purely functional environment treats the traveler as a generic, interchangeable sleep machine rather than an individual with a personality. By establishing distinctive aesthetic identities, the new room décors are more than just better looking. They are more likely to honor the identities of their guests. In this context, surface *is* substance, valuable in its own right.

Aesthetic identity—*I like that. I'm like that.*—is more specific and personal than "That's attractive" in some universal sense. Beauty itself takes many forms, and aesthetic meaning, signaling identity, is about more than beauty. The subjective value of a particular form varies from person to person. A young female Westin guest transported to the clubby, pin-striped Sheraton room might appreciate its attractiveness but still feel slightly out of place. Cruising the luxury shops of Beverly Hills, James Twitchell, an old-fashioned WASP, was acutely uncomfortable in the "Italianate" environments of stores like Armani, Gucci, and Prada, with their techno music and black-clad "ethnic" salespeople. But he felt right at home in the equally self-conscious "English faux luxe" of Ralph Lauren's Manhattan shop, with its "dark walls, oriental rugs, Stubbs horses and dogs on walls, cracked leather chairs, [and] claustrophobic closeness." All these designs are comparably attractive in some universal sense, but their pleasures and meanings differ greatly from person to person. We can't objectively declare the Westin superior to the Sheraton or Ralph Lauren superior to Prada. Their aesthetic value depends on the individual experiencing them.

Those old sci-fi visions of a future of universal jumpsuits and homogeneous high-rises would be tyrannical in reality, not because of the specific look and feel they employed but because no single style

can suit everyone. By contrast, today's aesthetic profusion—the choice of thirty-five thousand colors of plastic, fifteen hundred drawer pulls, thirty thousand fonts, motifs from nearly every culture that has ever existed—serves a variety of tastes and circumstances. And all that choice allows ever more specific signals of identity and affiliation. By combining aesthetic elements just so, we can suggest both individual particulars—*my* look, *this* brand—and group associations: If you like this style, chances are, you'll have other things in common with others who share the same taste. You'll feel at home in our hotel. You'll enjoy our magazine.

At their most valuable, aesthetic meanings go beyond social signals to personal affirmations of our sense of self. "The environment I'm in is going to be an accessory to who I am," says successful restaurateur Mico Rodriguez. Rejecting the "dilapidated cantina" look typical of the genre, he gave Mi Cocina, his Tex-Mex chain, a contemporary style inspired by the clean forms and brilliant colors of architects Luis Barragan and Ricardo Legorreta and the romance of Mexico City in the 1950s. His fine-dining restaurants feature sophisticated modern design with dashes of color, passion, and whimsy, creating varied environments of comfortable, inclusive elegance.

While these restaurants offer tasty food, they also provide stages on which customers can display their identities. For regulars, the restaurants become not just backdrops but integral aspects of personal expression. Rodriguez relates one of his proudest moments: "A sharp guy, a Hispanic doctor, told me, 'Mico, your restaurants are the way I want to live.' That brought tears to my eyes. Because he's saying, 'I'm going to do what I do in my life—I can work hard, I can surround myself with beautiful things in my home—but I have this image of being in your environment.'"

"I have this image" of my true self, not as a disembodied set of thoughts but as a visual, tactile creature, whose authentic identity is reflected in the sensory aspects of my person, places, and things. People can look at me and see something true about who I really am. I can see myself reflected in my surroundings. Surface and substance will match. This is the aim of aesthetic meaning—to capture and

convey identity, to turn our ineffable sense of self into something tangible and authentic.

Thanks to Hollywood's many establishing shots, we all know what Southern California looks like: palm trees against a blue sky or silhouetted against a sunset over the ocean. The image is not just a Hollywood fantasy. Palm trees really are everywhere in Southern California. For those who've lived there, the trees are not movie clichés but emotionally resonant symbols of home. Experience has invested the trees with meaning.

But palm trees are tropical plants, native to places with far more rain than the arid climate of Los Angeles or San Diego. The trees that identify Southern California were planted by developers to make the place look like an oasis rather than the desert it would be without irrigation. The symbolism worked. (So did the irrigation.) People moved west looking for paradise. The trees and their meaning grew over time, until palm trees had become inseparable from the region's identity. Now even a representative of the Native Plant Society admits that the palm trees belong in Southern California. "Even if we went to all native plants everywhere," he says, "I'd say we should keep the big, old palm trees, because by now they're part of our history." Foliage planted for manipulative purposes has come to have genuine social and personal meaning.

This paradox doesn't fit ideological theories about how people, places, and things should look and feel. For many creators and critics, the idea that aesthetic meaning is fluid and subjective is deeply unsatisfying. They want instead to erect a permanent standard by which to judge the meaningful aspects of aesthetics, a standard that doesn't depend on the preferences of varied and fickle individuals: an objective ideal of authenticity. "For architects," writes the editor in chief of *Architectural Record*, "to say a work is authentic represents highest praise."

To these analysts, authenticity establishes legitimate meaning. It draws the line between worthy ornament and aesthetic crime. It

determines which elements are acceptable in what setting, and which alterations are offenses against history, quality, or art. In this view, an authentic artifact, environment, or personal style connects surface with substance in some authoritative and clearly observable way. But what exactly does *authenticity* mean? The concept has many different, sometimes contradictory, uses. A library search for "authenticity" turns up books on such varied topics as forgeries and copies, the post-colonial search for national identity, the commercialization of country music, existentialist concepts of personal integrity, and fundamentalist Islam. For aesthetics, the most common and influential meanings of *authenticity* include:

1) *Authenticity as purity*. Whether applied to religious practice, ethnic identity, or "truth in materials," this fundamentalist concept of authenticity condemns dilution, malleability, and recombination, which it treats as forms of pollution. The original form of something, whether a building or a faith, is true and legitimate. Adaptation and evolution are suspect. "Folklore" is the authentic voice of the traditional *Volk*. "Fakelore" reworks tales for children. When an architectural critic fears that preserving Eero Saarinen's TWA terminal as anything other than a place to catch airplane flights "will diminish the authenticity of this singular structure," she is invoking this idea of authenticity.

In our "Age of Falsification," writes a critic, we are bombarded with the inauthentic, from virtual reality to "white female blues singers singing on National Public Radio in exactly the style of old black men from the Mississippi Delta." Nature, by contrast, is "always true" and thus "nature photography is one part of our culture where authenticity might make a stand." The purity standard grants particular authority to the natural and the functional. By this standard, dreadlocks are authentic on people with naturally locking hair, while hair weaves and permanents are fake. Streamlining is authentic for airplanes, inauthentic for toasters.

If function is authentic, fashion is not, even in contexts where it clearly matters. "At Nike, you can't use the *fashion* word, because it cuts into the canon of authenticity they've set up," says a former Nike designer. "The shoe has to be authentic— all for sport—and the end use has to be about performance." Nature and function are objective and pure.

2) *Authenticity as tradition, the way it's always been done.* Closely related to authenticity as purity, this idea is grounded in custom rather than claims of fundamental reality. Ethnic styles, such as kente cloth or bindi, are authentic if worn by people from the right ethnic group, inauthentic if adopted by outsiders. Authentic blues singers are "old black men from the Mississippi Delta," not young white women on NPR. Wood tables are authentic; Formica tables are not. Masonry bearing walls are authentic; a decorative masonry façade is not. When classicist architect Léon Krier writes that "if museums look like factories and churches like industrial warehouses, a basic value of the state is in crisis," he is invoking this idea of authentic form. Surfaces have meanings fixed by tradition.

3) *Authenticity as "aura," showing the signs of history.* This concept of authenticity runs directly counter to the purity standard. By this definition, authenticity is reflected in the changes and imperfections left by the passage of time—the signs of use, adaptation, and experience. Thus, to Naomi Wolf, a woman's loyalty "to her age, her shape, her self, her life" decrees that gray hair, fat, and wrinkles are authentic and hair dye, dieting, and face-lifts are not. An authentic appearance situates a woman in time and reveals something of her life experience. Similarly, an unrestored antique chest is authentic; a reproduction or refinished original is not. Patina is authentic; new versions of old styles are not. When architecture critic Ada Louise Huxtable writes of her "loathing of the term 'authentic reproduction,'" she is upholding this definition of authenticity.

The idea of "aura" comes from the famous 1935 essay "The Work of Art in the Age of Mechanical Reproduction," in which the critic Walter Benjamin identified the "aura" of a unique artwork as what was lost when many identical copies are produced and can be preserved without change over time. (He was particularly disturbed by moviemaking.) "The authenticity of a thing is the essence of all that is transmissible from its beginning, ranging from its substantive duration to its testimony to the history which it has experienced," wrote Benjamin. Unlike a copy, in this view, a unique work of art bears the signs of its history, including "the changes which it may have suffered in physical condition over the years as well as the various changes in its ownership."

Authenticity-as-aura often encompasses a historicist idea—that for every style there is a proper time and place. "Authentic is the real thing, and a reproduction, by definition, is not; a copy is still a copy, no matter how skilled or earnest its intentions," writes Huxtable. "To equate a replica with the genuine artifact is the height of sophistry; it cheapens and renders meaningless its true age and provenance. To imply equal value is to deny the act of creation within its own time frame, to cancel out the generative forces of its cultural context. What is missing is the original mind, hand, material, and eye."

This reasoning is why the U.S. Department of the Interior's historic preservation guidelines discourage "duplicating the exact form, material, style, and detailing of the historic building in the new addition so that the new work appears to be part of the historic building" or "imitating a historic style or period of architecture in new additions, especially for contemporary uses such as drive-in banks or garages." By this definition of authenticity, aesthetic motifs are developed for particular uses in particular circumstances and should not be borrowed in new times or for new purposes. Authenticity-as-aura thus evolves into its opposite, authenticity-as-purity.

What all these varied definitions have in common is that they're impersonal. They define authenticity based on rules that have little to do with the desires or purposes of those who create, use, or inhabit the subjects of the critique. By their very nature, objective standards reason from the outside in. But aesthetic meaning proceeds from the inside out, from personal psychology to material instantiation. Joan Kron, a journalist who writes about her own and other people's experiences with plastic surgery, refers to "those of us who feel misrepresented by our faces," a notion of the inauthentic that has no place in Wolf's reasoning.

Are the effects of time (or genes) really more authentic than a person's self-image? Is Michelangelo's Sistine Chapel more authentic if it's covered with the grime of centuries or if it's cleaned to show the colors the artist intended? Depending on the definition you choose, you can make a case either way. How about the aggressive fakery that defines Las Vegas or Disneyland? Surely it's an authentic expression of what those entertainment centers are all about. Yet what could be more phony? We cannot develop satisfying responses to such questions without considering the pleasures and meanings we want to derive from the objects in question.

The demand for authenticity appeals to our desire not to be deceived by surfaces, but the pursuit of an objective definition goes too far. That quest conflates deception—forgery—with recombination, reappropriation, and change. It removes both the subject and the audience, the source and the recipient, from the play of aesthetic symbolism. "Authenticity" becomes little more than a rhetorical club to enforce the critic's taste.

Rather than trying to erect an impersonal standard, removed from individual purposes, we can turn to more subjective definitions, truer to the way people actually use look and feel to define themselves and their surroundings. We can decide *for ourselves* what is authentic *for our purposes*, what matches surface with substance, form with identity.

We can define authenticity from the inside out. This approach to authenticity challenges the ideal of impersonal authority, replacing it with personal, local knowledge. Among the definitions this approach offers are:

1) *Authenticity as formal harmony, balance, or delight.* This concept of authenticity is more about pleasure than meaning. The "authentic reproductions" that so trouble Huxtable can claim that title because they accurately embody forms developed in the past—forms we continue to value for their sensory delights. A reproduction's "authenticity" is an assurance that it contains the aesthetic wisdom evolved through an earlier era's trials and errors. If we enjoy the old artifact, we will enjoy the reproduction, not because it is old (it isn't) but because it works formally. An inauthentic reproduction, by contrast, picks some historic elements and drops others, often making those choices on the basis of cost alone. Thus, tract homes with identical shapes but different stylistic veneers—Craftsman, American farmhouse, Tudor—are historically inauthentic. The inaccuracy matters not because the homes constitute a history report but because the designs' components are out of balance. The rooflines and massing don't match the veneers. If an "inauthentic" combination is in fact pleasing, it will become a new—and newly authentic—style.

This pleasure-oriented definition explains why we sometimes find plastic surgery so disturbing: It looks off. The skin is too tight. The eyes are a peculiar shape. Michael Jackson's face looks alien, and the tip of his nose is missing. People who object to Botox because it freezes facial muscles are arguing not for wrinkles as a record of age but for the pleasures of an expressive forehead. Cosmetic techniques that accurately reproduce youthful beauty don't give us authenticity-as-purity or authenticity-as-aura. They can, however, provide authenticity as formal pleasure. They look right and, indeed, often go unnoticed.

2) *Authenticity as a connection to time or place.* This definition represents one of the most common uses of the word *authenticity*, and one of the most criticized. When a Cheyenne, Wyoming, official commends the plans for a new parking garage by saying its historic detailing "helps add authenticity to the downtown area," he's using the term in this sense. Old-time Cheyenne had no parking garages, of course, but the garage design fits the town's style. It evokes Cheyenne's history and expresses its identity. Similarly, the Colonial revival architecture and furnishings popular in the 1930s provided a clean-lined alternative to Victorian and Edwardian fussiness—authenticity as formal pleasure—but those reproductions also offered a different meaning from sleek modernist forms: a connection to history and an affirmation of American traditions.

3) *Authenticity as self-expression.* What is authentic about those connections to time and place is, in fact, the way they serve identity. A mid-twentieth-century homemaker who furnished her dining room with Colonial reproductions was engaged not in time travel or archaeology but in self-expression: *I like that. I'm like that.* So was Princeton when it adopted architecture connecting it to Oxford and Cambridge. So are the young Japanese women who wear fake dreadlocks, bronze their skin, and adopt form-fitting, hip-hop fashions to assert their independence, drawing on the "strength and sexuality" they associate with African-American women. None of these signs of identity fits a definition of authenticity as purity, custom, or aura. But they are genuine expressions of inner truth.

In turning it from the objective to the subjective, we do not abandon the concept of authenticity altogether. We still recognize the possibilities of deliberate deception and of truthful representation. We need not confuse forgeries with originals. But defining authenticity

from the inside out replaces predetermined criteria with the specifics of time, place, and circumstance. A church building in twenty-first-century America doesn't have to look like a church in eighteenth-century England or fourteenth-century France to authentically reflect its religious mission. A town built for entertainment can imitate other places just for fun. A California office building can have a façade that looks like brick but is really siding that won't fall down when the earth moves. Plastic can be as authentic as glass.

One of the marks of our aesthetic age is an ever more common refusal to let external authorities dictate authenticity. Moralistic critiques of form are out of style, even among many arbiters of taste. Rejecting old design standards, in 1995 the Museum of Modern Art held an exhibit celebrating "mutant materials" that have unexpected characteristics. "Today, adherence to the 'truth' of a material is no longer an absolute for design," wrote curator Paola Antonelli. "New technologies are being used to customize, extend, and modify the physical properties of materials, and to invent new ones endowed with the power of change. Plastics can be as transparent as glass, as flexible as fiber, as metallic as aluminum; wood can be as soft as upholstery." Our increased understanding of materials allows us to invest them with new, useful, and pleasing characteristics. Why then should some arbitrary definition of material "truth" limit the artifacts we create? The "power of change" is itself an authentic attribute—for people and places, as well as for things.

If the meaning of aesthetics is to signal identity, and if that meaning arises from history, experience, and personality, then aesthetic authenticity cannot lie in some preexisting definition of truth. It must come instead from the match between form and desire. Authenticity is thus what "seems right," a decidedly subjective and changeable criterion, not something that can be deduced from nature. An authentic surface serves to make the invisible visible, even if accomplishing that purpose requires tampering with nature, custom, or inherited form. This authenticity is personal or social, not objective, and what we find authentic can change over time. The palm trees are authentic

symbols of Southern California, because everyone thinks of the place with palm trees, and because we want to think of it that way. The palm trees represent current reality and past aspiration, both of which are part of Southern California's identity.

Aspiration is the tricky part of identity, the "world of make-believe" that causes critics like Daniel Bell such discomfort. Often the identities we express with our aesthetic choices are not those we have but those we desire: "Your restaurants are the way I want to live." "We have added a thousand years to the history of Princeton." Sometimes these choices are unconscious. Sometimes they are calculated. We may take on the identities we want to own, hoping that surface will become substance, rather than accepting the ones we already have.

By experimenting with surface, we may also reinvent ourselves, emphasizing and developing previously unknown or subordinate aspects of our personalities. "I am not the sort of woman who goes blonde," writes novelist Jane Smiley, before explaining how she did just that and, in the process, what sort of woman she discovered herself to be. A feminist intellectual and practical Midwesterner, Smiley had always "abjured vanity." She wore glasses and plain white cotton underwear, had a "short, masculine hairdo," and never, ever shaved her legs or underarms. Her looks reflected her convictions. "If I dyed my hair," she thought, "that would lead to makeup, and inevitably, to manicures, facials, panty hose, and the wholesale submission to the patriarchy." But that reasoning itself reflected the stereotypes of an earlier era, the idea that women must choose between intelligence and beauty, mind and body, substance and surface.

In her early forties, Smiley discovered that her studied indifference to her appearance was sending unwanted signals and hiding important aspects of her personality. The man she was interested in didn't see her as a woman. She fretted to her therapist. The therapist sent her to his colorist. Thus began her new life of blonde hair and

shaved armpits—of new pleasure and new meaning. "Sometimes I stand in front of the mirror and simply admire it," she says of her caramel-colored hair. "It is a beautiful, layered, shimmering gold, soft and sparkly, a hair color that has no relation to me and no counterpart in the animal world. I would hate to give it up."

The hair color is artificial—hence it has "no relation" to Smiley—and she still isn't quite used to it. But it is also a part of her, something she would hate to give up. As an expression of who she is, her blonde hair isn't inauthentic; it's just different. By changing her surface, she discovered new dimensions of her substance. Having gone blonde to make herself seductive, and succeeded in that end, she found herself in a happy romance, confident and relaxed. She even claims to be nicer to her kids. "That androgynous, no-nonsense woman that I had been for thirty years turned out to be not quite me, or perhaps not simply me."

If objective authenticity is the standard by which we should judge look and feel, then Smiley's hair, Princeton's architecture, Southern California's palm trees, and the Hispanic doctor's favorite restaurants are nothing more than "diligently assembled illusions." They're lies, false fronts, pretenses to selves that don't (or didn't) exist. But aspiration is as real and powerful as current reality. History is full of examples of styles that signaled the desire for a hitherto unattainable public identity, one that expressed an inner sense of self. Hence, suffragettes adapted masculine fashions, wearing string ties and shirtwaist dresses. Denied public respect by slavery and segregation, African Americans affirmed their dignity and self-worth by dressing up for Sunday church services. The popularity of cut glass in the nineteenth century reflected both the pleasures of the sparkling material and working-class homemakers' aspirations to gracious living. Critics condemned both the material—a cheap imitation of crystal—and those aspirations as inauthentic, a sign of the corruptions of mass production and mass markets.

Like fashion, however, aspiration and the search for aesthetic identity exist whether or not markets are free to provide the raw materials. Commerce just makes things easier. Writer Charles Paul

Freund tells the tale of the Stalinist-era *stilyagi*, who put together a distinctive style based on their haphazard knowledge of American popular culture:

> *They wore jackets with huge, padded shoulders and pants with narrow legs. They were clean-shaven, but they let their hair grow long, covered it with grease, and flipped it up at the back. They sported unusually colorful ties, which they let hang well below their belts. What their fellow Muscovites most noticed about them, for some reason, were their shoes, which were oversized, with thick soles. There were some women in the movement as well, notable for their short, tight skirts and very heavy lipstick.*

The stilyagi, or "style hunters," chewed gum or made do with paraffin wax. They "affected an odd walk that involved stretching their necks as they went down the street." Above all, they called attention to themselves, assuming a freedom of expression that did not actually exist in Stalinist society.

That society, of course, had no stores selling all those artifacts of aesthetic identity. Ewen's "provocative surfaces," the marks of advertising and consumer culture, were against the law. So the stilyagi went to great trouble to achieve their peculiar looks. To flip their hair, they used homemade curling irons heated on the kitchen stove, often burning their necks in the process. They made their own clothes and shoes, using black-market materials. Like one of fiction's most famous aesthetically aspiring characters, Scarlett O'Hara, they turned curtains to new uses—in this case, fabric for those loud ties. To declare *I'm like that*, they invented an aesthetic identity that said *I like that*. "The stilyagi," writes Freund, "created their hair, clothing, and slang styles as a means of achieving the identities they were struggling to assume."

Aesthetic aspirations inevitably express some sort of dissatisfaction, a longing for a different sort of life, perhaps even a different self. Discontent fuels every quest for improvement, regardless of form.

Believing that the future can be better than the present does, after all, entail believing that the present isn't perfect. Whether that feeling leads to positive or negative action depends on the person. Aspiration can inspire either hope or despair, self-improvement or self-hatred. One teenager unhappy with his slight build may undertake a healthy workout regimen and, as he matures, become comfortable with his body; another may diet and exercise to excess, taking dangerous drugs and never overcoming his self-loathing. One homemaker may take pride and joy in creating a domestic environment of colors, textures, and furnishings, experiencing the sort of satisfaction others get from making art, climbing mountains, or solving engineering problems. Another may simply shop till she drops, substituting spending for accomplishment. From the outside, it is hard to know which is which.

Critics are far too quick to charge that aesthetic aspirations are inevitably painful, frivolous, or presumptuous. They therefore assume that any innovation that gives us more aesthetic choice or control, from acne treatments to fancy refrigerators, is something to decry for increasing aesthetic expectations. For most people, however, matching outward and inward identity is a satisfying and important, if sometimes difficult, process. Tinkering with the look and feel of our persons, places, and things—and with the identities they express—may merely fill empty hours with unsatisfying busyness. But more often, it affirms our ideals, expresses our connections with others, gives us the pleasures of problem solving and discovery, or simply allows us to enjoy surfaces for their own sake. Temperament and opportunity, not the inherent character of aesthetic experimentation, determine whether the process is frustrating or inspiring, empty or joyful.

The meaning of surface is not Meaning in some grand, metaphysical sense. Aesthetics does not tell us what our purposes should be. At most, it communicates something about what those purposes are, reminding ourselves and the world of what we think is important. Still, we often invest enormous value in look and feel, treating surface

signals of identity as equivalent to identity itself. High school kids get beaten up for wearing the wrong clothes and still refuse to conform. Police officers leave the force rather than change their hairstyles. Home owners go to legal war with each other over paint colors and garden styles. Superficial meaning may not be cosmically important, but neither is it trivial. Anything in which we invest so much significance, or from which we draw so much pleasure, inevitably becomes a source of conflict.

Five

THE BOUNDARIES OF DESIGN

Los Angeles artist Mike McNeilly was up high on the wall of a ten-story Westwood office building, painting a mural, when a building inspector showed up and ordered him to stop. McNeilly, who had permission from the building owner but no permit from the city, kept going. Then the cops showed up. "I was told in no uncertain terms from LAPD, 'You either stop painting or you're going to jail,'" he later recalled. With no desire to spend his weekend in the slammer, McNeilly quit working. He was charged with five misdemeanors.

For more than a year thereafter, a striking monument stared west down Wilshire Boulevard: a jaggedly incomplete Statue of Liberty, her face vanishing below her eyes. McNeilly had inadvertently created a graphic symbol of the intensifying conflicts between aesthetic expression and aesthetic control.

When "design is everywhere, and everywhere is now designed," whoever determines look and feel controls a great deal of economic

and personal value. As our surroundings get more aesthetically pleasing, the things we find ugly or disconcerting stand out. We demand better design, and that demand inevitably generates conflict. "Design" implies a single set of purposes served by a coherent aesthetic. But not everyone has the same purposes or finds the same elements enjoyable. Identities differ and so do tastes, including the taste for variety versus consistency. Depending on its boundaries, then, design can be satisfying or tyrannical. It ranges from the individualistic, expressing one identity among many possibilities, to the totalitarian, subordinating all particulars to a unitary vision.

Does the aesthetic imperative mean letting all of us pursue our individual aesthetic dreams? Or does it demand that we eliminate stylistic oddities to maintain a consistent theme? Both approaches generate meaning and pleasure. Both create aesthetic value. The challenge is to keep each in its place. To avoid design tyranny, we need to find the right boundaries—to discover rules that preserve aesthetic discovery and diversity, accommodating plural identities and tastes, while still allowing the pleasures of consistency and coherence.

Aesthetics may be a form of expression, but it doesn't enjoy the laissez-faire status accorded speech or writing. To the contrary, the more significant look and feel become, the more they tend to be restricted by law. The very power of beauty encourages people to become absolutists—to insist that other people's stylistic choices, or their trade-offs between aesthetics and other values, constitute environmental crimes. Individuals may expect more expressive freedom for themselves, but they often feel affronted and victimized by the aesthetic choices of others. This is particularly true for places, the touchstone category of our aesthetic era.

The desire for attractive, controlled, immersive environments extends beyond the walls of shopping malls or restaurants. When designer Karim Rashid says, "Our entire physical landscape has improved, and that makes people more critical as an audience," he's thinking of the market for products like his. But that critical audience doesn't just shop for trash cans and furniture. It buys houses and drives down city streets. And it has opinions about how the landscape

should look, opinions that increasingly shape not only personal choices but the rules governing the built environment. Instead of tolerating sights they don't like, from tacky porch furniture to innovative architecture, more and more people are demanding a world free of "visual pollution."

Home owners take offense at their neighbors' paint colors, their window frames, even their kids' play equipment. "The 'not in my backyard' creed, so deftly applied to public works, has been given a new kicker: 'and not in yours either,'" wrote a *New York Times* reporter after her backyard neighbors objected to the swing set she and her husband had put up for their young son. Following zoning regulations, the couple had placed the swing set well inside their yard, shielded by trees and bushes. But the neighbors complained they could see it from their bathroom window. "We like to think of your yard as an extension of ours," they said, voicing an increasingly common attitude. "People are definitely less tolerant than they used to be," says a suburban New York building inspector.

Over the past two decades, master-planned communities with standardized styles and prescriptive "pattern books" have become the norm for large-scale home developments. These communities sell predictability. While old-line suburbs started out fairly uniform to keep down construction costs, owners could (and did) dramatically transform their homes over time. Master-planned developments, by contrast, seek to control changes. Buyers are bound by contract to abide by rules designed to preserve a certain look and feel.

The Highlands Ranch community in Colorado, for instance, limits house numbers to no more than six inches tall and kids' backyard clubhouses to no more than twenty-four square feet. No white picket fences are allowed in most neighborhoods. An enforcement team cruises the streets looking for such offenses as deviant home colors. (A light purple house got neighbors particularly riled up.) A competing community, Prospect New Town, takes a contrasting tack, going so far as to require striking colors on its houses—no Highlands Ranch neutrals allowed. Prospect, too, tightly regulates its environment. The developers require changes on 95 percent of the new house plans sub-

mitted for their approval. "It sounds harsh," says one. "But somebody's taste has to prevail, or else it would be anarchy."

In this case, the taste enforcement occurs within a voluntary, profit-sensitive development that has to compete with nearby alternatives offering radically different design philosophies. Home buyers select the design regime that fits their personalities and lifestyles, and business success depends on design rules that please potential residents. But design restrictions aren't limited to competing contractual communities. The public sector has jumped into the act, bringing similarly uniform standards to property owners who don't necessarily want them.

Building appearance is getting the sort of government scrutiny once reserved for public health and safety. A 1993 survey found that 83 percent of American cities and towns had some form of design review to control building looks, usually on purely aesthetic (as opposed to historic preservation) grounds. Three-quarters of these regulations, covering 60 percent of cities and towns, were passed after 1980, an adoption rate survey author Brenda Case Scheer compares to "zoning in the 1930s." The trend appears to have accelerated in the late nineties.

Some communities prescribe design rules in detailed *do*s and *don't*s. Others use general terms like *appropriate* and *compatible*, illustrated with drawings showing acceptable and unacceptable examples. Scheer recalls a suburb that had no specific rules at all, allowing the design review board to outlaw whatever members happened to dislike. The result was an ad hoc checklist of idiosyncratic no-nos—"the *strangest* things," she says, "like they didn't want to have any windows with round tops on them. The decking on a deck couldn't run diagonally. If you had shutters, your shutters had to be able to close."

This town isn't an isolated example. Architectural review boards, planning commissions, and city councils often have broad discretion to determine and enforce taste standards, from mandating rooflines and window styles to specifying what kinds of trees can be planted. Minutes of routine meetings record officials opining that the red leaves of ornamental bushes will clash with the brick of a shopping

center sign and instructing a housing developer to build more single-story homes on certain streets. In one town, a city council member praised the beauty of Bradford pear trees, while in another an official condemned them as an "epidemic."

In Eden Prairie, Minnesota, authorities ordered a Caribbean restaurant to cut down its summertime palm trees because they undercut the downtown's "visual theme." Savannah, Georgia, told a hotel's owners they could not use a half-inch brick veneer to remodel the building but would have to use full-size bricks, reducing the size of the rooms. Mequon, Wisconsin, ordered McDonald's to keep its building beige and tan, rejecting the restaurant's plan to adopt a retro look with the chain's original red, yellow, and white color scheme. In Fairfax, Virginia, the owner of a golf driving range spent ninety-seven days in jail after refusing to plant nearly three hundred trees and shrubs ordered by local zoning officials.

In Portland, Oregon, you can no longer build a new home whose front is less than 15 percent windows and doors or whose garage takes up more than half the façade. The front door must be within eight feet of the longest street-facing wall. The goal of the ordinance, said a local official in response to critics, was to "put a stop to the ugly and stupid houses that we see going up." Environmental policy is not just about clean air and water anymore. It is, increasingly, about legislating tastes.

"To feel secure in a changing and diverse society, we seem to need consistency, neatness, and 'quality,' wrapped in a reassuring, even sentimental typology," writes Scheer, an architect and urban planning professor who has grown skeptical of the design-review process she once championed. "We are tired of ravaged commercial corridors, garish billboards, the ubiquitous and ever-changing steel-framed buildings coated in the flavor of the month. We want our neighbor to mow his lawn and keep his whirligigs out of sight in his own backyard."

Neither environmental aesthetics nor aesthetic conflict is limited to the outdoors, however. Personal appearance also sparks disputes, particularly within the workplace. Today's tolerance for divergent

styles makes conflict more apparent. With less social consensus to dictate the proper appearance, workers sometimes expect more expressive freedom than the boss's standards allow. When style is strategy and hotels have "casting directors," how employees look can be as much a part of the atmosphere as the grain of the furniture or the beat of the background music. To create its signature environment, Starbucks not only controls the look, feel, sound, and smell of its stores. It also gives employees a uniform and requires them to cover tattoos and remove most piercings—a rule whose existence demonstrates how common those once-transgressive adornments have become. "I just take it as a protocol," says a seven-year Starbucks veteran who hides his tattoos under wristbands. "It's a business."

Not all workers are so agreeable. Today's dress codes may be more about interior decorating than authority and conformity, but they can still provoke rebellion. Employees take their appearance as seriously as employers do, and they're especially likely to protest when the rules change. When Harrah's casino in Reno, Nevada, began requiring female employees to sign a promise to wear mascara, blush, powder, and lipstick to work, one bartender refused, was fired, and sued. When the Dallas Police Department began enforcing a long-ignored hairstyle policy, two officers refused to cut their dreadlocks and were fired. One filed a complaint with the Equal Employment Opportunity Commission; the other sued, alleging wrongful discharge.

At first glance, it may seem that only the employees in these cases are arguing for free expression, objecting to rules that violate their sense of identity. In fact, both sides want the freedom to establish an aesthetic personality. For the employee, that identity is personal; for the employer it's organizational. The employer is using how employees look to create a particular atmosphere or suggest what sort of place it is.

The two sides may even agree on what employees' appearance should signal and disagree only on the interpretation. To the cops who wouldn't cut their hair, dreadlocks are natural, practical hairstyles that represent honesty and strength. To the police department,

by contrast, dreadlocks signify insensitivity and insubordination, violating the department's need to present a "neutral and uniform image, to effectively relate to all segments of the population." A significant minority of the public sees locked hair as a sign of rebellion or racial separatism, inappropriate messages for a police officer to send. The problem is that dreadlocks do mean all these different, contradictory things. Both sides are right. Even more than beauty, meaning is in the eye of the beholder.

The policy question isn't whether freedom of expression is good but where the design boundaries should be. Who gets to decide which aesthetic matches which purposes? Forcing an employer to accept an unwanted style is in some sense like forcing a newspaper to publish articles that disagree with its editorial viewpoint, or like redesigning a magazine or reediting a film against the will of its owners. Authors, graphic designers, and movie directors have freedom of expression, but they can't require businesses to use their work. They have to compete with others offering different visions and talents, and they often have to alter their creations to suit their clients, or to quit jobs they believe are making unreasonable demands. And, of course, they're free to raise a public fuss about their would-be employers' bad judgment.

Such disputes are more amenable to the give-and-take of negotiation than to the black and white of law, which must operate without the parties' intimate knowledge of particulars. Successful managers will avoid driving off valued employees simply on the basis of looks, one reason for the spread of "business casual" dress and for the adoption of more stylish and personalizable uniforms everywhere from McDonald's to upscale hotels. Still, some conflicts are inevitable. As more lines of work incorporate aesthetic aspects, claims of expressive freedom and disputes over "creative differences" will spread into new areas.

Choosing employees may itself be partly a design decision, often a subliminal one: Who seems to match the place? Who will appeal to customers? The most important considerations are, of course, qualities of personality and character. But like casting a play, "casting" a

work role may mean considering appearance as well—not just how employees dress or wear their hair but how they look to begin with. When such considerations are overt, they, too, can provoke controversy. Given the history of legally enforced racial and gender discrimination, we tend to condemn any hiring choices that seem to reflect similarly superficial preferences.

In Britain, it may be all right for a personnel manager to tell an interviewer that his hotel hires "young, very friendly . . . people that look the part . . . [and] fit in with the whole concept of the hotel." American employers who look for a certain type, however, can find themselves in trouble with the law, which rarely recognizes design as a valid reason for favoring one job applicant over another. After celebrity hotelier Ian Schrager took over the Mondrian Hotel in Los Angeles, his new management fired the bell staff and hired a new "cool-looking" crew. All of the new staff was white, compared to only one of the fired employees. The EEOC filed a suit, which the hotel settled, paying each former bellman $120,000.

"Cool" comes in all colors, of course, which casts doubt on the Mondrian's rationale. But what if the hotel had fired its old bellmen and hired a cool-looking multiethnic staff? That probably wouldn't fly either. A jury made up of uncool regular folks would sympathize with the dismissed workers, says a plaintiff's lawyer. To avoid discrimination charges, warns an attorney who represents employers, the new staff "would also have to be multiage. If you think 'cool' means young folks, you've got a problem." The EEOC's lawyer in the Mondrian case goes further, arguing that hiring only "lithe" or "athletic-looking" people would violate the Americans With Disabilities Act, which would also protect anyone with "a limb impairment, or a facial impairment, or a disfigurement."

"It's one thing to have to have somebody who's slender and athletic and young-looking playing Tinkerbell in a Broadway production of *Peter Pan*," she says. "It's something entirely different if the job is to wait on tables, or if the essence of the job is to carry bags, or to check people in and make sure to get the correct information and assign the correct room."

Looks and personal style, which vary with the individual, are more like personality, strength, or initiative than they are like the status categories of race and gender. If a charming or intelligent person can have an edge in the job market, why not a handsome or stylish one? Neither charm nor intelligence is distributed any more equally than good looks. But in the lawyer's view, personal appearance is simply not a legitimate source of value outside a few conventionally artistic fields like theater. The "essence of the job" in a hotel, she insists, must have nothing to do with look and feel, which are extraneous considerations. A hotel shouldn't use its staff to create an aesthetically pleasing environment or send signals about what sort of place it is. Form is not part of function, goes this reasoning, so the law should not recognize an aesthetic imperative.

Fitness clubs feature beautiful bodies in their advertising and in their hiring. These businesses sell aesthetic aspiration; the boom in gym memberships reflects not just health concerns but heightened competition to look good. So it's not surprising that Jazzercise Inc. declined to certify a 240-pound woman as an aerobics instructor, telling her that "a Jazzercise applicant must have a higher muscle-to-fat ratio and look leaner than the public." At five feet eight inches tall, Jennifer Portnick was about one hundred pounds overweight. If she wanted to lead Jazzercise classes, the company said, she would have to develop a "more fit appearance."

Portnick filed a complaint with the San Francisco Human Rights Commission. Her argument was the same as the EEOC lawyer's: An aerobic instructor's form isn't part of her function. The "essence of the job" is to lead exercise classes, not to look trim doing so, and the essence is all that counts. Jazzercise, Portnick charged, had illegally discriminated against her. Under San Francisco's "fat and short ordinance" she had a strong case. The ordinance puts the burden on employers to prove that weight is a "bona fide occupational qualification" and declares that "weight may not be used as a measure of health [or] fitness." It flatly prohibits considering whether obese

employees might turn off customers: "The wishes, tastes or preferences of other employees or customers may not be asserted to justify discrimination." Under legal pressure, Jazzercise revised its rules.

More interesting than the legal result was the media's almost entirely sympathetic treatment of Portnick's cause. Beautiful bodies create anxiety as well as pleasure and aspiration, and the commentary on the case reflected that anxiety. What a relief it was to think that looks might be irrelevant even to leading aerobics classes! To argue that Portnick's obesity really made no difference at all to the job, however, commentators couldn't justify San Francisco's regulation on humanitarian grounds. They couldn't just say Jazzercise was cruel or unfair. They had to declare the law cost-free, even beneficial to the employer. So they insisted that Jazzercise's aesthetic strategy made no business sense—that, contrary to its understanding of its market, the company would actually be better off with fat instructors. Again and again, outside observers second-guessed the company's judgment and identity, declaring that obese fitness teachers would attract customers.

"Don't tell me her 'appearance' is a turnoff. The large, muscular, and graceful woman was the first fitness teacher I ever had who didn't embody some impossible physical dream," wrote syndicated columnist Ellen Goodman after attending a Portnick class. The hosts of ABC's daytime talk show *The View* took the same line. "A skinny broad is going to annoy me," said the show's famously hefty Star Jones. "Surely, there must be room for all types of fitness teachers," editorialized *The San Francisco Chronicle*, concluding, "We hope Portnick gets her wish."

Behind these arguments is a testable business hypothesis: that Jazzercise is leaving money on the table by not providing fat-friendly aerobics classes. Nothing stops these commentators, or those who agree with them, from pitting their aesthetic theory against Jazzercise's. The business is fairly easy to enter, and many nonprofit groups also offer potential venues. Portnick herself teaches at a local YMCA. A chain of Star Jones aerobics centers would even have celebrity selling power.

Experience, however, suggests that the commentators are wrong.

Despite an easy-to-enter marketplace and intense competition for new clients, the world is not full of fat aerobics instructors (although some niche classes do exist). Apparently most potential customers really do prefer teachers with trim bodies, whether because thin instructors inspire greater effort, because they're simply more enjoyable to look at, or because people who identify with fat instructors won't actually take aerobics classes.

The commentary also ignores the crucial issue of design boundaries, seeking to impose the commentators' aesthetic preferences—a range of body types—on every exercise studio. If "there must be room for all types of fitness teachers," that room does not have to be under the same roof. Jazzercise is one operator among many. Its rules do not dictate a uniform aesthetic to the entire marketplace any more than Star Jones's straightened hair means all women must wear their hair straight. In a diverse exercise marketplace, some chains might want to establish their identities around slim instructors, others might prefer fit-but-fat role models, and some might hire both. Just as master-planned communities can offer competing ideals that attract different sorts of home buyers—Highlands Ranch conservatism versus Prospect New Town avant-garde—so not all health clubs need to be the same. Forcing every organization into a single design strategy because that identity suits some potential customers is both intolerant and unnecessary.

But the temptation to second-guess other people's aesthetic choices is nearly irresistible. Everyone, after all, has opinions about what looks good (or bad) and when aesthetics is, or is not, a legitimate concern. Those convictions determine how we make our own world special and how we use look and feel to signal who we are. We enjoy having—and sharing—our opinions of other people's aesthetic choices, a habit that can, of course, be quite unpleasant when we're subject to those judgments ourselves: *Can you believe that hideous tie? . . . What a beautiful garden. . . . He obviously spends way too much time on his hair. . . . That's a cool car. . . . I like that house, but the green trim is too bright. . . . Bell-bottoms were ugly in the 1970s, and they're still ugly. . . . She'd look better if she colored her gray hair. . . .* Even without professional

critics, the world would buzz with aesthetic judgments. They are a normal part of human social interaction, a sign of the importance we "visual, tactile creatures" place on look and feel.

Our eagerness to make aesthetic judgments can blind us, however, to the differing aesthetic values of other people. Rather than trust the trial and error of experimentation and experience, we presume we can deduce in advance what's best, dismissing or ignoring contrary theories and opposing tastes. If our aesthetic preferences are good for us, we often assume they're good for everyone. Although we live in an age of aesthetic plenitude, we sometimes forget that our tastes may not be universal. The right house or neighborhood layout for me is not necessarily the right house or neighborhood layout for you; our identities, as well as our lifestyles, are different. Myopic aesthetic judgments become particularly problematic when the judges have the political power to enforce their tastes, all the more so when the law establishes no clear stopping point for that interference.

Consider these passages from the minutes of the design review board in Mount Pleasant, South Carolina, a suburb of Charleston. An architect is presenting plans for a restaurant to be built in the Towne Centre shopping center. Among other details, he explains: "The restaurant has a very nice back bar of custom designed mahogany and glass shelves. They have incorporated a nice area of glass block there instead of storefront windows to give texture and light and visual interest." After the planning staff comments on the design, board members weigh in:

> [The first board member said] they may have to get rid of the ceramic tile band, but brick detailing could be just as nice. The brick color should be uniform to allow the detail to be read rather than the brick texture. . . . He asked about the glass block. [The architect] said it is incorporated into the design of the bar itself to allow light through the bar. [The board member] said he cannot recall if any glass block was used in Towne Centre at all; but, he feels it is out of place. Glass block at a door tends to be uninviting. [Another board member] said it looks good. . . . [A third board

member said] his three concerns are the glass block on either side of the door, the left elevation has no detail from the back of the window on, and the rear elevation is a big green box. . . . Green is probably better than silver, but it would not be his choice.

These criticisms, expressing board members' personal feelings about tile, brick, glass block, and green paint, are a long way from straightforward rules like "plant trees and hide the garbage cans" meant to avoid imposing a nuisance on the neighbors.

Mount Pleasant does have lots of explicit design rules—no neon, for instance—but the board's critique is open-ended. If members don't like glass block or ceramic tile, they say so, even if the city has no law against either material. An architect who wants his plans approved will bend his client's budget, tastes, and aesthetic identity to suit the board, all the more so if he expects to submit future plans to the same board.

"Design review turns architectural designers into legal strategists and political conspirators; it suppresses artistry and innovation; and like other forms of absolute power, it corrupts those who wield it and compromises the processes they preside over," writes architect Denise Scott Brown. In the process, the goals of the original design are likely to be lost, overridden by outsiders' aesthetic judgments. Instead of glass block to "give texture and light and visual interest," you wind up with a standard plate-glass window, inoffensive but uninteresting. "In short," says Scott Brown, "design review is a lawyer's, not an artist's, solution to the problem of obtaining quality in design."

Such forced homogenization is what made Brenda Scheer begin to doubt the wisdom of many design review laws. As a planner in Boston, she and her staff used their regulatory power to reward developers who matched their idea of good design, sending back for revisions the plans they disliked. Over time, local architects got the message. "Projects submitted were more and more acceptable and similar, responding to the developing sense of what my staff would accept," she writes. "After several years, I was pleased: my view of the urban landscape became solidified and official."

But Scheer began to wonder whether a city of "acceptable and similar" buildings was such a good thing after all. Planners were implicitly turning the city into a single design project, reflecting a uniform vision. Intended to avoid bad architecture, design review had become an open-ended invitation to demand revisions, substituting the reviewer's judgments and priorities for the builder's. The process was stamping out variety and squelching architectural creativity. "One day," writes Scheer,

> *I sat in on a review of a simple housing project. One of the staff reviewers, a recent architecture-school grad, was marking up a set of drawings—drawings that in the early days of mediocrity would have been greeted with pleasure because of their sense of context and originality. He didn't like the porch or the roof detail. The size of the brick was "wrong." A bulb clicked in my head, and the long process of questioning began.*

When aesthetic experiments require official permission, even slightly unusual ideas tend to get screened out. (Hence the objection to glass block.) Innovations may offend conventional sensibilities or, just as likely, simply be hard to explain in advance. The result, writes Scheer, is that "all over the country, in every state and most cities, adventurous design is being smoothed out or blocked outright. At issue here is not the freedom of the 'prima donna' architects, but the potential of the city, of any designed environment, to be a sharp and stimulating place."

Even when planning authorities don't enjoy limitless power to revise and fiddle, they tend to overreach the boundaries of their knowledge. They don't have the building owner's understanding of or concern for the structure's organizational context and purposes. They haven't gone through the thinking to figure out how to solve specific problems of site, use, and budget. They may not share the owner's tastes or tacit understanding of what effects the design is trying to achieve. And, of course, they don't bear the costs, financial or otherwise, of the changes they dictate. The result can be absurd,

as in the strange case of the Frist Campus Center at Princeton University.

When the school decided to establish a full-service student center in the late 1990s, it hired Venturi, Scott Brown and Associates, who had already designed four new buildings for the campus and renovated many others. Robert Venturi, a Princeton graduate, and Denise Scott Brown had won plaudits for integrating the forms, colors, and decorative enthusiasm of the campus's traditional Gothic styles with the starker, machine-made geometries of contemporary architecture. Their buildings, concludes a critic, "demonstrated that a modern architect did not have to turn his back on history."

The campus center demanded that ability to integrate past and present. It would begin with a three-story Tudor Gothic building opened in 1909 to house the physics department. The old Palmer Hall had the modest doors and leaded windows typical of Princeton's older classroom buildings. It was substantial but essentially private. Along with extensive remodeling inside, the architects sought to turn the building into a campus focal point and obviously public place, giving new meaning to the old structure without doing violence to the original design. An extension at the rear would be transparent, with a two-story graphic of the Princeton shield etched in the rectangular wall of paned glass. Along the path in front of the building, a freestanding arcade—a row of rectangular columns topped by a horizontal beam—would invite entry through ten different openings. Across the 215-foot-long arcade's top, FRIST CAMPUS CENTER would be carved in letters two to three feet square. Each letter would project about a foot above the lintel.

"It is the outer layer which is saying, 'This building is very open,'" explains Venturi. "It does not have one single door in the center for four hundred students and physicists a day. You go through the arcade, and there are several openings that you slide into. That makes it a civic building, a community building in the campus, open and inviting."

For all the architects' thoughtful design, even his fans admit the arcade looked weird in models, "a little Potemkin façade," says one.

But the university trusted Venturi's judgment. "We have a long experience with Bob that is extremely reassuring," says an official. "He knows what he's doing. He's good at this." A student activist wasn't so trusting, though. When the local planning board invited comment, he made a passionate argument against "that big ugly thing." Although board members can't regulate aesthetics directly, they found another tool. What Venturi saw as an inviting outer building layer, an "iconographic frieze" integral to the overall design, the board declared an illegally large "accessory sign." Local regulations limit signs to 16 square feet and, by the planning department's calculations, the Frist carving was a 334-square-foot sign.

With a typical combination of anger and humor, Venturi vented his protests in a memo to the university titled "Why the Tasteful Frieze on the Front of the Frist Campus Center Is Not a Vulgar Sign but a Tasteful Frieze—Designed Also by a Highfalutin' Architect." He cited historical precedents, from Elizabethan manor houses to Princeton's own campus architecture "teeming" with symbolic decoration. His arguments failed. The board refused to grant a sign variance. Rather than abandon the arcade altogether, as opponents hoped, the university came up with a novel solution. It erected the structure without any carving, but with room to add the letters later. The shapes of the absent words' tops still rise above the lintel. Like the partly finished Lady Liberty in Los Angeles, the odd humps serve as a monument to the ongoing conflict over look and feel.

Even without the offending sign (or frieze), the design worked. The arcade, which matches the old building's brick and limestone exterior, does create an attractive and inviting entrance that marks Frist as an important, if less clearly labeled, campus gathering place. The space between the arcade and the building forms an implicit outdoor vestibule. Campus visitors who see the mysterious humps and hear their story tend to think the town's rules absurd. These visitors aren't quibbling over the meaning of *sign*. They're wondering why off-campus authorities got to decide anything at all about a structure that is barely visible from the road. If design review can reach inside a university campus, where does it stop?

―――――

As Princeton's primary physics building, Palmer Hall was long ago obsolete. But it took a novel architectural solution to adapt the building to its new use, a solution no one had thought of before. The campus center's unfamiliar arcade challenged the imaginations of people looking at models, and it fit uneasily into existing planning categories. Only because the university and the architects were stubborn and wily did the arcade survive.

Without the right design boundaries, we risk turning the aesthetic imperative into a justification for homogeneity and stasis, blocking experimentation and crushing the sources of new pleasure and meaning. The aesthetic discovery process is too unpredictable for fixed, uniform standards. Even individuals with settled tastes and identities want some variety over time, as the enduring power of fashion demonstrates. New technologies, from air-conditioning to computer-assisted design, make new styles possible, while cultural and ideological changes generate new identities demanding new aesthetic expressions. There is no one best way, and a static model of "good design" threatens the process through which aesthetic meaning and pleasure evolve. Trying to avoid all aesthetic mistakes can be as damaging as mistakes themselves.

"If you go to Germany or you go to Switzerland and you go through the countryside, there are all these houses that are exactly the same, [only] a little variation. Sometimes they even have coordinated geranium flowers. It looks beautiful—a great place for a vacation," says Logitech founder Pierluigi Zappacosta. The landscape is tightly regulated in these countries, curbing individuality and experimentation in the name of good design.

Things are different in Italy, which also happens to be famous for its wildly creative design industries. "If you go to the Italian countryside where people really live and work, you cannot find two houses that look the same. It's continuous experimentation. And 99 percent of them are *ugly*, but ugly—ugly, ugly, ugly," says Zappacosta. But, he

suggests, the culture that allows that experimentation, tolerating failures, is the same culture that produces aesthetic breakthroughs. He quotes a design professor friend: "It is tolerance for the ugliness that is the basis for the greatness of Italian design."

Of course, somebody enjoys those coordinated geraniums, and German design is famous for qualities of its own. No single standard, *even the standard that allows maximum variety and experimentation*, can please everyone. Again, the challenge is not to eliminate design but to get the boundaries right. We don't want to force everyone into the world of "anything goes" (itself a particular design choice) but to match design with audience, to align coherent aesthetic with shared purpose. Overstretching the bounds of design implies two unappealing alternatives: too *little* design, offering "something for 'everyone' but nothing specifically for anyone," like the department stores young people shun for their lack of identity, or too *narrow* design, imposing a single well-defined aesthetic on people it doesn't suit.

When legal authorities seek to avoid conflict by eliminating distinctive aesthetic identities—whether that means banning glass block or requiring aerobics instructors who represent all body types—we find ourselves in the homogeneous world of too little design. No one is offended, but no one is pleased. Narrow design, by contrast, excludes all but a limited range of styles, imposing a single clear identity. Thus Portland's ordinance essentially dictates a New Urbanist ideal adapted from early-twentieth-century neighborhoods, excluding many modern designs.

Such sweeping bans spring from the belief that "ugly and stupid houses" are an offense against the community, a form of visual pollution. Invoking pollution is a way of taking aesthetics out of the realm of expression, where liberal societies generally err on the side of freedom, and prescribing a single design for a large territory. But fighting aesthetic "pollution" isn't as straightforward as reducing air or water pollution, because the harms are entirely subjective. While air or water pollution may also have some subjective effects, at least in theory we can base regulatory standards on objective risks to health and safety.

There are no epidemiological standards for good design. As a result, regulation tends to rely on assertions of raw power, reflecting personal quirks rather than predictable rules. While design review boards made up of lay citizens drive architects crazy with their "offend no one" blandness dictates (too little design), expert reviewers can just as easily use their power to enforce their favorite professional dogmas (too narrow design). The Washington Fine Arts Commission even vetoed a headquarters proposed by the American Institute of Architects, apparently because its postmodern style offended the commission's modernist views.

This problem does not mean that aesthetic spillovers cause no harms. If look and feel can be subjectively valuable, they can also be subjectively detrimental. Economists talk about pollution in terms of "externalities," which impose involuntary costs on third parties who don't reap the benefits; to the person bearing them, those costs are real regardless of whether some expert can measure an objective harm.

When Bard College proposed a performing arts center designed by Frank Gehry, neighbors in its Hudson Valley community protested. Glimpses of the flashy stainless-steel building, they argued, would spoil the views from hiking trails and from an 1804 mansion preserved as a historic site. To avoid lengthy court battles, the college moved the building site farther inside campus, raising construction costs by about $10 million. When I mentioned the case in a column on aesthetic conflicts, my editor responded with a note excoriating Gehry's design: "The Bard development was a modernist monstrosity that would have damaged property values in a fifteen-mile radius. Isn't there an externality here that has to be addressed? And if [Bard president and symphony conductor Leon] Botstein can force me to look at something like this, the next thing you know he will force me to listen to Schoenberg in the Grand Central waiting room."

The fifteen-mile radius is hyperbole—it's hard to imagine any building whose architecture alone could affect such a wide area—but the general point is legitimate: Aesthetic choices create spillovers. They impose costs on people with different sensibilities. Not surpris-

ingly, most aesthetic conflicts arise from externalities. We don't care that much about aesthetic choices we never experience. Your ugly house bothers your neighbors; your ugly sofa does not.

But just about everything people do in society—from the way they raise their children to the way they worship God—creates spillovers, many of them subjectively harmful. Only an isolated hermit has no effect on other people. And to some onlookers, negative aesthetic externalities would include not only peeling paint, cluttered billboards, or strange architecture but bad skin, thunderous thighs, or a penchant for plaid. Taste is subjective, and aesthetic identity is often personal. Are spillovers really a sort of criminal assault, or are they something more ambiguous? Should we really ban, tax, or otherwise deter any activity that has unpleasant effects on third parties?

Economist Ronald Coase asked that provocative question in a famous 1960 article, "The Problem of Social Cost," which helped win him the 1991 Nobel prize. He began with an important but counterintuitive point: Pollution is not a simple matter of physical invasion or evildoing. It is a by-product of valuable actions. Simply eliminating the pollution at its source would require harms of its own, by eliminating or reducing that value. The self-professed pollution victim is asking to reap benefits by inflicting harms, to create a mirror image of the original problem. Seeing the Gehry building may damage observers who find it a monstrosity, but denying Bard its stainless-steel building would damage the college.

The policy issue is one of trade-offs—costs and benefits, not good and evil. "The problem which we face in dealing with actions which have harmful effects is not simply one of restraining those responsible for them," observes Coase. "What has to be decided is whether the gain from preventing the harm is greater than the loss which would be suffered elsewhere as a result of stopping the action which produced the harm."

If a Portland resident builds a house with a big garage door facing the street, people who find that façade unfriendly are harmed. But if the city forbids that design, making two-car garages impossible to fit on many lots or forcing builders to design homes with less living

space, home buyers who want garages are harmed. The question from a Coasean perspective is, Which is the greater harm, and how should we avoid it? It's incorrect simply to assert that intruding on someone's line of sight is the action that should be prevented. We have to consider the costs and benefits for both sides.

Thinking of the problem as one of reciprocal harms and benefits, Coase realized that if making deals in the marketplace costs nothing, the final level of pollution will be the same regardless of how the law assigns liability. If a factory has the right to operate even if it pollutes, then people who don't want to breathe stinky air can pay the owner not to pollute. If, on the other hand, the neighbors have the legal right not to suffer pollution, the factory can pay them to waive that right. In either case, the pollution will be set at the level that makes everyone as happy as possible. This insight came to be known as the Coase Theorem.

In the Bard case, chances are good that the offended neighbors would have been satisfied with less than $10 million in exchange for letting the building stay put. But an enforceable agreement would have been hard to put together, perhaps impossible. As Coase would be the first to point out, we don't live in a world where deals are free. Gathering information, rounding up all the affected parties, negotiating contracts, monitoring compliance, and so on are all costly. Transaction costs can make agreements difficult, especially when a lot of people are involved. That's why air pollution that harms many dispersed people can't be controlled through simple bargaining. In the real world, the way rights are assigned does matter. We want to mitigate significant harms, but we don't want to deter activities that create more value than they subtract.

In that cause, Coase argued that it's essential not only to consider both the offense and the personal and social value of the activity that gives rise to it but also to look at all the options, on both sides, for ameliorating the harms. Imagine, he proposed, that a factory spews smoke that causes $100 in damage. Traditional economics might suggest that the government put a $100 tax on the factory to compensate

for the pollution. That gives the company an incentive to eliminate the pollution by, for instance, installing a $90 device.

But, noted Coase, the $90 device may not be the only way to avoid $100 in damage, or the most efficient. Again, you have to consider both sides. The harm exists not only because the factory creates smoke but because neighbors are there to be damaged. Suppose instead of eliminating the pollution at the source, the neighbors could avoid it for just $40, by either installing some other technology or perhaps even moving. (Coase obviously chose these figures to illustrate the mathematics of the choice, not as realistic cost estimates.) That would be an even better approach, because it would keep the overall harms to a minimum. If the neighbors had the right not to breathe smoke, the factory would presumably pay them the $40. But the government would have to recognize that the harm had disappeared, even though the smoke had not.

In many cases, if we consider all costs, all benefits, and all possible remedies, it turns out that the least costly way to deal with aesthetic conflicts is what we might call the Italian solution—to look away from the stuff we don't like. The small cost to us is dwarfed by the large benefit to the owner and, in some cases, to other people as well. This is particularly true since the costs of aesthetic tolerance tend to decline over time, another difference from more objective types of pollution. Our senses detect changes in our surroundings more keenly than the ongoing levels of stimuli; we unconsciously adjust our expectations to the background. That's why we don't notice bad smells after a while and why we come out of loud concerts to find ordinary speech seemingly muffled. In the built environment, once-discordant elements tend to become part of the background, going largely unnoticed. And there is a systemic advantage. By tolerating minor negative spillovers from other people's aesthetic choices, we, too, enjoy the advantages of personal expression and aesthetic innovation.

These sorts of calculations, done less explicitly, help explain why home owners generally have had broad freedom to decorate their

yards and home exteriors to their own taste—a large benefit to them, at a small cost to neighbors who disagree but can look away. Even when harms are too substantial for the "look away" approach to work, it's often less costly to ameliorate spillovers than to abolish otherwise valuable activities. Because the social value of mobile phone service is so high, for instance, U.S. law prohibits communities from completely banning cell-phone towers. Phone companies don't have the right to build a tower anywhere they want, but the towers can't be kept out altogether. Towns have to find less costly ways to deal with spillovers, requiring disguises on towers, locating them in less intrusive places, or demanding reasonable compensation to nearby residents.

For the cell-phone towers or the Portland garage regulation, the conflict is between aesthetic considerations and other values. If the towers didn't provide a nonaesthetic benefit, no one would want them. Similarly, hardly anybody thinks houses look better with big garage doors facing the street; that design is simply an efficient way to fit a house on a lot. Like smoke from a factory, we can generally agree that a cell-phone tower or a "snout house" does create a negative spillover. That assessment is subjective, but widely shared. In a world without technical or financial constraints, pretty much everyone would agree on what to do. The dispute is about relative costs and benefits, not about what's ideal.

Because of that underlying agreement, it's often possible to find a compromise solution, incrementally improving aesthetics while preserving most nonaesthetic benefits. A big-box store whose architecture is cheap but plain can assuage the neighbors' concerns by spending somewhat more for landscaping or architectural detail, as Wal-Mart has begun to do as it moves into urban locations where neighbors are closer by. Like the cell-tower solutions, these approaches generally work only if the store has a right to operate, subject to reasonable accommodations to the neighbors' sensibilities (the political version of a Coasean bargain). If offended neighbors can block the store altogether, or if a single objector can tie up the issue in court, the store may not be built, even at the cost of making

the public at large worse off. Where there's enough flexibility, however, both sides can often find an agreeable solution when aesthetics conflicts with other values.

In other cases, the dispute is more fundamental. There is no agreement on what would be ideal in a world without financial or technical constraints. Tastes simply clash, making trade-offs difficult, if not impossible. When Portland bans houses without many front windows, it's outlawing modern architecture that some people like very much. Critics of the Portland rule usually cite Frank Lloyd Wright's work as something that would be illegal, but the same is true of many midcentury styles, including the Eichler tract homes that today enjoy cultlike devotion and command a price premium. By contrast to the garage rule, this taste conflict wouldn't go away if resources were unlimited. When aesthetics oppose aesthetics, one design regime or another has to win.

In an older neighborhood in Louisville, Kentucky, an art therapist and a graphic designer shocked traditionalist neighbors by building a high-style contemporary house with a façade of plastic, corrugated metal, and concrete tiling. Trying to address neighbors' concerns, the home owners changed some exterior colors, but tastes differed so radically that a satisfactory compromise wasn't possible. Neighbors sued, charging that the house violated deed restrictions. "They want us essentially to tear the house down or dramatically change the exterior," said the couple's lawyer. "I don't see there's a middle ground." The couple won the case in court. The judge ruled that the neighbors couldn't pick and choose when to apply design rules that had been flouted for decades. That the house "is not in keeping with their neighborhood's traditional aesthetics cannot be a basis to selectively enforce the deed restrictions," he said.

When aesthetic preferences are diametrically opposed, the spillovers are not entirely negative. To the contrary, some third parties reap benefits. Some people in Louisville are thrilled with the unusual home; local architects have included it in special tours, and one neighbor calls it "a beautiful addition to the neighborhood." The conflict isn't just between the owner and third parties but between

different groups of third parties. Toting up the costs and benefits of an aesthetic spillover, we have to include not only the benefits to the owner, which are generally high, but the dispersed benefits to bystanders who share the same tastes.

Ultimately, the only way to mitigate aesthetic conflicts is to establish design boundaries that recognize the wide variety of people and the impossibility of deducing from aesthetic principles what individuals will, or should, value. We have to return to Adam Smith: to accept the importance of specialization and to understand that a *large market* of many people need not be a *mass market* of homogeneous goods. Good design boundaries won't try to find the one best way to dress, to run an aerobics class, to design a restaurant, or to build a neighborhood. They'll embrace pluralism. They'll allow competition and discovery, including discovery of how big the boundaries should be. A niche design that pleases many people will expand over time. A niche that loses popularity will shrink.

Design boundaries can surround an organization (a restaurant chain's signage and interior design, a company's dress code, a religious order's habit), an informal group (friends' costume echoes, a subculture's adornment, a fan group's team logos), or a geographic area (a neighborhood, a shopping district, an office park). Boundaries work best when the rules are clear and members have voluntarily accepted them, when the units are small enough for members to exit without extraordinary cost, and when different design regimes compete.

In the built environment, the need for small units means thinking of an area not as a single design but as a collection of small, self-governing districts with their own design rules—whether prescriptive details, generic structures, or no restrictions at all. If you don't like the rules, you can move without disrupting the rest of your life. The area's overall order emerges from the decentralized decisions of those competing units and the individuals who choose them. Over time, new sets of design rules develop to satisfy previously unmet demands.

In liberal societies, we take such pluralism and competition for granted in most aesthetic realms. Only repressive societies try to dictate dress by law. Only centrally planned economies try to decide without competition what furniture or dishes people should want. If you don't like the green-dominated Starbucks, you can go to the blue-dominated Starbucks two blocks away—or to the bright-green-and-orange tea bar or the Populuxe diner down the street. You can decorate your living room with distressed furniture and folk art, antiques and Persian rugs, or subdued modern couches and chocolate-and-oatmeal walls. Unless you've enlisted in a cable TV makeover show, you don't have to accept what a design czar decrees, and you can change or mix styles at will. Despite some well-publicized disputes, employee dress codes are mostly no big deal, because there are many employers and professions, with many different views of dress; one of the dreadlocked cops quickly got a job in a neighboring police department, while the other became a schoolteacher.

It's hard, however, to fully embrace the idea that there are many good ways to make a neighborhood. In Louisville, some of the most eloquent advocates of architectural freedom sneered at the neighbors' "German 'cave-style'" houses and mocked their affection for brick. While the legal dispute hinged on technical questions, the public debate was between those who declared that the iconoclastic home owners "have no sense of place" and those who said they "should be applauded for trying to be different"—between those who believe continuity is good and those, including the home owners, who believe in "questioning tradition." Like the question of what dreadlocks "really" mean, this dispute can't be settled on the facts. It's a clash of values.

Such ideologically charged disputes are typical. Critiques of the built environment commonly seek not to make incremental improvements, or to offer another choice among many, but to redesign the world into someone's vision of the single right way to live. Designers often believe that the right environment will make people better, with "better" defined by the designer's vision of the good society. If we build suburbs with yards and cul de sacs, away from the smoke and

crowds of the city, as the twentieth-century Garden City movement advocated, labor and capital will live in peace. If we build new houses with porches, goes today's New Urbanist reasoning, we'll be neighborly like in the good old days. (Never mind that air-conditioning makes hanging out on the porch less necessary or desirable.) If we outlaw big garages, people will abandon their automobiles. If we build unusual houses, people will be tolerant. If we make a city exactly the way I want to live, everyone will be like me.

When it comes to the built environment, a genuine design pluralist is hard to find. Certainly, the last place I expected to meet one was in an urban-planning firm in Irvine, California. The Orange County town is the epitome of tightly controlled design, a squeaky-clean Edge City of office parks and master-planned neighborhoods, a place without billboards or whirligigs. It's so tidy that when my husband started teaching at the University of California campus there he couldn't find a gas station.

On a bright April day, I've come to Irvine to talk with Steve Kellenberg, who creates master plans for large-scale developments that sell more than a thousand homes a year. These "high-production, high-velocity" businesses represent the present and future of American home construction, supplying homes for the booming suburbs of the Sunbelt. I'd heard Kellenberg tell an audience of developers about survey data showing that 63 percent of buyers in master-planned communities want more diversity, while only 32 percent want their neighborhood to look consistent.

That was what I wanted to hear. Like many variety-loving city dwellers, I'm leery of master-planned communities, even though I know they're extremely popular. It's bad enough that even my little eighteen-unit town-house complex has ridiculously conformist rules—no plants by the front door, no non-neutral window coverings, no door decorations except around Christmas—but at least our homes are literally connected to each other, making the cost of spillovers high. I can't imagine wanting to live in a whole neighborhood of similar uniformity.

But people really are different.

Over and over again, Kellenberg comes back to that message, expressing a tolerance that arises as much from relentless pragmatism as from liberal idealism. If you're in the business of designing environments people will pay money to live in, you can't kid yourself about what they value. You can't design your idea of utopia and force everyone to conform to it; if you try, everyone who isn't just like you will go elsewhere to find a home.

Unlike me, some people really do prefer uniformity to variety, regardless of cost. Not everybody thinks it's bad if every house on the street looks pretty much like every other one, or if people can't change their houses much over time. Some people *like* that sort of predictability. It makes them feel secure, at home in their neighborhood. Even if cost were no object, not everybody would want the same thing I'd pick.

"We have this incredible tendency to overgeneralize about the population and to say, 'Everybody wants this—everybody wants to live in a community where you can't paint your house unless it's the right color and you have to close your garage door,'" says Kellenberg. "Well, the fact is that there really are a lot of people who want that kind of controlled, predictable environment," often because they've had bad experiences in deteriorating neighborhoods. "And there are others that find that an incredibly repressive regime and wouldn't live there if you *gave* them a house, because they believe there should be an organic, fluid, self-expressive environment."

People are different.

"You have people in Irvine that love living in Irvine," he says. "And you have people that moved to Irvine and leave after five years because they hate it, and they move to Seal Beach or Santa Ana," nearby towns with few design restrictions. In a diverse society, some people will indeed want a lot of rules, "but it clearly isn't something that is *the right way* of doing it for everybody." Neither is the alternative.

People are different.

Even those survey statistics are misleading aggregates. Some people care a lot about diversity; others really, really want consistency. A

lot are in the middle. Some people want to be sure to run into their neighbors. Others just want to stay in with their big-screen TVs or to socialize with the friends they already have. Some people want to be able to walk to the store without seeing a car. Others want to be able to drive in and out easily. The difference isn't one of demographics—age, income, education, and so on—but of identity and attitude. In the same price range, for the same size families, you can find people who want all sorts of different neighborhood designs.

What the survey numbers actually say is that part of the housing market has been underserved. For years, large-scale developers have focused so much on those home buyers who want a predictable environment and the most house for the money that they've ignored other groups. Offer the long-ignored groups a different sort of design, and they'll reward you handsomely. This pragmatic, trial-and-error process of discovering new sources of aesthetic value is less grandiose, and perhaps less inspiring, than the ideological search for the one best way to live. But it is also less divisive and venomous.

You can see its latest products in the spanking-new streets of Ladera Ranch, a huge new development about a half-hour drive southeast of Irvine. A blue-gray Cape Cod home, with the deeply sloping roof of its saltbox ancestors, sits next to an updated beige and brown Craftsman with a low-pitched roof. Down the street is a Spanish Colonial with a red-tile roof and around the corner a stuccoed house whose turret recalls the fantasy homes of 1920s Los Angeles. Although many garages face the street, violating the Portland prescription, most are recessed so they don't dominate the landscape. You see porches and yards and sidewalks—social space. And between the sidewalk and street is something no new Southern California community has gotten in a generation: a small parkway planted with trees, spindly today but promising charm and shade as the neighborhood ages.

These are mass-produced homes, with metal windows and Hardiboard concrete siding rather than wood. They'd never pass purists' tests of authenticity. But they offer something genuine and rare—variation in more than façade, rooflines and massing that

match their styles, a street of different colors and different forms. Built on the empty hillsides of what once really was a ranch, Ladera Ranch is turning the previously unfulfilled desire for varied and sociable neighborhoods into extraordinary profits. The development sells twelve hundred houses a year for prices 10 percent to 14 percent higher per square foot than in the more conventional community right next door. The landscaping and construction quality cost more, acknowledges Kellenberg, but even accounting for those costs, "it still appears that there's a 7 to 10 percent lift in the base values that can only be explained by people being willing to pay more to live there."

People are different.

Specialization pays. "There really is a lot of the market that doesn't want everything to look the same, that does want to have individuality in their home, that does want a diversity of neighborhoods, that wants [the design] to feel like it grew out of the heritage of the place, that are interested in meeting their neighbors, that would enjoy having the street designed as a social space, that would like to have other social spaces and social opportunities that they could participate in," he says.

Ladera Ranch's design owes much to the New Urbanism, with its emphasis on community and its understanding of streets as social spaces. But Kellenberg dismisses the New Urbanism's one-size-fits-all doctrines, its "singular mission" that "rejects everything other than New Urbanism." Lots of beloved neighborhoods, he notes, don't conform to New Urbanist prescriptions. The design for Ladera Ranch isn't New Urbanism. It's specialization—specialization within specialization, in fact. The development includes four different neighborhood styles, each crafted to suit a different personality and lifestyle. And if you want something different, you don't have to buy a place in Ladera Ranch. You can go next door. There's something for everyone and, if there isn't, a smart developer will figure out how to fill in the gaps.

The seeming homogeneity of master-planned communities—the planning that gives them a bad name among intellectuals—turns out to be real-world pluralism once you realize that everyone doesn't

have to live within the same design boundaries. Community designs and governance structures are continuously evolving, offering new models to compete with the old. This pluralist approach may overturn technocratic notions of how city planning should work, but it's the way towns are in fact developing in the United States, suggesting that these institutions offer real benefits to residents. From 1970 to 2002, the number of American housing units in home-owner associations, including condominiums and cooperatives, rose from 1 percent to 17 percent, with more than half of all new units in some areas in these associations.

As an alternative or supplement to large-scale local government, some economists and legal scholars have begun debating ways to let home owners who aren't in private associations form them, whether for whole neighborhoods or just a few blocks. Some proposals envision the privatization of former city services like garbage collection and of zoning-style regulations. Others want only a specialized complement to city governance, with special fees to cover services that people in that small area particularly value. For instance, suggests a legal scholar, "if artists were to concentrate their studios on a particular city block, their [Block Improvement District] could make unusually heavy expenditures on street sculptures. Indeed, the prospect of forming a Block Improvement District might encourage artists to cluster together in the first place."

Some of these plans would require unanimous agreement, others a supermajority. The question of whether new boundaries can be drawn around residents without their individual consent is a difficult one. If unanimous agreement is necessary, a single holdout can make everyone worse off. But retroactively limiting what property owners can do with their homes raises the same problems of pluralism that allowing small districts is supposed to avoid.

This problem is especially great when the new district isn't truly self-governing. Many cities, for instance, allow a supermajority of home owners to petition to make their neighborhood a historic district subject to special aesthetic controls—potentially a good model of specialized design boundaries. Unfortunately, historic districts usually

have to conform to procedures established by a higher level of government. They can't create processes and rules tailored to the wishes of those they govern. In Los Angeles, for instance, a Historic Preservation Overlay Zone is regulated by a five-member board. Unlike a home owner association board, members are appointed by city officials and other board members, and only three of the five must be residents of the area they govern. Since residents don't have a direct vote, they can't easily predict, or check, the board's actions.

Even some preservation activists admit to concerns. A San Fernando Valley resident who's campaigning to make her neighborhood a historic zone says she isn't looking to crush individual home owners' self-expression, only to raise awareness of the history and value of the neighborhood's midcentury Eichler homes. But some local preservationists are sticklers for architectural authenticity, narrowly defined. If the board is captured by purists, she admits, it might even outlaw the pistachio-green siding she and her husband chose to match their vintage car. "I don't think we'd like that too much ourselves," she says.

Even in the best of circumstances, small, self-governing districts wouldn't eliminate aesthetic conflict. Neither do master-planned communities. As anyone who's lived in a small condo complex knows, even small groups of people disagree. Governance rules simply provide processes for resolving disputes. And they help people know what to expect, avoiding the nasty surprises and bitter conflicts that result when aesthetic rules are imposed after the fact. The best we can hope for isn't perfection but fairness, predictability, and a reasonable chance of finding rules that suit our individual preferences. The advantage of narrow boundaries is that if all else fails, we can vote with our feet, not only improving our own situation but sending a signal that the competition is offering a better design package.

The more difficult it is for people to enter and exit—to find design rules to their liking—the more general the rules need to be. A four-block special district can have very prescriptive rules that would

be inappropriate for an entire city. A metropolitan area like Orange County that is made up of many smaller cities can offer a range of city-level design regimes.

In larger areas, one way to accommodate different tastes within an overall sense of structure is to make the rules fairly generic. Consider the difference between a work uniform, a requirement to wear black, and a general prescription for "business casual." All three establish an organizational identity, but each allows more individual choice and flexibility than the previous one, accommodating a wider range of appearance and personality. To attract a diverse group of employees, to avoid turning off independent or creative individuals, or simply to stay up-to-date as fashions change, it may be better to keep the dress code as general as possible.

Along similar lines, Brenda Scheer suggests that urban-design regulations should pay more attention to the urban forms that are hard to change and concentrate less on the stylistic details that are easily altered. It's easy enough to ignore a single building you don't like, especially once it's been around awhile. But street widths, setbacks, and lot sizes affect the whole experience of being in a particular neighborhood. They establish the underlying structure that creates the sense of place. "If you get the lots right and the blocks right and the street right and the setbacks right, somebody can build a crummy house and it will sit there for thirty years, and somebody will tear it down and build a nice one," she says. "There's a kind of self-healing process that's available if the structure is fine."

This model allows for flexibility, personal expression, and change, while still preserving a coherent underlying design. It echoes the pattern identified by Stewart Brand in *How Buildings Learn*, which examines how buildings are adapted to new uses over time. Brand explores what makes architecture resilient and capable of "learning" as its purposes change. A building, he notes, contains six nested systems: Site, Structure (the foundation and load-bearing elements), Skin (the exterior), Services (wiring, plumbing, heating, etc.), Space plan (the interior layout), and Stuff. The further out the nested sys-

tem, the more permanent. Moving around furniture (Stuff) is easy; altering a foundation (Structure) is difficult. In a building:

> *the lethargic slow parts are in charge, not the dazzling rapid ones. Site dominates Structure, which dominates the Skin, which dominates the Services, which dominate the Space plan, which dominates the Stuff. How a room is heated depends on how it relates to the heating and cooling Services, which depend on the energy efficiency of the Skin, which depends on the constraints of the Structure. . . . The quick processes provide originality and challenge, the slow provide continuity and constraint.*

A well-designed, adaptable building, Brand argues, respects the different speeds and different functions of these nested layers. It keeps them separate, allowing "slippage" so that the quick inner layers can change without disrupting the more permanent systems. (You don't have to tear up the foundation to fix the plumbing.)

Scheer's proposal applies a similar model to the surrounding environment. She essentially adds a seventh layer we can call the Street. By limiting design restrictions to the Street, Site, and possibly Structure, rather than the usual obsession with Skin, she makes room for evolution and learning. Like Brand, she emphasizes the effects of time. Given enough slippage between outer and inner layers, we can correct flaws and adapt to changing circumstances while preserving some underlying sense of order. A city, she says, is "a living thing, it's a changing thing, and it has to adapt or it dies. A city that is not having a continuous renewal is a dying place."

A dynamic model of city life recognizes that not just purposes or technologies change over time. So do tastes. Like Capri pants and stiletto heels, aesthetic spillovers go in and out of fashion, flipping from positive to negative and back again. Hard as it is to believe today, from the end of World War II until the 1980s, the Art Deco hotels of Miami Beach were considered "tacky, in bad taste, and old fashioned." When the Miami Design Preservation League was

formed in 1976, recalled one of its founders a decade later, South
Beach "was considered a disgrace to the city, because of its cheap neon
lights, 'funny-shaped' buildings, and the signs along Ocean Drive
blaring 'rooms $5 a week.' "

Similarly, American tastemakers have for decades condemned
neon signs as the epitome of commercial tackiness, and many cities
continue to ban neon. Others, however, have rediscovered the lively
pleasures of the lights. While some neighboring cities such as Santa
Monica have been forcing businesses to take down their neon signs,
Los Angeles has spent about half a million dollars helping building
owners restore and relight historic neon signs. The city's Museum of
Neon Art not only preserves vintage signs but lends them to the pop-
ular Universal CityWalk outdoor shopping area. Commercial neon
has slowly regained its 1920s status as a source of public pleasure.

The built environment is filled with examples of once-scorned
designs that have become architectural touchstones or popular icons.
When it was new, a critic called the Golden Gate Bridge an "eye-sore
to those living and a betrayal of future generations." *Architectural
Record* critic Suzanne Stephens provides a wide-ranging tour of sim-
ilar examples:

> *Because of his idiosyncratic Baroque architecture, Francesco
> Borromini was criticized by his [seventeenth-century] contempo-
> rary, the writer Giovanni Bellori, as "a complete ignoramus, the
> corrupter of architecture, the shame of our century." John
> Vanbrugh's early-18th-century Blenheim Palace was panned for its
> unclassical Elizabethan corner towers, and his work reviled by his
> influential client, the Duchess of Marlborough.*
>
> *Other buildings were judged harshly in their time as well: The
> works of Frank Furness and his followers in Philadelphia were too
> contrived and too awkward for critics in [*Architectural]
> RECORD a hundred or so years ago. In 1889 artists, architects, and
> writers, including Charles Garnier and Guy de Maupassant, called
> the Eiffel Tower "useless and monstrous." Frank Lloyd Wright's
> Larkin Building in Buffalo was deemed "ugly" by eminent critic*

Russell Sturgis in [Architectural] RECORD in 1908, and in 1959 his Guggenheim Museum was dismissed by visionary architect Frederick Kiesler.

In 1931 Lewis Mumford charged that New York's Chrysler Building by William Van Alen was full of "inane romanticism" and "void symbolism," while Douglas Haskell felt Howe and Lescaze's International Style PSFS Building of 1932 was just a "filing cabinet." . . . Will Michael Graves' 1983 Portland Building—along with recent work by Eric Moss, Bernard Tschumi, Michael Hopkins, and Frank Gehry, which have received criticism (even in these pages)—be subject to a revised perspective as time goes by? We will have to wait.

Tolerating strange styles can create significant value over time, as the unfamiliar becomes familiar, leading to aesthetic appreciation. As Stephens also suggests, however, the test of time works both ways. Sometimes, we indeed come to love, or at least to ignore, once-controversial artifacts. In other cases, we look back and wonder, "What were we thinking?" Did people really believe architecture called Brutalist could be *good*? Acclaimed twenty years earlier, the Portland Building made a 2002 *Metropolis* magazine list of "The Twentieth Century's Worst Design Ideas," an assessment that itself may be subject to future revision. A generation from now, we may regard Frank Gehry's buildings as beautiful art or hideous folly. Or we may find them something altogether different: nostalgic reminders of turn-of-the-century enthusiasms, regardless of their formal merits.

Time adds meaning to form. After the Twin Towers were destroyed, many news reports revisited the critical revulsion that had greeted the World Trade Center. *New York Times* critic Paul Goldberger had called the buildings "blandness blown up to a gigantic size," opining in 1979:

By now the twin towers are icons, as familiar in souvenir shops as those little miniatures of the Empire State Building. We have all come to some sort of accommodation with the towers, God help us, and there have even been moments when I have seen them from afar and admitted to some small pleasure in the way the two huge forms, when approached from a distance, play off against each other like minimal sculpture. But the buildings remain an occasion to mourn: they never should have happened, they were never really needed, and if they say anything at all about our city, it is that we retreat into banality when the opportunity comes for greatness.

Shortly after September 11, I heard a radio interview in which Goldberger recalled his harsh words somewhat sheepishly. He acknowledged that the buildings had grown on New Yorkers over time and, of course, that their destruction had given their memory a permanent emotional resonance.

As the now-lost towers testify, personally and communally we come to cherish landmarks we associate with significant places and experiences. This value itself often creates conflict, because those special places are often owned by other people. "Let's face it," says a Los Angeles activist trying to preserve the exuberant Populuxe-era architecture called Googie. "Our public spaces in Los Angeles are *private* public spaces—Ships coffee shop affected more people than any city building or the Los Angeles Museum of Art." That's true not only of L.A. but of most of the United States, a nation whose most notable landmarks include office buildings, hotels, theaters, churches, mansions, and university halls with private, often commercial, owners. Even Mount Vernon remained a private home belonging to the Washington family until 1858, when a woman appalled by its disrepair organized the Mount Vernon Ladies' Association to buy and restore the estate. (The private association continues to own and support the property, which receives no government funding.)

In an influential examination of aesthetic regulation, legal scholar John J. Costonis argues that emotional attachment, not formal beauty, properly drives public efforts to preserve iconic buildings.

Aesthetic regulations, he writes, "respond to our perception of the environment as a stage, rich in icons that infuse our lives with constancy, self-confirmation, eroticism, nostalgia, and fantasy." Costonis's psychological insight seems sound, but his analysis offers little reassurance to building owners, for whom time often has just the opposite effect, reducing value and increasing costs. Third parties enjoy the heightened emotional benefits of continuity without bearing the escalating maintenance expense or forgoing the profits of alternative uses.

Consider Oklahoma City's Gold Dome, a 1958 bank building featuring a gold-plated geodesic dome. After Bank One acquired the dome in a merger with another bank, it estimated that the building needed about $2 million in renovations, including new air-conditioning, roof repairs, and asbestos removal. With twenty-seven thousand square feet, the building was nearly six times too big for Bank One's purposes. In the era of ATMs and branches in supermarkets, banks no longer want giant showcases. But locals were horrified when Bank One announced plans to demolish the dome and replace it with a small branch and a chain drugstore. Like San Francisco's Transamerica pyramid or Seattle's Space Needle, the Gold Dome had come to represent Oklahoma City. As a symbol, the dome's communal value was large, even though its private benefits had dwindled and its private costs increased.

"It may be financial folly to restore the dome, but it would be a great gesture to Oklahoma City if Bank One could find a way to do so," wrote a local columnist, acknowledging the uneven distribution of costs and benefits. "The dome is a community focal point, a serendipitous little inner-city oddity. Look at it and you're momentarily transported back to 'The Jetsons.' . . . The dome—along with the elegant, modern tower that's paired with it—is a rarity in Oklahoma City. It is an architectural landmark."

The columnist got his wish, minus the financial folly. The uproar delayed the demolition, encouraging the company to put the building on the market. At the last minute, the bank found a buyer. A local optometrist plans to convert the dome to professional offices, retail

space, and an Asian cultural center. The bank will build a small
building next door. The $1.1 million sales price wasn't as high as the
company wanted but, said a bank official, "All things being equal,
we'd rather not tear the dome down."

It's easy to say something is precious if you can enjoy it at someone
else's expense. Talk is cheap. Like review boards redrawing building
plans, preservation authorities sometimes exercise almost unlimited
power to require property owners to maintain old buildings without
compensation for their troubles. One result is that the buildings don't
have to be widely valued for either their pleasures or their meaning.
They just have to appeal to somebody with more political influence
than the owner.

Over the past decade, the Charleston, South Carolina, Board of
Architectural Review has expanded its jurisdiction from a relatively
small area of antebellum mansions into some of the poorest parts of
town. At particular issue are four-room "freedman's cottages,"
believed to have been built by emancipated slaves. The freedman's
cottages are often in terrible shape and, even if restored, would be too
small to command rents high enough to recoup the expense. One
owner who was denied permission to tear down four freedman's cot-
tages estimated they'd cost $100,000 each to repair and would still
rent for only $200 to $300 a month. In another case, a man unfortu-
nate enough to inherit a freedman's cottage spent four years fighting
for permission to tear it down after Hurricane Hugo damaged the
place beyond habitability. The city offered a mere $4,000 for the
dilapidated structure, a ninth of its assessed value for tax purposes.
Officials frequently fined the owner for not maintaining the property
before finally giving him permission to demolish it.

The tiny homes do reveal something about Charleston's history,
but as useful houses they're obsolete. Black Charlestonians fortunately
have better housing options in the twenty-first century than they had
in the nineteenth; they don't want to live in tiny, run-down houses,
however historic. That makes the review board's preservationist zeal
quite costly to the people who happen to own the cottages. If a freed-
man's cottage is of interest to historians but not to potential residents,

then historians should buy and preserve it as a research site, demonstrating its value by paying the owner. Otherwise, their cheap talk just encourages neglect and, in this case, perpetuates a history of injustice.

Oklahoma City, by contrast, had to put its money where its mouth was, demonstrating that the Gold Dome really was a cherished icon. Activists couldn't force Bank One to maintain the building as a free architectural museum for their pleasure. Saving the dome required finding someone to buy it, compensating the bank. Given the value locals attach to the Gold Dome, preservationists conceivably could have put together $1.1 million from private sources, or the city could have used tax funds to buy the building. Fortunately, neither step was necessary, since the structure captured a commercial buyer's imagination, and no authenticity-oriented law hampered its conversion to new uses.

Giving the public a voice, making time for counteroffers (or, in predesignated cases, giving a city or preservation group the right of first refusal), and providing funds to buy or maintain particularly meaningful structures, while leaving the ultimate decision to the building owner, seems to strike the best long-term balance of rights in dealing with icons. In Oklahoma City, the delay was crucial, because it gave the public a chance to let Bank One know how much people cared about the dome. A commercial establishment that draws its customers from the local area has a strong business motive to honor their aesthetic values, whether by improving the landscaping of a parking lot or preserving a beloved building. (An individual owner with eccentric tastes may be less susceptible to public pressure, since eccentric tastes and caring what the neighbors think don't tend to go together.)

There's no perfect solution to such conflicts, of course. If owners have to be compensated to preserve icons, there's always the danger that they'll pretend to threaten their buildings in order to extract payment. And sometimes icons will fall to the wrecking ball, lacking adequate support to save them. Even so, the greater danger lies in fostering what Scheer calls "the culture of aesthetic poverty," depriving

the urban landscape of beauty, inventiveness, and meaning. If building or preserving a potential icon makes it subject to de facto confiscation, property owners will erect and maintain only boring buildings. Or they'll be sure to tear down their buildings before public sentiment can interfere with their freedom of action. Or builders will limit the aesthetic details to the inside, with no free benefits to the general public.

Even without such perverse incentives, cost-conscious building owners often avoid investing in positive spillovers. "All the beauty, all the marble, all the stuff is put on the inside," laments Scheer, angry about the "fabulous internal environments" of malls and hotels that look like giant boxes from the outside. "An old hotel from the nineteenth century would die before they would do that. It would have been considered rude." Nineteenth-century hotel owners could count on controlling their building's fate, however. If they erected a showcase only to find it no longer useful, they could sell it for new purposes or raze it without punishment. Putting up a building that the public could enjoy didn't invite the public to assume control of that building's design or destiny. And those nineteenth-century hotels were special places, catering to a wealthy elite that expected aesthetic quality inside and out. When the general public began to stay in hotels more often, plain function—"the best surprise is no surprise"—was good enough.

Now, however, the quality-demanding elite is no longer so elite. It includes most of us. That means Scheer's lament about the culture of aesthetic poverty need not continue indefinitely. In the postwar era of function and convenience, the general public was relatively insensitive to aesthetics, tolerating an ugly environment in exchange for other benefits. Aesthetic regulation might have improved the landscape, but it was politically unpopular, because on the margin most people preferred low-cost function.

Now that people increasingly care about look and feel in their private choices, aesthetic regulation is less necessary to control blatant public ugliness. The same taste shift that has made the spread of design review politically viable is slowly but surely changing the def-

inition of what's commercially necessary. If owners have the freedom to create, alter, and destroy them if necessary, fabulous external environments are sure to follow their interior counterparts. Our greatest fears of the aesthetic future are not of too little design but of too much.

Six

SMART AND PRETTY

The aesthetic imperative is here to stay. The indicators may fluctuate with the economy—fewer new companies that need logos, advertising, and Web sites mean less work for graphic designers; fewer new products mean less work for industrial designers; fewer new hotels or restaurants mean less work for interior designers—but the underlying phenomenon remains strong. Every start-up, product, or public space calls for an aesthetic touch. Personal appearance demands new forms of attention and offers new sources of pleasure and meaning. Aesthetic proliferation gives us more choices, opportunities, and responsibility than ever before. We expect look and feel to express, and to help establish, the identity of people, places, and things. What once was good enough isn't any longer. Function alone does not suffice.

When Hubbard Street Grill closed after eight years in Chicago's River North neighborhood, owner David Schy blamed competition from high-end chains like Spago, California Pizza Kitchen, and Rock

Bottom Restaurant & Brewery. No matter how good Schy made the food, his restaurant just couldn't match their resources. The chains spread fixed costs like advertising over multiple outlets, and their bulk purchases of everything from ingredients to insurance let them negotiate lower unit prices.

But a *Wall Street Journal* profile also revealed an aesthetic blind spot. "When Mr. Schy opened his restaurant," it recounted, "he didn't spiff up the loft warehouse space that housed it—except to paint a mural on one wall and get a new sign. He didn't even buy new tables and chairs, using ones left by the previous restaurant." Schy gave Hubbard Street Grill no aesthetic identity. As competition intensified, he kept expanding the menu but did nothing to improve the restaurant's atmosphere. To him the real business of dining was the food. Unlike the national chains, and unlike such flourishing local-chain operators as Mico Rodriguez, Schy treated the restaurant's look and feel as an afterthought, little more than waste. "People are coming out for a $3 million [decorating budget] with lousy food because the décor matches people's outfits," he said scornfully.

By all accounts, however, the competitors' food is fine. Indeed, Schy adapted many of their dishes for his own menu. Like the reliability of automobiles, the quality of restaurant food has improved greatly, making look and feel the deciding factors for many patrons. Chicago diners weren't really choosing between lousy food and good food but between good food in an appealing environment and better food in an unappealing one. On Hubbard Street Grill's closing day, a customer summed up what the restaurant had offered: "The décor stinks, it's too loud, you can't hear. But the food is good." By defining his restaurant's quality along that single dimension, ignoring the rest of the dining experience, Schy alienated people who expected more.

As the tale of Hubbard Street Grill illustrates, the aesthetic imperative creates losers as well as winners, costs as well as benefits. Look and feel add value to our lives, but that value doesn't come for free. The relative cost of style has dropped, but it is still one of many different possible goods. Choosing more aesthetic value means forgoing some alternative. The age of look and feel, like every other era,

demands trade-offs. Wrestling with those choices, and finding ways to make aesthetics ever less costly, will shape life in an increasingly aesthetic world. The challenge is to embrace the pleasures and possibilities of the aesthetic age while not losing sight of other values—neither rejecting the genuine worth of look and feel nor turning them into the ultimate goods.

Illustrating the kinds of trade-offs we face, education writer Joanne Jacobs complains that schools teach children PowerPoint rather than critical writing and reward attractive presentations that get basic facts wrong. "In science, the lab report is another chance to shine graphically—even if that lovely diagram refutes Galileo," she writes in an opinion piece called "Dumb, But Pretty." Students are spending lots of time on aesthetics instead of traditional academic pursuits, she worries, and design quality matters in their grades:

> *In seventh grade pre-algebra, my daughter's math grade depended, in part, on the cover design for her Problem of the Week write-up. Solving the problem wasn't enough. Solving it and explaining how you solved it and why you approached it that particular way and how else you might have solved it and why you think you're right and how you "felt" about the problem . . . All that wasn't enough. It had to look pretty to get a top grade. . . .*
>
> *Technology's pizzazz trumps other priorities. In "Oversold & Underused: Computers in the Classroom," Larry Cuban praises humanities teacher Alison Piro's use of technology. "After reading several works in utopian literature, groups of students had to create their own utopias and make a film (using AVID software) that would 'sell' their utopias to their audience, their classmates."*
>
> *Students "were in the media center, using butcher paper, pencils and pens for about three days before we ever got to the technology," Piro explains. "Then we spent a whole day researching images on laser disk, video and the Internet. Then we spent a whole other three days and a Saturday working with AVID."*
>
> *That's eight days working on assembling visuals and manipulat-*

ing software. And then the class will need more time to watch each group's video. It's jazzy. It's fun. But is it worth all that time?

Science mistakes aside, these aren't horror stories. Nobody gets a high grade in the pre-algebra class without solving the problem correctly; a good-looking cover matters only on the margin. Like a restaurant patron who expects delicious food *and* attractive décor, the grade rewards not "dumb but pretty" but "smart *and* pretty." Students who are good at both math and graphics do better than those who are good only at math. That standard wouldn't have helped me any in seventh grade, but it seems no inherently worse than rewarding history students for well-wrought prose, giving written tests in gym, or requiring crafts skills for science fair projects.

The fundamental question, which is impossible to answer without further information, is what schools are really giving up to spend more time on aesthetics. After all, before anyone ever heard of PowerPoint, students devoted many hours to doing busy work to keep them quiet, to reading aloud assignments that were supposed to be homework, and to putting together "creative" projects like skits and posters. They cheered at pep rallies and performed in talent shows. They idled in study halls. Not every school hour was directed toward rigorous intellectual pursuits. The typical school day has plenty of marginally productive hours—some of them devoted to repetitive or insignificant academic instruction—that could be more valuably used to develop aesthetic skills. If teachers are substituting what another writer calls a "Crayola curriculum" for critical thinking and writing skills, it's not because aesthetics is inherently incompatible with rigorous academics but because such teachers are avoiding rigor in all its forms.

The "smart and pretty" standard reflects what's happening in the nonacademic world, where aesthetic competence makes a difference on the margin. While we should guard against substituting style for content, a temptation especially for teachers who were not themselves high academic achievers, it's foolish to ignore or denigrate aesthetics,

denying its rising importance. Designing a book jacket may seem trivial and "entertaining," compared to writing a book report. But in real publishing, a cover designer must understand the work and capture its essence in an enticing, quickly grasped form—not at all an easy task. And authors certainly don't think that cover designs are unimportant.

Assuming that attractive presentations must be stupid repeats the fallacy that tells teenage girls they have to choose between brains and beauty, leading many to choose the latter. The more prominent aesthetics becomes, the more important it is to avoid such false dichotomies. Attractive surfaces do not necessarily imply lack of substance. The trade-offs we make aren't all-or-nothing choices. They're decisions on the margin: What do we value *next*? Like the pre-algebra teacher who rewards graphics but requires correct answers, we can maintain academic standards while developing aesthetic skills.

Of course, the pre-algebra teacher arguably should assign more or harder problems rather than worrying about graphic design, which has little to do with math. Piro's humanities class offers a better model for using aesthetics in the service of academics. Students start by reading several utopian works, a demanding traditional assignment. Creating videos may take somewhat more time than writing papers, but it's a similar exercise in communication. Whether made for class or for commercial release, movies combine aesthetics with communication, pleasure and subliminal meaning with narrative and rhetorical function. The look and feel of a video are like the sound and connotations of the words in a piece of prose. They're essential to the overall experience, providing nuances and emotion, but they aren't substitutes for the message itself.

Outlining concepts on butcher paper and researching and assembling visuals require not just time but serious thought about how most effectively to convey ideas and persuade an audience—the same rhetorical challenge posed by an essay or speech. Adding the video to a mix of reading, writing, and class discussions strengthens the course's academic demands. The project increases the chances that students will leave with both an understanding of utopian literature

and the rhetorical skill to translate abstract ideas into concrete illustrations.

Like a skilled chef complaining about restaurants with fancy décor, Jacobs is voicing the frustrations of the intellectually adept student confronted with academic demands she can't easily meet. As look and feel become more important, students who could once excel through memory and analytic ability alone find themselves facing new, seemingly irrelevant, requirements. Aesthetics, they protest, isn't supposed to count in school. What does graphic design have to do with math? Why should a class on utopian literature require you to think in pictures? Why can't you get an A for work that's smart but ugly—or altogether undesigned?

Three decades ago, I dreaded being graded on artistic skill, of which I had none, rather than intellectual prowess. Fortunately, my social studies teacher was placated with coffee-based tie-dyeing (think South America). My project was stupid because my aesthetic skills weren't good enough to support substantive thoughts. Fortunately for my grade, the teacher didn't take aesthetics any more seriously than she took social studies. She looked only for decoration, surface without substance, and had low standards even there. It was enough to be "creative" and "expressive." The teacher viewed artwork as intuitive and innate, the opposite of intellect or skill. She thus neither taught technique nor demanded that form serve meaning.

Although not itself content, aesthetics enhances communication. It's an essential tool for holding attention and adding emotional depth to factual meaning. Given current computing power, that tool is available not just to the artistically gifted but to everyone. Aesthetic skill can be more than a "fun" substitute for learning or an easy-to-grade assignment for teachers who don't want to read papers. Rather than relying on native ability and self-directed learning, good schools will cultivate aesthetic skills, teaching students to master basic tools and techniques as they once mastered handwriting and typing (or sewing and carpentry). Some students will be more talented than others, but nobody has to be an artist to accomplish the basic task. How well students deploy these skills for rhetorical effect is still a test of

intellectual mastery, assuming, of course, that the teacher cares as much about getting students to learn as about making them feel good about themselves—a question that has nothing to do with aesthetics.

The heightened importance of aesthetics does shift the rewards for certain abilities. Verbal aptitude faces competition from new media, which demand more from the traditionally gifted but also offer new opportunities for intellectual achievement. An insightful student who writes poorly may be able to produce an effective multimedia presentation, relying on nonverbal skills to convey his ideas. For those of us who value good writing, this shift at first seems like a loss. But that conclusion depends on what we assume as the alternative—a miraculous acquisition of writing skills or a failure to communicate altogether—and whether the class still demands that students learn the underlying facts and ideas.

Aesthetic skills are real skills. While not analytical, they nonetheless help us to perceive and understand the world. And, like advanced math for would-be engineers, they're essential prerequisites for students who might want to pursue design careers. A young industrial designer celebrates schools' heightened emphasis on aesthetics. "I think that young children are learning how to incorporate art with more traditional learning programs," she says, in response to a question about how education has changed since she was in school. "The system is more comprehensive and well-rounded. When learning about the Brooklyn Bridge, students not only learn the history, but engineering, drawing, literature, etc. When I was a kid, art was thought of as a fun elective, not an integral part of my education. Meanwhile, art training was the one thing I needed most."

If a science teacher accepts a diagram that contradicts Galileo, the teacher's ignorance, not the graphic design, is to blame. Galileo himself was not just a great scientist, mathematician, and writer but an accomplished draftsman who recorded his lunar observations in watercolors. Before romanticism declared art the province of a talented, bohemian few, drawing and painting were both common scientific tools and signs of personal refinement. Galileo used pictures as well as words to persuade. His work was smart *and* pretty.

The aesthetic imperative does not lower standards. Understood correctly, it raises them, bringing to the general public the skills, pleasures, and expectations once reserved for a courtly elite. Our challenge is to appreciate the added benefits of aesthetics, not to treat look and feel as sufficient in themselves. As David Hume observed in the eighteenth century, using *luxury,* the common term for the aesthetic pleasures then spreading to the urban middle class,

> *Luxury is a word of uncertain signification, and may be taken in a good as well as in a bad sense. In general, it means great refinement in the gratification of the senses; and any degree of it may be innocent or blameable, according to the age, or country, or condition of the person. . . . To imagine that the gratifying of any sense, or the indulging of any delicacy in meat, drink, or apparel, is of itself a vice can never enter into a head that is not disordered by the frenzies of enthusiasm. . . . These indulgences are only vices when they are pursued at the expense of some virtue, as liberality or charity; in like manner as they are follies when for them a man ruins his fortune and reduces himself to want and beggary. Where they entrench upon no virtue but leave ample subject whence to provide for friends, family, and every proper object of generosity or compassion, they are entirely innocent.*

Beauty is not a measure of goodness or truth, but neither is aesthetic pleasure a sure sign of decadence or a foolish waste of time. It is valuable on the margin, as one good among many. Aesthetics is pre-rational or nonrational, not irrational or antirational. Look and feel appeal directly to us as visual, tactile, emotional creatures, but they do not inevitably override our cognitive faculties, much less our sense of right and wrong. The fear that we'll get carried away, accepting a dumb but pretty world, is a worthwhile warning. Aesthetic abundance does pose that risk. But we will realize that fate only if we forget that aesthetics can be a complement to, not merely a substitute for, other values.

———————

The utopian-literature project suggests an interesting paradox. Only because the cost of moviemaking has dropped dramatically can a teacher even consider assigning students to produce a film. AVID software used to be too expensive for anyone but commercial operations (and it's still out of reach of most public schools, though less-expensive alternatives exist). Behind this aesthetic trend, as behind so many others, are falling prices. But today's cheap moviemaking still exacts a cost—those "eight days working on assembling visuals and manipulating software," time cut dramatically by Internet research and digital editing but still a significant investment. The relative cost of aesthetics is falling, making look and feel more prominent. But that cost isn't zero.

As consumers, whether paying customers or noncommercial onlookers, we enjoy the benefits of aesthetic investments. We've come to expect them. But those investments, whether for restaurant design or hair highlights, take time and money. And they don't necessarily return their costs in anything more than the audience's appreciation. In a competitive market, diners may not pay more to eat in a pretty restaurant. They just won't take their business next door. By bringing design to new areas or coming up with newly appealing styles, aesthetic innovators can reap rewards, as Motorola did with its green pager. But eventually their success inspires imitation, competing away most of their price premium.

When imitation is relatively easy and competition is intense, aesthetic benefits often go entirely to the consumer. Consider women's shoes. Embroidered and beaded shoes used to sell for luxury prices, no less than $100 a pair and usually more. They required skilled artisans to make, so moderately priced shoes couldn't cover the manufacturing expense. But in the late 1990s, automation drove down the cost of these adornments and improved their durability. Because sophisticated skills were no longer needed, the work could be done in cheap labor markets like China.

Did fancy shoemakers suddenly garner enormous profits? Not at all. The shoe business is far too competitive. Instead, embroidery and beads began to appear on shoes selling for $70 instead of $250. "Because the savings in labor costs are mostly passed on to the consumer," concludes a report on the industry, "profit margins are no greater on these shoes than on unadorned Mary Janes." Shoemakers have to hope that the new designs will lure people to buy more shoes, increasing total sales. As economists measure it, shoe industry productivity hasn't increased much, if at all. But the standard of living has gone up, because consumers can get more aesthetic value for the same price. The world may become more pleasing without becoming more profitable.

Much of the value created through aesthetics doesn't make it into the economic data that shape perceptions and policy. The problem isn't with the statisticians, who are neither careless nor incompetent. Intangible goods like aesthetics are inherently difficult to measure and count, especially if competition means their value isn't reflected in higher prices. Although government statisticians make some adjustments for easily measurable improvements like computer memory or car features, they would treat this season's $70 pair of embroidered women's dress shoes as the equivalent of last season's $70 pair of plain women's dress shoes. (Technically, they'd delete last year's shoes and add this year's as a new product, but the effect is the same.) If you're toting up national income or measuring consumer price increases, a $20 steak dinner at a beautifully designed restaurant is just like a $20 steak dinner in a warehouse environment.

Adjusted for inflation, the price of a movie ticket in 2001 was lower than in 1990 and much lower than its peak in 1971, yet sound systems and special effects are substantially improved. Holding other quality factors constant, moviegoers get more for their money today. The benefits of rising technical standards go to ticket buyers, not to the theaters or producers, so those benefits don't show up in economic statistics. A movie ticket is a movie ticket, as if nothing had changed.

If quality goes up while price stays the same, consumers get more

for their money. The real economy is more productive, and the real standard of living rises. But quality improvements without price increases usually don't affect economic statistics, or they appear only years after the higher standards have become common. These improvements also don't boost corporate profits and, hence, have no effect on measured productivity.

These errors wouldn't matter much if the gap between statistics and real life stayed the same over time—if the relation between rising quality and prices remained constant. In that case, the trends in the data would still give an undistorted picture. But if aesthetic quality is accelerating, along with other intangible advantages such as variety, the measurement problem gets progressively worse. We see quality increases everywhere but in the economic data. This "productivity paradox" has major implications for how we track economic progress.

Ignoring hard-to-measure quality improvements means overestimating inflation and understating growth. That can distort government policy. It may encourage the Federal Reserve to tighten credit more than economic growth justifies, fighting inflation that doesn't exist and potentially setting off deflation. The Fed, however, is free to add judgment to its decision making, allowing for statistical errors, and its economists are acutely aware of the measurement problems. Government spending programs, by contrast, tend to treat the data as perfect, automatically ratcheting up all sorts of payments based on official inflation statistics.

More important than the direct policy effects is the data's psychological effect. Incomes look stagnant even while living standards are rising. Since we so quickly become accustomed to higher aesthetic standards, we forget what things used to be like. We look at the official data and conclude we're poorer than we really are. Missing some of the economy's greatest advances, we believe pessimists who say progress has effectively ended. Or we focus all our optimism on flashy technology and miss the incremental improvements in everyday life.

The more we invest in aesthetics, the less productive the economy is likely to appear. Certainly there's no measure of the added value of

typeset résumés or PowerPoint slides—one reason such common communications tools seem frivolous to old-fashioned managers. But the investment isn't waste. Audiences expect the graphic quality today's software makes possible, even if that means spending more time on preparation. Turn in a typed résumé or use handwritten transparencies, and viewers are likely to infer an undesirable meaning. They'll think you're sloppy, or indifferent, or technologically clueless. What was once a luxury, or a strategic advantage, is now just a requirement to stay in the game.

This is true not just for places and things but for personal appearance. We have access to beauty technologies our forebears could only imagine. We may love the results, but all that self-improvement takes time as well as money, whether for dermatologist visits, gym workouts, or hair care. "The emphasis now on grooming for women in public life is just so intense," complains the literary critic Elaine Showalter, a "champion shopper" who writes often about fashion. "It takes forever. Clearly there are movie stars and models who do spend literally hours a day. Normal professional women do have to spend, I certainly do, an extremely prolonged amount of time doing all these things—the manicures and the pedicures, the hair streaking, all the *meshugas*, not to mention just the basic upkeep."

We want other people to look better and so wind up trying to look better ourselves, perhaps because we care about our appearance and enjoy the pampering, perhaps because we feel compelled to keep up with the competition. Resistance is futile, concludes a resigned Showalter. Escalating standards may be a pain to meet, but they reflect what people value and what we can now achieve. "There's no point in shaking your tiny fist at Revlon. It's not going to do a bit of good. You just have to deal with it," she says. "But I wish it could be handled more technologically—there should be pills for it."

In the early 1990s, doomsayers across the political spectrum fretted that the future would have no jobs for anyone but computer programmers and other select "knowledge workers." We were headed toward a "two-tier" society, warned archconservative Pat Buchanan on *Crossfire*, prompting agreement from his left-wing guest. "It's unrealistic to expect that eighty percent of the American public . . . are going to be reeducated and trained for the very elite, sophisticated scientific and technological jobs that are available," responded Jeremy Rifkin, author of *The End of Work*. These pessimists didn't count on the aesthetic imperative. They imagined an economy in which the only sources of value were physical or intellectual, not sensory or expressive.

Since most of us don't have the time or talents to master or manage every aspect of look and feel by ourselves, we increasingly contract out our aesthetic puzzles. Here, as in other fields, specialization allows each of us to concentrate on the things we do best or enjoy most, lowering costs and increasing quality. Turning once-amateur activities into professional pursuits pushes expectations higher and higher, since specialists are more proficient at their craft than generalists and get still better over time. "The notion now that a corporation of any size would have the CFO's wife design the annual report is ludicrous," says a design observer. "It's just ludicrous. But they did in the sixties."

Sewing and basic cabinetry were once tasks done inside the family. Today amateurs still make dresses or build furniture for fun or, occasionally, to save money. Most of us, however, buy our clothes and tables from commercial experts who provide higher quality for less time (in this case the time it takes to earn the money we pay them). Over the past couple of decades, the same sort of specialization has spread to a wide range of aesthetic tasks, from cooking and landscaping to hair coloring and manicures. Some of these jobs require years of professional education, while others take mostly on-the-job

experience. In many fields, from hairdressing to landscaping, the range of formal training—and of concomitant niches and pay—is enormous. Although it has room for surgeons and computer scientists, the aesthetic economy is in no way limited to "very elite, sophisticated scientific and technological jobs."

"What seems normal to me, and to most of the women I know, would still seem bizarre, not to say wicked, to our mothers' generation," writes a New York City journalist. "Imagine paying people to shop for you, walk your dog, clean your house, cook for you, color your hair, nails, face, toes, wax you, massage you, exercise you, tan you. On one admittedly spectacularly manic day, I calculated, guiltily, that it must have taken sixteen or seventeen other people to help me do all the things I needed to get done in that 24-hour period. Imagine! The trouble is that I can't imagine living without them."

Most of us still manage with fewer than sixteen helpers, but the demand for style experts and aesthetic workers is clearly exploding. Instead of spending precious weekends planting grass and pulling weeds, a couple of busy doctors hire a landscaping crew to give them a perfectly groomed front yard, delighting the neighbors and freeing their time for family activities. A television costume director and magazine stylist says she had so many calls to help outfit business executives that her assistant started a style-consulting business. A graduate-student friend looking for a special outfit wishes she could hire someone with impeccable fashion sense to take her shopping. If trends continue, in a decade that sort of expertise-for-hire will likely be common, even for grad students.

All those room-makeover TV shows are giving home owners do-it-yourself ideas. They're also revealing just how helpful interior designers can be and demonstrating that design consultants don't work just for rich people. And they make the profession look like fun, inspiring young viewers to consider design careers. "I have more eight-year-olds running up to me at the airport grabbing onto my legs," says a designer featured on The Learning Channel's *Trading Spaces*. "They're on fire for design."

The burgeoning demand for aesthetic expertise overturns the cul-

tural assumptions we've inherited from the romantics, who opposed art to technology and feeling to rationality; from the modernists, who treated ornament as crime and commerce as corruption; and from the efficiency experts, who equated function with value and variety with waste. In the age of look and feel, technology and art cooperate. The proliferation of commercial styles represents not waste and delusion but the affirmation of personal pleasures. This new era challenges all of us—designers, engineers, business executives, and the public at large—to think differently about the relation between surface and substance, aesthetics and value.

Designers have long lived in fear that people will think they're frivolous, treating their work as "pretty but dumb," denigrating their hard-won expertise, and putting them first in line for budget cuts. Nearly every definition of *design* starts by emphatically stating that the profession isn't just about surfaces. "People think that design is styling," says a design curator. "Design is *not* style. It's *not* about giving shape to the shell and not giving a damn about the guts. Good design is a renaissance attitude that combines technology, cognitive science, human need, and beauty to produce something that the world didn't know it was missing." In an all-too-common move, her correctly expansive view of design—design is not *just* style—slips into a defensive denigration of aesthetics—"design is *not* style."

On television, complains the magazine of the American Society of Interior Designers, "interior design shows' mission rarely goes beyond furniture, fixtures and finishes." The magazine's editors want the public to know that "interior design is more than decorating." It's "about making people feel comfortable and perform properly in their space." But the design that excites eight-year-olds in airports, and the adults along with them, is not the utilitarian problem solving that professionals so often assume is their sole source of legitimacy and prestige. In the age of look and feel, we want more than efficient rooms that make us "perform properly." We want styling, decoration, adornment. We want designers for all the pleasure-generating skills they take such rhetorical pains to deemphasize, as if they were engi-

neers and as if engineering were the only legitimate source of material value.

Functionality is, of course, important. Nobody wants a hard-to-navigate kitchen, another confusing "butterfly ballot," or a car with counterintuitive controls. But functionality can be a background quality rather than design's primary justification. Design provides pleasure and meaning as well as function, and the increasing demand for aesthetic expertise reflects a desire not for more function but for more pleasure—for the knowledge and skill to delight our senses. For designers, embracing the age of look and feel means dropping their defensiveness about the pleasures their work creates. Making things beautiful or interesting is as valuable, and necessary, as making things work.

Besides, making things beautiful can also make them work better. One of the most prominent advocates of "usability" in industrial design has recently become a proponent of more aesthetic design. Drawing on neuroscience research about how emotion affects performance, usability guru Donald Norman now advocates what he terms a "heretical" view: "Attractive things work better." Color computer displays don't add functionality to word processing or e-mail, for instance. But even profit-oriented business executives strongly prefer color, and they are willing to pay extra for it. That paradox intrigued Norman.

When color computer displays first came out, I knew that color didn't make a difference for stuff like word processing and e-mail. There were many scientific studies showing that color didn't matter for readability. You could read just as fast without it. I decided that I needed to understand this because more business people insisted on color. So I got myself a color display and took it home for a week. When the week was over, I had two findings. The first finding was that I was right, there was absolutely no advantage to color. The second was that I was not going to give it up.

The difference lay not in "information processing" but in "affect," in how full-color monitors made people feel about their work. By affecting neurochemicals in the brain, affective signals "change the parameters of thought," writes Norman, "adjusting such things as whether reason is primarily depth first (focused, not easily distracted) or breadth first (creative, outside-the-box thinking, but easily distracted)." Attractive design can reduce anxiety and enhance judgment, encouraging creative problem solving. Norman hasn't given up his demand for usability, of course; he's simply expanded the definition. "Let the future of everyday things be ones that do their job, that are easy to use, and that provide enjoyment and pleasure," he writes. We can demand that everyday objects be both smart *and* pretty.

As the rewards of aesthetic professions grow, they draw people who once might have pursued less expressive crafts. This shift causes some problems, since the world still needs plumbers, truck drivers, and accountants. Public policy professor Richard Florida recalls serving on a Pennsylvania economic development advisory panel in the 1990s:

> *At one of our meetings, the state's Secretary of Labor and Industry, a big burly man, banged his fist on the table in frustration. "Our workforce is out of balance," he steamed. "We're turning out too many hairdressers and cosmetologists, and not enough skilled factory workers" like welders and machine-tool operators to meet the labor market's needs. "What's wrong?" he implored the group.*

For someone accustomed to thinking of hairdressing as an effeminate, low-prestige profession, the mismatch is especially puzzling. Why would young people—especially men—want to style hair when they could bend metal? There must be something wrong with the schools.

But the mismatch reflects widespread preferences. For several years after this incident, Florida queried audience after audience, asking which they'd choose: a machine shop job with high pay and job

security or hairdressing with lower pay and more risk. "Time and again, most people chose the hair salon, and always for the same reasons"—flexibility, freedom from supervision, stimulation, creativity, and the immediate satisfaction of their customers' pleasure. "I suspect that similar motives drive many of the people who choose the hair salon in real life—as well as the growing numbers of young people who are 'good with their hands' but choose to wrap their hands around a tattooing needle, DJ turntable or landscaping tools rather than the controls of a turret lathe." The aesthetic imperative means those young people can find the jobs they prefer, and that those jobs will enjoy increasing prestige. It also means that hiring machinists could get a lot more expensive, and that factory work may need reorganizing.

In the age of look and feel, "creative" individuals no longer need to be isolated, romantic souls who've given up worldly success for the sake of their art. Their talents can be the essential complements to the skills of others. "We span the whole spectrum—people who are just engineers and couldn't draw a stick figure, and others who are talented artists and never used a computer before they came here," explains a movie studio's digital-effects head. "And in the middle are a few people working on shots who have a strong and deep understanding of the science and the software and the art." Those rare individuals who can do it all will naturally earn special rewards, but smart organizations don't need omnicompetent people in every spot. Rather, they build teams of people with diverse talents, including aesthetic skills.

This development poses cultural challenges of its own: How do artists, engineers, and business executives communicate without talking past each other? How willing is each group to give up the conviction that its approach is not merely appropriate for solving certain problems but the sole source of legitimate value and the morally superior way to live? After two centuries of portraying aesthetic expression as either irrational, antibourgeois rebellion or self-indulgent, feminine frivolity, how do we get used to a world in which aesthetics is both a major tool of rhetoric and a significant source of

economic value? Can we accept our visual, tactile nature without relinquishing our cognitive, tool-making side? Can we recapture the wisdom of the Renaissance, learning again to accept a world that is smart *and* pretty?

Specialization goes only so far in meeting the aesthetic imperative. No matter how many consultants you hire, personal appearance isn't something you can contract out like gardening or restaurant design. You can pay someone to paint your nails, color your hair, or wax your eyebrows, but they're still *your* nails, *your* hair, and *your* eyebrows. Specialists may do a better, faster job than you could, but you have to be there when they do it. Hence Showalter's cri de coeur: If technology can make embroidered shoes and typeset résumés cheap and easy, why can't it deliver personal beauty at a lower cost in time and money? *There should be pills for it!*

No form of aesthetics matters more to us than personal appearance, the most inescapable signal of identity. We are not just visual, tactile creatures; we are visible, touchable creatures, inextricably bound to the bodies others see us in. That human consciousness arises from and inhabits physical form is the great mystery and the fundamental reality of our existence. Our bodies are us. Yet our sense of self does not always match our physical form. Our bodies impose definitions and limitations that falsify our identities and frustrate our purposes.

Memoirist Barbara Robinette Moss is a dark-eyed brunette with pale, perfect skin, an oval face, and neat, symmetrical features. Looking out from the pages of a fashion-magazine interview, she seems completely at home. Yet her lovely, tranquil face is not the one nature decreed. "By the time I was thirteen, my face had grown askew," she writes.

> *The upper portion of my skull had become so long it forced my lower jaw back, allowing it no room to develop. My puffy, red upper gum line showed, and my upper teeth protruded so much*

that I couldn't touch my lips together. I could put my baby sister's
fist in my mouth without opening it, a game that made her laugh. . . .
I thought of my twisted face as a Halloween mask, hoping to toss
it aside. New faces are not easily acquired, though, and if your par-
ents have seven kids and live in poverty, it seems impossible.

In her late twenties, Moss had experimental surgery to change her looks. A teaching hospital covered the cost in exchange for permission to let medical students and a film crew follow the complex operation. Her father warned that Moss wouldn't recognize herself once the doctors finished cutting and moving her bones.

I'll recognize myself, I thought. I've always been right here,
underneath, like an underground spring. As I was wheeled into sur-
gery, a few months later, I told the doctor, "Just cut away every-
thing that's not me."

In an interview, Moss says she "always planned on discovering the face I have now. It was like wearing a concrete mask, then just chipping away until I got to the real face underneath. When I finally got my face, I knew it was mine." Some critics see in such dramatic surgical alteration "a thoroughly superficial identity that someone has built with a scalpel." But to the person who inhabits a once-false face, that scalpel-built identity is anything but superficial. It is a surface that finally matches the substance perceived from within.

Advancing biomedical technologies give us control over biological conditions our ancestors would have accepted as only natural. Some of these conditions meet the traditional criteria for disease, but many do not, at least not without contortions. Critics of plastic surgery rightly scoff at treating small breasts or big noses as the equivalent of asthma or diabetes. Moss's old face was unusual and ugly, the unwanted product of genetic bad luck, malnutrition, and medical neglect. But it was not, strictly speaking, diseased. Moss had had no accident and suffered no birth defect. By the time of her surgery, her functional limitations had already been repaired with braces and

headgear to improve her bite. She could have lived the rest of a normal, healthy life with her old face. But, in some important way, it wouldn't have been the real her. Her inner identity did not match her outer self. High-tech and artificial, aesthetic surgery let her claim her authentic face.

We unnecessarily torture the language when we insist that every undesirable biological condition must be called a disease in order to justify changing it. It is more accurate to say we are biological creatures whose consciousness defies the limitations of our form. Not all those limitations threaten life or cause physical pain. But that doesn't mean we don't want to alter them—to redesign our bodies for the sake of meaning and pleasure as well as function, to match our outer and inner selves. Indeed, no aesthetic technology is more welcome, or more potentially meaningful, than one that gives us greater control over our own looks, allowing us to align our bodies with our minds.

As much as we yearn for their powers, however, we often fear the march of beauty technologies. The more our bodies become subject to design—to willful aesthetic control rather than random chance—the more responsibility we face not only for who we are and how we act but for how we appear. That prospect can be exhilarating, but it is also scary. Most of us are not as desperate as Moss. We can live with our old faces, despite their flaws, as long as the rest of the world doesn't expect perfection. But what if standards keep rising? Are we doomed to spend all our time and energy in an impossible quest for beauty?

To understand why that all-consuming quest is an unlikely prospect, we have to separate two aspects of any aesthetic technology: what's possible and what it costs. Many aesthetic results are possible but uncommon, either because they're not desirable or because they're simply too difficult or expensive to justify in most circumstances. With little difficulty, you can have blue hair or, with contact lenses, red eyes. But most people don't want them. And just as not every public rest room has a marble floor, not everyone is up for plastic surgery. The gain is simply not worth the cost. Just because a change is medically possible won't make it pervasive. Cost matters, and so does desire.

It's easy to lose sight of how that balance operates. Both fans and critics tend to hype beauty technologies, treating them as more common than they are. In its annual "Age Issue," *Vogue* informs readers that an "ageless society" is here, courtesy of the plastic surgeon's scalpel:

> *Instead of a secret weapon of 50- and 60-year-olds, cosmetic surgery is now a beauty tool seized upon by their daughters. Instead of a painstaking means for serious repair, it is now an often relatively hassle-free method for upkeep, meticulous tweaking, and even age prevention. And instead of a luxury for the wealthy, it is sometimes considered a necessity for anyone with a decent income. . . . With cosmetic-surgery techniques safer, easier, and closer to foolproof— or so women think—the traditional markers of age are fast disappearing from the collective visage of American women.*

Vogue paints a misleadingly jolly picture, making surgical "tweaking" sound barely more complicated than manicures. We squeamish readers know better, which is why most of us aren't rushing to make "upkeep" appointments.

The costs that exasperate Showalter also limit our expectations. Most of us don't seriously consider plastic surgery, because it's painful, risky, time-consuming, and expensive. It's gross, and we can't even be sure we'll like the results. We're not going to spend our lives in anesthesia and recovery so surgeons can keep fixing our falling faces. Plastic surgery is more and more common, but it's hardly the norm. The costs—in pain, danger, and time, as well as money—are simply too high.

But suppose cosmetic surgery, or a substitute technology, really were "hassle-free"—as painless, low risk, inexpensive, reliable, and correctable as hair coloring. Our reactions would surely change. When fixing physical flaws is safe and easy, even people who care only a little about their looks will do it, because doing so requires sacrificing very little else. As costs drop, artifice begins to turn aesthetic have-nots into haves. Good teeth and clear skin used to be the

unusual markers of exceptional beauty. Now they're the signs only of normal care and attention. Poverty still leaves its marks, as it did on Moss, but even those are often reparable. Technology and commerce bestow beauty more equally than fate. Give us a way to be smart *and* pretty, and we'll take it.

The cheaper and easier aesthetic technologies get, the more we use them. At the same time, however, those falling costs keep look and feel from crowding out all other values. We may be able to have more of everything, especially if incomes are rising. But even in a less optimistic case, we can have a lot more aesthetics in exchange for just a little less of other things. The age of look and feel is a product of those shifting relative costs. As a result, the aesthetic imperative does not consume us. We don't wind up spending all our time and attention on appearances.

Unless, of course, we want to. Just as athletes and intellectuals lead unbalanced lives by the standards of those with other priorities, so some people find enormous meaning and pleasure in personal beauty. A marketing executive and part-time swimsuit model says she happily gave up brainy Washington, D.C., for Miami's high-maintenance South Beach culture of tanning, teeth bleaching, and cosmetic-surgery touchups. "She feels she must be beautiful—svelte, taut, curvaceous, tanned and expensively styled—to belong in this community where striking beauty is common," recounts a reporter. She doesn't mind the effort, or the shallowness of the culture. South Beach suits her. "Like so many other people here, she loves walking into it, competing, posing."

With their single-minded focus on appearance, the denizens of South Beach make a disturbing cultural model. To people with other values and interests, they seem boring and superficial. A society dominated by such people would quickly stagnate. Even the progress of beauty technologies depends on people who care about something more enduring than partying and looking good: surgeons, chemists, computer programmers, dental researchers, and many others. But the beautiful people of South Beach don't represent the future, at least not for most of us. They're just a subculture, a specialized niche made

up of those who care about beauty not merely on the margin but first and foremost. These folks aren't waiting for Showalter's time-saving beauty pills.

One of our greatest anxieties about beauty technologies, however, is not that they'll be too dangerous, exclusive, expensive, or time-consuming—and thus limited to South Beach enthusiasts—but that they'll be too safe, prevalent, and cheap. Everybody will use them, and we'll all wind up looking the same. To stoke fears of genetic medicine, *WorldWatch* magazine created a cover montage of naturally brunette people—an Amazonian child, a sari-clad woman, an African-American boy, and so forth—with bright blue eyes. The message was clear: If changing eye color becomes too easy, people will alter what nature decrees. The world will get weird and homogeneous. Everybody will have blue eyes.

To the disgust of its opponents, genetic medicine promises not only better health but more aesthetic control, even without the prenatal modifications that are so controversial. Within a decade or two, it's quite possible we'll be able to build our muscles, cure our baldness, or lighten and darken our skin with gene therapy. Unlike the genetic engineering that would alter a person's genetic makeup before birth, gene therapy seeks to change the cells of an already-living person. People with hemophilia or cystic fibrosis, for instance, might be cured by inserting genes that change their blood or lung cells; the genes they pass on to their children would remain unchanged. Although these disease treatments themselves are still in the future, and other sorts of gene therapy may be even further off, a leading geneticist predicts that cosmetic gene therapy will "spread like wildfire" once it's affordable and effective.

The more power we achieve over how our bodies look, whether through genetics, surgery, drugs, or other means, the more we will alter our outer selves to match our inner selves. But as long as those biological decisions are up to individuals themselves, it's foolish to dread a uniformly blue-eyed world. Plenitude and self-expression are as central to the age of look and feel as the pleasures of universal forms. We want to look good but also to look special, to incorporate

both the beauty of aesthetic universals and the markers of unique identity. We don't all dress the same. Why would we all want the same color eyes?

The age of look and feel works against a single aesthetic standard—whether for persons, places, or things—because the aesthetic imperative itself has emerged from pluralism and the individual pursuit of happiness and meaning. Most people prefer clear skin, but we like it in many different shades. Some of us even want tattoos. Blond hair is cheap and easy already, and, as a result, has become far more common. But the world is still full of brunettes, redheads, and the occasional person with green or blue hair. What is vanishing is not diversity but gray hair, the mark of age, and even that is unlikely to disappear altogether.

When aesthetic choices are left to individuals, we wind up with variety, because tastes and identities differ. The particular mix itself changes over time, as the desire for novelty keeps any single style from becoming permanent. If cosmetic genetic therapy ever does spread like wildfire, we can expect it to come in a reversible, or changeable, form. Permanent aesthetic modifications are rarely as popular as temporary ones. Reversibility not only lowers risks. It allows for fashion.

Every cultural and economic change produces the same fundamental fear: that in the unknown future, there will be no place for people like me, or for the things I value. The rise of look and feel is no different. We worry that South Beach will take over the world, that no one will have pale skin or brown eyes, that everyone will need a knack for art, that pictures will displace writing, that nobody will value the diligent but disheveled, the kind but plain. We worry that we'll sacrifice contemplation to sensation, function to form.

"The fashionistas don't write books you can refute. They don't quote Rousseau," David Brooks warns his fellow conservative intellectuals. "But if their world becomes the whole world, pretty soon we'll all be changing scarves and looks and personalities every six

months in desperate competition for attention and cool. The trivial will crowd out the eternal." We're afraid there will be no place for philosophers, for statesmen, for nerds. Everyone will have to be cool. No one will have to think.

In his 1986 short story "The Beautiful and the Sublime," Bruce Sterling imagines a near future in which artificial intelligence has become so powerful, ubiquitous, and cheap that rational thought is no longer considered a particularly human activity. Business, science, and engineering are out. Art, emotion, and grand gestures are in. "Feeling—perception, emotion, intuition, and taste—these are the indefinable elements that separate humanity from the shallow logic of our modern intelligent environment." The iconoclasts who persist in applying rational analysis to invent new things are as countercultural and impoverished as bohemian artists once were, and just as frustrated. "Damn it," says one, "Claire and I build things, we shape the world, we try for real understanding! We don't just do each other's nails and hold hands in the moonlight!"

If the age of look and feel meant nothing but manicures and moonlit strolls, many of us would have reason to worry. But the evidence suggests just the opposite. The aesthetic imperative requires integrating art and science, emotion and cognition, not tossing out rationality to embrace feeling. GE Plastics can't offer thirty-five thousand colors without a lot of precise chemical engineering and financial analysis, and its customers would have no use for colorful plastic without chip designers, mechanical engineers, and assembly-line workers. The proliferation of typefaces, the new shapes of automobiles, the distribution of high-style furnishings, and the falling prices of Christmas lights depend on software and logistics that taste and emotion could never create. The age of look and feel runs on specialization. By tapping the talents and skills of diverse people, it allows us all to enjoy a world that's both smart and pretty. We benefit from the knowledge and strengths of others.

The aesthetic age won't last forever. The innovations that today seem exciting, disturbing, or both will eventually become the backgrounds of our lives. We won't notice them unless they're missing.

Like convenience or hygiene, instant communication or rapid trans-
portation, look and feel will simply be part of modern, civilized life.
We'll assume they were always there, like indoor plumbing or
recorded music—that we couldn't possibly have lived without their
pervasive presence.

New styles and new aesthetic technologies will continue to devel-
op, of course, and old ones to evolve or improve, but at some point
aesthetics will no longer be the frontier. When we decide how next to
spend our time, money, or creative effort, something else will top our
priorities. Something else will disturb the familiar ways of business
and culture. Something else will challenge our conventional notions
of "real" value. That something else may be radically new, the prod-
uct of currently far-fetched technologies. It may be a major improve-
ment in an existing good—a faster, cleaner form of transportation, an
instantaneous mode of manufacturing. It may be as ancient as story-
telling or exploration.

The age of look and feel will eventually pass. But its products and
discoveries will endure. The paradox of aesthetics is that it is at once
trivial and eternal. Look and feel exist in every human time frame,
from the ephemeral to the millennial. "If there's anything we've rec-
ognized, it's that what endures is not anything material," declared a
fashion editor after September 11.

> *Objects and belongings can be beautiful or emotionally impor-
> tant, and as time passes, those things will once again be something
> to celebrate. But I was particularly struck by newspaper stories
> about the residents living near the World Trade Center. In the days
> after the attack, they were given permission to go to their homes to
> retrieve what was important to them. Some took animals, but many
> took nothing, realizing as they stepped through the ruins that they
> already had with them what mattered most: a life to be lived.*

She is right. Without a life to be lived, look and feel have no pur-
pose or meaning. They don't matter apart from our subjective expe-

rience of their satisfactions. Look and feel are material. They aren't transcendent. Their value depends on us.

But she is also wrong. On the very same page, designer Karim Rashid argues that the material is what lasts:

> *What really endures are artifacts, effigies, things that speak about a time, place or civilization. When people say to me that everything seems trivial or meaningless, I believe the opposite. Objects outlive us, and they are the symbols of our culture and history.*

We have the pots, jewelry, and wall decorations of our ancient ancestors, and a few of their stories. We know nothing of the joys and sorrows of their family lives and care little for their political intrigues. Their faiths have disappeared or changed utterly; their science has been superceded. The things that mattered most to them have vanished. What remains is the superficial. It is how we know them. And when we too are dust, our descendants will have Rashid's curvy plastic trash cans.

"Every object in one's life," concludes the designer, "should bring heightened meaning, pleasure or function, or there is no need for it." How we choose says something about who we are, to the present and to the future. We know the world through our senses and, despite our many protests to the contrary, through our senses we imbue our world with value. We can reject aesthetics in the mistaken belief that it cannot coexist with other values. We can, on the same assumption, let style consume us. Or we can enjoy the age of look and feel, using surfaces to add pleasure and meaning to the substance of our lives.

NOTES

Preface

ix As soon as the Taliban fell Dexter Filkins, "In a Fallen Taliban City, a Busy, Busy Barber," The New York Times, November 13, 2001, p. A1. "In Kabul, Hooray for Bollywood," Newsday, December 27, 2001, p. A12. Carol J. Williams, "Afghans Dust Off Long-Hidden Yen to Have Fun," Los Angeles Times, December 17, 2001, p. A3. Carol J. Williams, "The Beauty Shop Beckons in Post-Taliban Kabul," Los Angeles Times, December 15, 2001, p. A1. Barry Bearak, "Kabul Retraces Steps to Life Before Taliban," The New York Times, December 2, 2001, p. A1. Yannis Bechrakis, Reuters photographer, e-mail to the author, November 27, 2001.

ix When a Michigan hairdresser Debbie Rodriguez, quoted in David M. Halbfinger, "After the Veil, a Makeover Rush," The New York Times, September 1, 2002, sec. 9, p. 1.

x "The right to shave" Tunku Varadarajan, "Liberation Time," Opinion Journal, November 17, 2001, http://www.opinionjournal.com/columnists/tvaradarajan/?id=95001482.

x "How depressing was it" Anna Quindlen, "Honestly—You Shouldn't Have," Newsweek, December 3, 2001, p. 76.

xi *"a great simulacrum"* Jon Jerde, quoted in Ed Leibowitz, "Crowd Pleaser," *Los Angeles Magazine*, February 2002, p. 52.

xii *A conservative journalist . . . a liberal social critic* Rod Dreher, "Urban Jungle Gym," *The Washington Times*, August 23, 1993, p. C1. Norman M. Klein, "A Glittery Bit of Urban Make-Believe," *Los Angeles Times* (Valley edition), July 18, 1993, p. B17.

xii *Suddenly CityWalk was full"* Richard Kahlenberg, "The City on the Hill," *Los Angeles Times* (Valley edition), May 23, 1993, p. B15.

xii *the most vital public space"* Ed Leibowitz, "Crowd Pleaser," p. 50.

xiii *"It's a very special building"* Frans Mudzugu, quoted in Matt Steinglass,"Little Italy," *Metropolis*, October 2002, pp. 66–70. Steinglass is the Togo-based critic.

xiv *"It's a big drawing"* Timothy Clifford, "Notebook: 'It's a Big, Big Story When You Find a Michelangelo,'" *Scotland on Sunday*, July 14, 2002, p. 3. Also Timothy Clifford, "A Candelabrum by Michelangelo," *Apollo*, September 2002, pp. 30–40. Peter Katel, "The Mystery in Box D366," *The Washington Post*, October 13, 2002, p. W16.

xiv *"Renaissance artists of the highest caliber"* Sarah Lawrence, director of the Cooper-Hewitt's master's program in the Decorative Arts, quoted in Katherine Roth, "Rare Michelangelo Drawing Discovered in Back Room of NYC Museum," Associated Press, July 9, 2002.

Chapter One: The Aesthetic Imperative

2 *"Aesthetics, or styling"* Peter Wahsner, interview with the author, January 23, 2001. Other interviews on Selkirk trip with Greg Quinn, ColorXpress leader; Keith Dunlap, marketing development manager for Visualfx; Kristine Esposito, manager, Innovation Center; Themis Pantazis, marketing communications program manager; David Perilstein, public relations consultant.

3 *"15 percent to more than 100 percent higher"* Keith Dunlap, e-mail to the author, January 30, 2001.

3 *"The sky's the limit"* James S. "Jay" Pomeroy, manager, global public relations, interview with the author, July 19, 2002.

3 *Kyocera's mobile phone* George Anders, "Hard Cell," *Fast Company*, May 2001, p. 116. The engineer quoted is Gary Koerper.

4 *Squishy "soft-touch" plastics . . . "I love the smell . . ."* Keith Dunlap, interview with the author, January 23, 2001. In July 2002, the company announced its "softfx" program, which matches silicone elastomers

from GLS Corp. with GE Plastics products so that, for instance, a power drill whose handle is diamond-effect hard plastic can have a matching rubberized grip. Jay Pomeroy, interview with the author, July 19, 2002. Keith Dunlap, e-mail to the author, July 18, 2002.

5 *"We are by nature"* David Brown, interview with the author, November 9, 2000.

5 *"quirky underside"* Martin Eidelberg, quoted in Linda Hales, "When Designs Delight," *The Washington Post*, November 12, 1998, p. T12.

6 *As a midcentury industrial designer* Harold Van Doren, *Industrial Design: A Practical Guide to Product Design and Development*, 2nd ed. (New York: McGraw-Hill, 1954), p. 166.

7 *"the power of provocative surfaces"* Stuart Ewen, *All Consuming Images: The Politics of Style in Contemporary Culture* (New York: Basic Books, 1988), p. 22.

7 *"making special"* Ellen Dissanayake, *Homo Aestheticus: Where Art Comes From and Why* (Seattle: University of Washington Press, 1992, 1995), p. 56.

8 *"Aesthetics, whether people admit it . . . "* Dave Caldwell, quoted in Vikas Bajaj, "Electronic Manufacturers Emphasize Form with Function," *The Dallas Morning News*, April 4, 2002, p. 5D.

8 *"Deciding to buy an IBM"* Heidi Pollock, "How to Buy a Computer, Part I," iVillage, http://www.ivillage.com/click/experts/goodbuygirl/articles/0,5639,38862,00.html.

8 *A Salt Lake City grocery shopper* Deborah Moeller, e-mail to the author, December 27, 2001, and interview with the author, April 8, 2002.

8 *A political writer* Michael Barone, interview with the author, April 8, 2002.

9 *"Good Design is not about the perfect thing"* David Kelley, founder and CEO of IDEO, quoted in Aaron Betsky, "When 'Good Design' Goes Bad," *Metropolitan Home*, November/December 2000, p. 128.

9 *"The role of design is to make life enjoyable"* Yogen Dalal, AIGA Risk/Reward Conference, October 7, 2000.

9 *Contrary to some assertions* On roughness, see David Brooks, *Bobos in Paradise* (New York: Simon & Schuster, 2000), pp. 82–83, 92–93. On smoothness, see Mark Kingwell, "Against Smoothness," *Harper's Magazine*, July 2000, pp. 15–18.

9 *"Beauty is now proclaimed"* Joel Garreau, "The Call of Beauty, Coming in Loud & Clear," *The Washington Post*, February 19, 2002, p. C1.

10 *"The consumer is a chameleon"* Kimberly Long, leading stylist at
 Procter & Gamble, quoted in Veronica MacDonald, "The Hair Care
 Market," *happi: Household & Personal Products Industry*, December
 2000, p. 12.

10 *Hartmut Esslinger* Owen Edwards, "Form Follows Emotion," *Forbes
 ASAP*, November 29, 1999, pp. 237–38.

10 *"Mass production offered millions"* Bruce Sterling, "The Factory of the
 Future," *Metropolis*, August/September 2002, p. 139.

11 *What if someone didn't like the fixed way* Michael Maccoby speech,
 Applied Brilliance Conference, June 8, 2000. Now a Harvard Business
 School professor, Maccoby was the *Crimson* reporter.

11 *Typographers win awards* A reference to the work of Stephen Farrell
 and Pablo Medina, both featured in the Cooper-Hewitt, National
 Design Museum's National Design Triennial. See Steven Skov Holt,
 Ellen Lupton, and Donald Albrecht, *Design Culture Now* (New York:
 Princeton Architectural Press, 2000), pp. 36–37, 142–43.

11 *"When we started American Elle"* Gilles Bensimon, quoted in "Fifteen
 Years of Fashion," *Elle*, September 2000, p. 112.

11 *"fashion options, as opposed to mandates"* David Carr, "Magazine
 Imitates a Catalog and Has a Charmed Life, So Far," *The New York
 Times*, September 16, 2002, p. C1.

11 *"I thought there was room"* James Truman, editorial director of Condé
 Nast, quoted in David Carr, "Magazine Imitates a Catalog and Has a
 Charmed Life."

12 *A furniture executive talks* Philip Alter, vice president of merchandis-
 ing at Frontera and Frontera.com, quoted in Lisa Martin, "New
 Interiors Blend Comfort and Culture," *The Dallas Morning News*,
 October 13, 2000, p. G1.

12 *The French interiors magazine* "Customisation maison," *Maison
 Française*, October 2000, p. 35. Translation by the author.

12 *"differences with depth"* Grant McCracken, *Plenitude* (Toronto:
 Periph.: Fluide, 1997), p. 23.

13 *"Instead of finding a style"* Lara Hedberg, "From the Robie House . . .
 To Our House," *Dwell*, October 2000, p. 10.

14 *"We think of ourselves as Modernists"* Karrie Jacobs, "The Fruit Bowl
 Manifesto," *Dwell*, October 2000, pp. 15–16. Adolf Loos, "Ornament and
 Crime," in *Ornament and Crime: Selected Essays*, ed. Adolf Opel, trans.
 Michael Mitchell (Riverside, Calif.: Ariadne Press, 1998), pp. 167–76.

14 *Target introduces a line* Dave Gerton, buyer for home décor, Target, speech, Industrial Designers Society of America 1999 Design Conference, July 16, 1999. Gaile Robinson, "Architect Is Best-Known for Target Toilet Bowl Brushes," *Contra Costa Times*, December 23, 2000, p. C-6.

14 *credit cards* Judy Tenzor, American Express, interview with the author, December 2000. Brooke White, Nordstrom, interview with the author, April 25, 2000.

15 *"We're seeing design"* Mark Dziersk, interviews with the author, July 15, 1999 and April 11, 2002. The 32 percent figure comes from an IDSA survey.

15 "Design has become the public art" Steven Skov Holt, quoted in Charles Gibson, "A View of Tomorrow: Everyday Objects Designed for Consumers to Need and Actually Enjoy," ABC World News Tonight, March 10, 2000, http://www.abcnews.go.com /onair/CloserLook/wnt_000310_CL_design_feature.html.

15 *A Time cover story* Frank Gibney Jr. and Belinda Luscombe, "The Redesign of America," *Time*, March 20, 2000, pp. 66-75.

15 *"The Style Wars"* Gina Leros, "The Home Front," *SundayLife! The Sun-Herald Magazine*, November 12, 2000, pp. 8–10.

16 *"very dynamic, and hungry"* Nazli Gonensay, quoted in Amy M. Spindler, "The Empire Strikes Back," *Fashions of the Times* (*The New York Times Magazine*), February 25, 2001, pp. 174–77.

16 *"the real international capital of fashion"* Amy M. Spindler, "Do You Otaku?" *Fashion of the Times* (*The New York Times Magazine*), February 24, 2002, pp. 134–36. See also Rebecca Mead, "Shopping Rebellion," *The New Yorker,* March 18, 2002, pp. 104–11.

16 *As recently as 1970* Historic figures from David Brown, interview with the author, November 9, 2000. Current numbers from Core77.com and Sensebox.com listings. Core77 covers design in general, while Sensebox is specifically concerned with graphic design.

16 *the South Korean government* Nho Joon-hun, "Design Korea Campaign Kicks Off," *The Korea Times,* October 11, 2001, http://www.hankooki.com/kt_tech/200110/t2001101116554645110.htm.

16 *Even Italy* Karim Rashid, e-mail to Tim Duggan, December 27, 2002. Current numbers from Core77.

16 *Since 1995, more than forty* Karim Rashid, e-mail to Tim Duggan, December 27, 2002.

17 *"And 1,350 lived"* David Brown interview.

17 *There are about 150,000 graphic designers* Ric Grefé, e-mail to the author, January 18, 2001.

17 *Worldwide, at least fifty* David Brown interview.

17 *"There's no such thing as an undesigned"* Michael Bierut, interview with the author, November 11, 2000. Bierut's term as president of the AIGA board ran from 1999 to 2001.

18 *When he came to Palo Alto* Pierluigi Zappacosta, interview with the author, September 27, 2000.

19 *"Black-Eyed Pea used to be"* Paul Jankowski, interview with the author, October 24, 2001.

19 *"Design is everywhere"* David Brown remarks, AIGA Risk/Reward Conference, October 7, 2000.

20 *libraries, even churches* Michael A. Lindenberger, "Libraries Shed Bookish Image," *The Dallas Morning News*, February 6, 2002, p. 1A. Tom Greenwood and Rick del Monte, interviews with the author, April 2, 2002. Virginia Postrel, "Come All Ye Faithful," *D Magazine*, July 2002, pp. 47–50.

20 *The company employs scores of designers* Brooke K. McCurdy, director, business development, Starbucks, interview with the author, August 23, 2000.

20 *"Every Starbucks store"* Howard Schultz and Dori Jones Yang, *Pour Your Heart Into It: How Starbucks Built a Company One Cup at a Time* (New York: Hyperion, 1997), p. 252.

20 *Within a generation* Julie Taraska, "All the Pretty Truck Stops," *Metropolis*, November 1999, pp. 120–24, 153, 155. Phil Patton, "Turnpike Stops Worth the Trip," *The New York Times*, July 27, 2000, p. F9. Rick Marin, "Behind the 'M' and the 'W,'" *The New York Times*, August 2, 2000, p. B11. Ray A. Smith, "Self-Storage Centers Put On a Prettier Face," *The Wall Street Journal*, April 10, 2002. Sam Gaines, special projects editor, *Plant Sites & Parks* magazine, e-mail to the author, January 10, 2001. Kenny Kahn, vice president, marketing, Muzak, speech, AIGA Risk/Reward Conference, October 8, 2000.

20 *"immersive environments"* Tim Kelley, "The More Things Change," *Innovation*, Summer 1999, p. 35.

21 *"We had to go to a little iron shop"* Hilary Billings speech, AIGA Risk/Reward Conference, October 7, 2000.

21 *"Crate and Barrel changed the world"* David Brown interview.

21 *In a 1976* Vogue *article* Chessy Rayner, quoted in "Rich Kids' Compound," *Vogue*, January 1976, pp. 96–97. Chris Lohmann, vice president, fixtures marketing, Kohler Co., interview with the author, January 16, 2001. Queena Sook Kim, "The Super-Model Home," *The Wall Street Journal*, August 6, 2002, p. D1.

21 *Home-improvement shows are booming* Steve Thomas of *This Old House*, quoted in Alec Foege, "Fix-It Fixation," *MediaWeek*, July 15, 2002, pp. 21–26. "Night and Day," *ASID Icon*, August 2002, pp. 12–16. Jeannine Stein, "Inside 'Trading,'" *Los Angeles Times,* September 26, 2002, sec. 5, p. 1.

22 *Membership in the American Society of Interior Designers* Michelle Snyder, ASID public relations manager, e-mail to the author, November 11, 2002.

22 *"buying for aesthetics, not collecting"* Richard Lazarus, senior vice president for business development, Eyestorm, quoted in William L. Hamilton, "Wall Décor: It's on the Wall, It's in a Frame, but Is It Art?" *The New York Times*, March 8, 2001, p. B1.

23 *Starwood Hotels & Resorts* Richard L. Martini, senior vice president, design and construction, Starwood, interview with the author, October 13, 2000.

23 *"If Americans are going to spend"* Edward Rendell, quoted in "Redeveloped Airports Welcome Travelers to Cities," *World Airport Week*, November 16, 1999, pp. 1–3.

24 *"The original shopping centers"* Carl Hagelman, senior vice president of planning and design, Taubman Company, interview with the author, June 6, 2001.

24 *The goal, says the mall's manager* Laurel Crary, interview with the author, May 31, 2001.

24 *In a 2001 report titled* Chris Warhurst and Dennis Nickson, *Looking Good, Sounding Right: Style Counselling in the New Economy* (London: The Industrial Society, 2001), pp. 12–15, 34.

25 *StyleWorks, a New York–based* StyleWorks Web site, http://www.styleworks.org.

25 *For the first time ever, the Gallup Organization* Gallup News Service, "Who Is Better Looking—Bush or Gore?" August 29, 2000.

25 *Contemplating the politics of cuteness* Hank Stuever, "A Really Hot Date: Come Nov. 7, What It All Boils Down to Is: Who's Cuter?" *The Washington Post*, October 23, 2000, p. C1.

25 *"glamour spiral"* Matt Drudge, "Sen. Plain Jane: Hillary Caught in Glamour Spiral," January 29, 2001, http://www.drudgereport.com/hrc3.htm. Also Lloyd Grove, "The Reliable Source," *The Washington Post*, February 2, 2001, p. C3.

25 *"The underlying topic"* Albert Morris, "Bald Truth of Blair's Follicle-Rich Triumph," *The Scotsman*, June 16, 2001, p. 19.

25 *"a fetus in a suit"* Andrew Sullivan, "What Has Become of William," *The New York Times Magazine*, May 20, 2001, p. 46.

26 *"He's losing it pretty rapidly"* Bob Roberts, "Iain Duncan Smith: Tony Blair Is Losing His Hair Pretty Rapidly and He Brushes It Like a Teased Weetabix," *The Mirror*, August 18, 2001, p. 19.

26 *German chancellor Gerhard Schroeder* Peter Finn, "Court: Stay Out of Schroeder's Hair," *The Washington Post*, May 18, 2002, p. A20.

26 *"The chic-est man on earth"* Booth Moore, "Afghan Leader's Wardrobe Honors a Diverse Nation," *Los Angeles Times*, February 1, 2002, sec. 5, p. 1.

26 *"the bloom of an American lady is gone"* Thomas Hamilton, who traveled to the United States in the 1830s, quoted in Arthur Marwick, *Beauty in History: Society, Politics, and Personal Appearance c. 1500 to the Present* (London: Thames and Hudson, 1988), p. 189.

26 *"personable"* Arthur Marwick, *Beauty in History*, pp. 338, 182.

27 *"Looks sell books"* Linton Weeks, "Judged by Their Back Covers," *The Washington Post*, July 2, 2001, p. C1.

27 *"gorge factor"* Fiachra Gibbons, "The Route to Literary Success: Be Young, Gifted But Most of All Gorgeous," *The Guardian*, March 28, 2001, p. 3.

27 *The number of nail salons* Nails Fact Book 2001–2002, p. 40. The number of salons rose from 26,752 in 1991 to 49,462 in 2001. The number of manicurists, "practicing nail techs," jumped from 113,934 in 1991 to 328,342 in 2001.

27 *The market for skin-care "beauty therapists"* Datamonitor, "The Lure of the Beauty Salon: Vanity is now worth £900 m," press release, October 25, 2000.

28 *Nearly three-quarters of middle-aged women* AARP Research and Roper Starch Worldwide Inc., *Public Attitudes Toward Aging, Beauty, and Cosmetic Surgery* (Washington: AARP, 2001), pp. 38–43.

28 *U.S. hair coloring sales* Information Resources Inc. data, including sales from supermarkets, drugstores, and mass merchandisers excluding

Wal-Mart. With Wal-Mart, the largest mass merchandiser, sales would be significantly higher.

28 *Sixty percent of the women in Japan* Thomas Fuller, "A Fashion Twist: Asians See Hair to Dye For," *International Herald Tribune*, May 26, 2001, p. 1.

28 *"Hair-dyeing used to be driven"* Yoshitsugu Kaketa, vice president and manager of the consumer products division of Nihon L'Oreal K.K., quoted in Taiga Uranaka, "Japan Train Stations No Longer a Sea of Black Hair," *The Japan Times*, June 19, 2002.

28 *"The two biggest changes"* Ritsuko Tsunoda, an analyst at Merrill Lynch in Tokyo, quoted in Sharon Moshavi, "In Japan, the 'Do' Does It," *The Boston Globe*, July 22, 2001, p. A12.

28 *"just one of the many attractive ways"* Anne Hollander, "Is It Real, or Is It Clairol?" *Slate*, July 7, 1998, http://slate.msn.com/?id=3107.

28 *Clairol aims its Herbal Essences* Allison Fass, "Clairol Tones Down a Campaign in an Effort to Give Its New Hair Products a Separate Personality," *The New York Times*, June 25, 2001, p. C8. Executive quoted is Elizabeth Kenny, senior director of marketing for hair color.

29 *"about breaking the rules of hair color"* Barbara White-Sax, "Color Power," *Supermarket News*, April 30, 2001, p. 39. The youth-oriented brand was a smash hit, shooting almost immediately to fourth in sales among hair colors, an unusually successful debut.

29 *Teen boys in the United States spend* Jenni Smith, "Beauty Kings: Styling-Product Firms Targeting Teenage Boys," *The Dallas Morning News*, October 22, 2000, p. 1A. Statistic is from Teen Research Unlimited.

29 *"I have this mousy brown hair"* David Graham, "Message in a Bottle," *The Toronto Star*, December 28, 2000, Life section, p. J6.

29 *A Brisbane, Australia, salon owner* Fadi Haddad, quoted in Richard Keely and Dominique Jackson, "Boy, It's a Look To Dye For," *The Australian*, January 19, 2001, p. 13.

29 *"Buff Revolution"* Jonathan Rauch, "Buff Enough?" *Reason*, November 2000, pp. 59–61.

29 *a magazine headline* Michelle Cottle, "Turning Boys Into Girls," *The Washington Monthly*, May 1998, pp. 32–36.

29 *"ornamental culture"* Susan Faludi, *Stiffed* (New York: William Morrow, 1999), p. 35.

30 *From 1992 to 2001, the number of patients* American Society of Plastic

Surgeons, "2001 Cosmetic Surgery Trends: 1992, 1998, 1999, 2000, 2001," fact sheet. These totals include both surgical and nonsurgical procedures, such as Botox injections.

30 *Sixty percent of American women* AARP Research, *Public Attitudes Toward Aging, Beauty, and Cosmetic Surgery*, pp. 60–63.

30 *U.S. and Canadian orthodontists claimed* American Association of Orthodontists fact sheet.

30 *"The dental profession's traditional domain"* Jeff Morley, D.D.S., "The Role of Cosmetic Dentistry in Restoring a Youthful Appearance," *The Journal of the American Dental Association*, August 1999, pp. 1166–72.

30 *"are primed to be the next deodorant"* Seth Stevenson, "The Great Whitening Way," *Slate*, April 1, 2002, http://slate.msn.com/ ?id=2063524.

30 *Doctors declare teenage acne scars* American Association of Dermatologists, "Treatment the Key To Eliminating the Physical and Emotional Scars of Teenage Acne," press release, October 18, 2000.

30 *In 2001, more than 111,000 Americans* American Society of Plastic Surgeons, "2001 Age Distribution: Cosmetic Patients," fact sheet.

30 *"Now, if you have some bad acne . . . "* Patrick Wen, "They've Got the Look: New Medical Devices, Drugs Help Ease the Awkward Age," *The Boston Globe*, September 15, 2000, p. A1.

31 *"long-standing anthropological conviction"* Grant McCracken, *Plenitude 2.0*, beta version, http://www.cultureby.com, p. 26.

31 *"Why were there no serious books . . . "* Penny Sparke, *As Long As It's Pink: The Sexual Politics of Taste* (London: Pandora, 1995), p. viii.

31 *"the new term for an overflowing wardrobe"* Elaine Showalter, "Fade to Greige," *London Review of Books*, January 14, 2001, http://www.lrb.co. uk/v23/n01/show01_.html.

32 *good-looking people earn more* Daniel S. Hamermesh and Jeff E. Biddle, "Beauty and the Labor Market," *The American Economic Review*, December 1994, pp. 1174–94. Jeff E. Biddle and Daniel S. Hamermesh, "Beauty, Productivity, and Discrimination: Lawyers' Looks and Lucre," *Journal of Labor Economics*, 1998, pp. 172–201. Ciska M. Bosman, Gerard A. Pfann, Jeff E. Biddle, and Daniel S. Hamermesh, "Business Success and Businesses' Beauty Capital," National Bureau of Economic Research, *Economics Letters*, 2000. Daniel S. Hamermesh, Xin Meng, and Junsen Zhang, "Dress for Success: Does Primping Pay?" *Labour Economics*, 2002.

32 *"Musics cross-culturally"* Denis Dutton, interview with the author, February 7, 2001.

32 *the "focal colors" of white, black* Roger N. Sheparc, "The Perceptual Organization of Colors: An Adaptation to Regularities of the Terrestrial World?" in *The Adapted Mind: Evolutionary Psychology and the Generation of Culture*, Jerome H. Barkow, Leda Cosmides, and John Tooby, eds. (New York: Oxford University Press, 1992), pp. 495–532.

32 *"Our response to beauty is hard-wired"* Nancy Etcoff, *Survival of the Prettiest: The Science of Beauty* (New York: Doubleday, 1999), p. 24.

Chapter Two: The Rise of Look and Feel

34 *In 1927, the influential adman* Earnest Elmo Calkins, "Beauty the New Business Tool," *The Atlantic Monthly*, August 1927, pp. 145–56.

35 *only half of American homes* U.S. Department of Commerce, Bureau of the Census, "Housing: Then and Now, 50 Years of Decennial Censuses," December 2000, http://www.census.gov/hhes/www/ housing/census/histcensushsg.html and http://www.census.gov/hhes/ www/housing/census/historic/plumbing.html. The first housing census was done in 1940 and found that about 45 percent of homes had full plumbing, undoubtedly an increase since the late twenties.

35 *a typical office clerk* Emily H. Huntington and Mary Corringe Luck, *Living on a Moderate Income: The Incomes and Expenditures of Street-Car Men's and Clerks' Families in the San Francisco Bay Region* (Berkeley: University of California Press, 1937), p. 143. While this survey was done in 1933, it replicates 1925 research and finds little change in clothing patterns, other than the substitution of silk stockings for cotton and the disappearance of men's stiff collars.

36 *The most important aesthetic trend* Huntington and Luck write on p. 20, "It was unquestionably the motion picture which in a few short years has practically revolutionized the attitude of the workingman's wife to her own personal appearance and that of her family. Without it the prosperity wave of the early twenties—to judge from previous experiences of increases in buying power in their effect on consumer habits— could not have produced this change in attitude. Even so, it can hardly be said that, within the general level of well-being illustrated by these household accounts, there is much luxury in the provision of personal care."

36 *"convenience and correctness"* Pentagram Design, *Pentagram book five*
 (New York: Monacelli Press, 1999), p. 419. On pre–World War II vari-
 ety, see Regina Lee Blaszczyk, *Imagining Consumers: Design and
 Innovation from Wedgwood to Corning* (Baltimore: The Johns Hopkins
 University Press, 2000). Market research techniques developed in the
 1950s played an important role in standardizing goods to reach the
 largest possible audience.

37 *design historian Thomas Hine* Thomas Hine, *Populuxe: From Tailfins
 and TV Dinners to Barbie Dolls and Fallout Shelters* (New York: MJF
 Books, 1986, 1999), p. 61.

37 *"rationality meant efficiency"* Penny Sparke, *As Long As It's Pink*, p. 78.

37 *Britain's wartime Utility scheme* Judy Attfield, "Good Design by Law:
 Adapting Utility Furniture to Peacetime Production: Domestic
 Furniture in the Reconstruction Period 1946–56," in *Design and
 Cultural Politics in Post-war Britain*, Patrick J. Maguire and Jonathan
 M. Woodham, eds. (London: Leicester University Press, 1997), pp.
 99–109.

38 *"they see the 'contemporary style'"* Earnest Race, quoted in Penny
 Sparke, *As Long As It's Pink*, p. 192.

38 *"the teardrop swelled"* Edgar Kaufmann, "Borax, or the Chromium-
 Plated Calf," *Design Review*, August 1948, pp. 88–92.

39 *"Our conservative men are conservative"* Edith Efron, "New Plumage
 for the Male Animal," *The New York Times Magazine*, September 8,
 1945, pp. 16, 44.

39 *"there's less groupthink"* Michael Bierut, e-mail to the author, May 10,
 2001. Although himself a graphic designer, Bierut is a partner in
 Pentagram, a firm whose work spans all sorts of design, from products
 to architecture and interiors.

39 *Car companies make fewer* B. Peter Pashigian, Brian Bowen, and Eric
 Gould, "Fashion, Styling, and the Within-Season Decline in
 Automobile Prices," *Journal of Law and Economics*, October 1995, pp.
 281–309. Kim B. Clark and Takahiro Fujimoto, *Product Development
 Performance: Strategy, Organization, and Management in the World Auto
 Industry* (Boston: Harvard Business School Press, 1991), p. 8.

41 *the company estimates that between one hundred and one hundred fifty*
 Bob Rodgers, interview with the author, June 7, 2001. Mark Tatge,
 "The Harder Side of Sears," *Forbes*, November 13, 2000, p. 282.

41 *After correcting for inflation* U.S. Census Bureau, "Historical Income

Tables—Families," http://www.census.gov/hhes/income/histinc/
f08.html. The most recent figures are for 2001.

42 *a woman's cashmere turtleneck* The average hourly wage of a produc-
tion and nonsupervisory worker in manufacturing was $4.53 in 1975
and $14.22 in 2001. A cashmere turtleneck was priced at $58 in a Woolf
Brothers department store ad appearing in *The Dallas Morning News*,
December 11, 1975, p. 5. As of May 30, 2001, the Macy's Web site iden-
tified the original price for a comparable cashmere turtleneck as
$79.99. The sale price was $23.99. This method of wage-adjusted com-
parison pricing is adapted from W. Michael Cox and Richard Alm,
Time Well Spent: The Declining Real Cost of Living in America, 1997
Annual Report, Federal Reserve Bank of Dallas. Michael Cox provid-
ed the wage figures above, which are taken from Census data.

42 *The average American woman owns seven pairs* "Price and Fit," Cotton
Inc., *Lifestyle Monitor*, Summer/Fall 2000, p. 6, http://www.cotton-
inc.com/lsm16/homepage.cfm?Page=2531.

42 *"pantries for clothes"* Curtis Rist, "Closet Control," *This Old House
Online*, http://www.thisoldhouse.com/toh/interiors/
article/0,13422,198462,00.html.

42 *Inexpensive, high-quality stone slabs* Michael Reis, editor, *Stone World*,
interview with the author, November 12, 2002.

42 *Consider Christmas lights* David L. Margulius, "Walking in a Wired
Wonderland," *The New York Times*, December 20, 2001, p. G1. David
VanderMolen, e-mail to the author, December 24, 2001.

44 *"We should never have the desire"* Abraham H. Maslow, *Motivation and
Personality*, 3rd edition, (New York: Harper & Row, 1970), p. 7.

44 *"Experiential and aesthetic needs"* Bernd Schmitt and Alex Simonson,
*Marketing Aesthetics: The Strategic Management of Brands, Identity, and
Image* (New York: The Free Press, 1997), p. 321 n.1.

45 *unimaginably poor Stone Age weavers* Elizabeth Wayland Barber,
*Women's Work: The First 20,000 Years: Women, Cloth, and Society in
Early Times* (New York: Norton, 1994), pp. 89–94.

46 *a market for "road candy"* David Kiley, "Baby Boomers Splurge on
'Road Candy,' Just for Fun," *USA Today*, June 21, 2001, p. A1. The
expert quoted is Carol Morgan of Strategic Directions Group.

46 *"If you put out an automotive appliance"* Wes Brown, quoted in Keith
Naughton, "Honda's Midlife Makeover," *Newsweek*, August 5, 2002,
pp. 42–43.

47 *"a wonderfully designed product"* Michael Wurth, interview with the author, September 22, 2000. When interviewed, Wurth had recently become the vice president for innovation and design at Moen Inc. He had previously spent much of his career in the residential and office furniture businesses.

48 *The division of labor* Adam Smith, *An Inquiry Into the Nature and Causes of the Wealth of Nations*, vol. 1, R. H. Campbell and A. S. Skinner, eds. (Indianapolis: Liberty Classics, 1981), pp. 31–36.

48 *"When industrial products are exported"* Peter Zec, "Good Design: Lifestyle and Product Culture for a Global Age," Innovation, Summer 2002, p. 35.

49 *more and more people clustered* John W. Wright, ed., *The New York Times Almanac 2002* (New York: Penguin, 2002), p. 244.

49 *"starting to feather their nests"* Bob Rodgers, interview with the author, June 7, 2001.

49 *"It was the advent of the credit card"* Roger Horchow, interview with the author, May 23, 2001.

50 *home magazines "were gaining"* Hilary Billings speech, AIGA Risk/ Reward Conference, October 7, 2000.

51 *"I can't help patting them"* "Sony's VAIO Triggers Tiny Notebook PC Boom: Designer," *AsiaBizTech*, June 18, 1998, http://www.nikkeibp. asiabiztech.com/Database/98_Jun/18/Inv.01.gwif.html.

51 *"made people look at computing"* Donald Albrecht, quoted in Charles Gibson, "A View of Tomorrow: Everyday Objects Designed for Consumers to Need and Actually Enjoy," *ABC World News Tonight*, March 10, 2000, http://www.abcnews.go.com/onair/CloserLook/wnt_ 000310_CL_design_feature.html.

51 *"The old Beetle had to look"* Owen Edwards, interview with the author, April 2001.

52 *"We think that aesthetics"* Jay Pomeroy, interview with the author, July 19, 2002.

52 *Starbucks designers use 3-D animation* Cayce Justus, "High-Quality In-House 3D Animation: Creating a Starbucks," *PC Graphics & Video Magazine*, November 14, 1997, pp. 32–38.

52 *Software adapted from pilot-training* Chuck Clark, marketing director, E&S RapidSite, interview with the author, June 18, 2001.

53 *"demystify the shapes for the contractor"* Robert Ivy, "Frank Gehry: Plain Talk with a Master," *Architectural Record*, May 1999, p. 184.

53 *"The technology allows a designer"* Mark Dziersk, interview with the author, July 15, 1999. Dziersk was at the time president of the Industrial Design Society of America.

53 *Coming next: realistic three-dimensional* Karen Chan, "Free Floating," *The Wall Street Journal*, June 25, 2002, p. R19.

53 *To embed her intricate textile-design* Jhane Barnes, interview with the author, August 11, 1999.

54 *Journalism professor Carl Sessions Stepp* Carl Sessions Stepp, "Then and Now," *American Journalism Review*, September 1999, pp. 60–75.

54 *A modest commercial typesetter would carry* Barbara Burch, e-mail to the author, June 14, 2001.

55 *Phil's Fonts* Ralph Smith, interview with the author, June 25, 2001, and http://www.philsfonts.com.

55 *"lawyers are giving clients"* Michael Bierut, interview with the author, November 11, 2000.

56 *"We take it for granted"* David Brown, interview with the author, November 9, 2000.

57 *"We've handled this prohibition"* e-mail to the author, July 27, 1999.

58 *Until recently, retailer Chiasso* Dave Marshall, interview with the author, January 4, 2003.

58 *"Design is being democratized"* Frank Gibney Jr. and Belinda Luscombe, "The Redesign of America," *Time*, March 20, 2000, pp. 66–75.

59 *"Last year it was all about manicures"* Elaine Showalter, interview with the author, June 4, 2001.

59 *From 1980 to 2000, the Chinese population* According to the U.S. Census Bureau, there were slightly more than 800,000 U.S. residents of Chinese ethnicity in 1980 and 2.4 million in 2000, slightly less than 1 percent of total residents. The Chinese population of California also tripled, from about 300,000 to nearly 1 million, or about 3 percent of total residents. Ruth Ryon, "Building Industry Shows, Seminars to Examine 'Critical Issue of '90s,'" *Los Angeles Times*, October 15, 1989, p. K9.

60 *"It was similar to discovering"* Sarah Rossbach and Master Lin Yun, *Feng Shui Design* (New York: Viking, 1998), p. 6.

60 *More working mothers mean teenage boys* Ruth La Ferla, "Boys to Men: Fashion Pack Turns Younger," *The New York Times*, July 14, 2002, sec. 9, p. 1.

61 *Today's corporate chieftains* Michael Maccoby speech, Applied
 Brilliance Conference, June 8, 2000. Now a Harvard Business School
 professor, Maccoby sees this trend as an effect of the rise of the entre-
 preneurial "productive narcissist" over the more authority-respecting
 "obsessive" temperament common among corporate executives in the
 Organization Man era.

61 *Twenty-seven percent of males* Kim Kitchings, Cotton Inc. director of
 marketing, interview with the author, May 24, 2002.

61 *Even Chiasso's decidedly unfrilly* Dave Marshall, interviews with the
 author, August 2, 2001, and May 15, 2002.

62 *"A lot of people think I'm gay"* Alex Williams, "You're So Vain," *New
 York*, April 2, 2001, p. 24.

62 *40 percent of his college's students* David Brown, interview with the
 author, July 3, 2001.

62 *"Style represented a challenge"* Barbara Summers, *Black and Beautiful:
 How Women of Color Changed the Fashion Industry* (New York:
 Amistad, 1998, 2001), pp. 41–43. Shane White and Graham White,
 *Stylin': African American Expressive Culture from Its Beginning to the
 Zoot Suit* (Ithaca: Cornell University Press, 1998) has much interesting
 material on the tensions between African Americans' traditionally
 expressive aesthetics and the quest for bourgeois respectability.

63 *In the 1950s, a London art-school student* Julian Robinson, *The Quest for
 Human Beauty: An Illustrated History* (New York: W. W. Norton,
 1998), p. 9.

63 *"a style that is decidedly homosexual"* Holly Brubach, "Men Will Be
 Men," April 1983, in *A Dedicated Follower of Fashion* (London:
 Phaidon Press, 1999), pp. 108–13.

64 *"Nose ring time"* My Hairy Brother, "Nose Ring Time," a parody to
 the tune of "Closing Time" by Semisonic, http://www.myhairybroth-
 er.com/lyrics.htm#noseringtime.

64 *"What if Martha Stewart was a goth?"* Trystan L. Bass, "About Gothic
 Martha Stewart," http://www.toreadors.com/martha/about.html.

Chapter Three: Surface and Substance

67 *"The moral of the story"* Iain Morris, quoted in Eric Nee, "Open Season
 on Carly Fiorina," *Fortune*, July 23, 2001, p. 120.

67 *"see that view as tantamount"* Michael Bierut interview with the
 author, November 11, 2000, and e-mail to the author, May 9, 2001.

68 *"In advertising, packaging, product design"* Stuart Ewen, *All Consuming Images*, pp. 22, 149.

68 *"the machinery of gratification"* Daniel Bell, *The Cultural Contradictions of Capitalism*, 2nd ed. (New York: Basic Books, 1996), pp. 283, 293–94, 70. Bell's 1996 critique is heavily influenced by Warner Sombart's *Luxury and Capitalism*, which in Bell's words "made the idiosyncratic argument that illicit love and the style of life it produced gave rise to luxury—and capitalism." He also cites Rousseau on adornment's origins in falsehood: "Rousseau related what happened in that mythical moment when young men and women, growing up, began to meet around a large tree or campfire, to sing and dance and be 'true children of love and leisure.' But when 'each one began to look at the others and wanted to be looked at himself,' public esteem became a value. 'The one who sang or danced the best, the handsomest, the strongest, the most adroit, or the most eloquent, became the most highly considered; and *that was the first step toward inequality and, at the same time, toward vice.*' Those who had lost out, so to speak, began to dissemble, to adorn themselves, to wear plumage, to be sly or boisterous; in short, 'for one's own advantage to appear to be other than what one in fact was, to be and seem to become two altogether different things; and from this distinction [arise] conspicuous ostentation, deceptive cunning, and all the vices that follow from them,'" pp. 294–95.

69 *"circle of manipulation"* Theodor W. Adorno and Max Horkheimer, "The Culture Industry: Enlightenment as Mass Deception," in Juliet B. Schor and Douglas B. Holt, eds., *The Consumer Society Reader* (New York: The New Press, 2000), pp. 4–5.

70 *"The worship of God is increasingly"* Sinclair B. Ferguson, "'Repent,' Said Jesus; Do Evangelicals Hear Him?'" *The Dallas Morning News*, January 27, 2001, p. 4G. Ferguson is a minister in the Church of Scotland.

70 *One sign of the "age of falsification"* Kenneth Brower, "Photography in the Age of Falsification," *The Atlantic Monthly*, May 1998, p. 93. In Platonic thought, of course, storytelling itself is a suspect act, creating falsehoods.

71 *In the seventeenth century* The first quote is from a sermon by John Donne; the second is from Thomas Tuke's 1616 tract *A Treatise against Painting and Tincturing of Men and Women*. Both are quoted in Frances E. Dolan, "Taking the Pencil out of God's Hand: Art, Nature, and the

Face-Painting Debate in Early Modern England," *PMLA*, March 1993, pp. 224–39.

71 *"civil rights for women that will entitle"* Naomi Wolf, *The Beauty Myth: How Images of Beauty Are Used Against Women* (New York: Anchor Books, 1992), pp. 55–66.

72 *"If you look like you spend too much time"* Emily Toth, quoted in Alison Schneider, "Frumpy or Chic? Tweed or Kente? Sometimes Clothes Make the Professor," *The Chronicle of Higher Education*, January 23, 1998, p. A12.

72 *"The most important thing that I have to say"* Hillary Rodham Clinton, "Remarks of Senator Hillary Rodham Clinton," Class Day, Yale University, May 20, 2001, http://clinton.senate.gov/~clinton/speeches/010520.html.

73 *Hillary Clinton's hair is so famous that there used to be a Web site* The domain name hillaryshair.com now belongs to an unrelated pornography site that draws traffic from the many links still aimed at the old site.

74 *"book about waste"* Robert Frank, *Luxury Fever: Why Money Fails to Satisfy in an Era of Excess* (New York: The Free Press, 1999), p. 9.

74 *"if, within each social group"* Robert Frank, *Luxury Fever*, p. 9.

76 *"the status symbol of the 1990s"* Robert Frank, *Luxury Fever*, p. 24.

76 *"I was convinced that if I built"* . . . *"I love looking at my Viking"* Fred Carl and Tawana Thompson, quoted in Molly O'Neill, "The Viking Invasion," *The New Yorker*, July 29, 2002, pp. 40–45.

77 *"objects as rich in meaning"* James B. Twitchell, *Living It Up: Our Love Affair with Luxury* (New York: Columbia University Press, 2002), p. 1.

77 *"I saw something I hadn't seen before"* James B. Twitchell, *Living It Up*, p. 91.

77 *"I believe myself to be everything"* James B. Twitchell, *Living It Up*, pp. 102–3. Twitchell has his wife play a similarly degraded role on a shopping trip in Palm Beach. Her equally unexpected rebellion takes a different form; she takes off and goes shopping without him, buying luxuries, such as Paloma Picasso earrings, that she likes and can afford on her own salary.

79 *"Typewriters and telephones"* Vance Packard, *The Hidden Persuaders* (New York: David McKay, 1957), p. 172.

79 *"been seduced by the case plastic"* Steven Den Beste, *USS Clueless*, January 7, 2002, http://denbeste.nu/cd_log_entries/2002/01/fog0000000118.shtml.

80 *Consider a story told by Anne Bass* Anne Bass, "The 1980s," *Vogue*, November 1999, pp. 492, 542.

81 *"fashion's X-factor"* Amy M. Spindler, "Are Retail Consultants Missing Fashion's X-Factor?" *The New York Times*, June 13, 1996, p. B8.

82 *"The shifty character"* Anne Hollander, *Sex and Suits* (New York: Kodansha, 1994), pp. 11–12.

82 *Sociologist Stanley Lieberson has studied* Stanley Lieberson, *A Matter of Taste: How Names, Fashions, and Culture Change* (New Haven: Yale University Press, 2000).

83 *"Fashion has its own manifest virtue"* Anne Hollander, *Sex and Suits*, p. 12.

84 *"the jumbling of styles in modern art"* Daniel Bell, *The Cultural Contradictions of Capitalism*, pp. 13–14.

84 *"modern style speaks to a world"* Stuart Ewen, *All Consuming Images*, p. 23.

84 *"On the one hand, style speaks for the rise"* Stuart Ewen, *All Consuming Images*, p. 38.

85 *"The patina of an object allows it"* Grant McCracken, *Culture and Consumption* (Bloomington: Indiana University Press, 1988), p. 35.

85 *"tailor or barber [who] in the excess"* Sir Thomas Elyot, quoted in Grant McCracken, *Culture and Consumption*, p. 33. Spelling has been modernized.

86 *"crops may fail"* Jenna Weissman Joselit, *A Perfect Fit: Clothes, Character, and the Promise of America* (New York: Metropolitan Books, 2001), p. 33.

87 *"Fashion is a perpetual test"* Anne Hollander, *Sex and Suits*, p. 21.

88 *"I try to help her not judge"* Jeffrey Leder, quoted in Abby Ellin, "How Fathers Can Help Daughers in the Body-Image Battle," *The New York Times*, September 18, 2000, p. B7.

88 *When Florida Secretary of State* Janny Scott, "When First Impressions Count," *The New York Times*, December 3, 2000, sec. 4, p. 3. Kim Folstad, "She Monitors Election, We Monitor Her," *The Palm Beach Post*, November 18, 2000, p. 1D. Hayley Kaufman, "Fashion Victim," *The Boston Globe*, November 16, 2000, p. D2.

88 *"Herman Munster"* Mark Steyn, "Game Face Otherwise Occupied," *Chicago Sun-Times*, October 15, 2000, p. 48.

88 *"a big, orange, waxy"* Maureen Dowd, "Dead Heat Humanoids," *The New York Times*, October 5, 2000, p. A35.

88 *"she failed to think"* Robin Givhan, "The Eyelashes Have It," *The Washington Post*, November 18, 2000, p. C1.

89 *"While Gore yammered"* Andrea Peyser, "Oh, How I Wish That I'd Never Voted for Gore," *The New York Post*, November 24, 2000, p. 5.

89 *as Apple discovered* Virginia Postrel, "Can Good Looks Guarantee a Product's Success?" *The New York Times*, July 12, 2001, p. C2.

90 *"a Wal-Mart is 'ugly'"* Dan Hansen, "The Beauty of Wal-Mart," *Happy Fun Pundit*, August 9, 2002, http://happyfunpundit.blogspot.com/ 2002_08_04_happyfunpundit_archive.html.

91 *"As a designer, I am still reeling"* Michael Bierut, e-mail to the author, September 18, 2001.

92 *"One of the signatures"* Michael Bierut, e-mail to the author, September 19, 2001.

92 *The Afghan women* Saira Shah, "Beneath the Veil: The Taliban's Harsh Rule of Afghanistan," *CNN Presents*, September 22, 2001. Virginia Postrel, "Free Hand," *Reason*, March 2002, p. 82.

Chapter Four: Meaningful Looks

94 *"a visual language"* Jessica Helfand, "Hey, Mr. Design Man," *Los Angeles Times Book Review*, January 28, 2001, p. 6.

94 *To an ancient Roman* Michel Pastoureau, *Blue: The History of a Color*, trans. Markus I. Cruse (Princeton: Princeton University Press, 2001).

95 *To the British Victorians* Paul Atterbury, ed., *A.W.N. Pugin: Master of Gothic Revival* (New Haven: Yale University Press, 1995). Paul Atterbury and Clive Wainwright, eds., *Pugin: A Gothic Passion* (New Haven: Yale University Press, 1994). Eve Blau, *Ruskinian Gothic: The Architecture of Deane and Woodward 1845–1861* (Princeton: Princeton University Press, 1982). John Ruskin, *The Stones of Venice*, J. G. Links, ed. (New York: De Capo, 1960).

96 *"By the simple device of building"* Donald Drew Egbert, "The Architecture and the Setting," http://mondrian.princeton.edu/Campus WWW/Otherdocs/setting.html.

96 *Blair Hall not only greeted arriving trains* Raymond P. Rhinehard, *Princeton University: The Campus Guide* (New York: Princeton Architectural Press, 1999), pp. 45–46, 131–2.

97 *"Recently, I visited a large record company"* Jivana, quoted in Francesco Mastalia and Alfonse Pagano, *Dreads* (New York: Artisan, 1999), p 74.

97 *"Over the last eight years that I have worn"* Veronica Chambers, "Hair,"

in *Body: Writers Reflect on Parts of the Body,* Sharon Sloan Fifer and Steve Fifer, eds. (New York: HarperCollins, 1999), pp. 19–27.

98 *"what a person dreamed about at night"* Alice Walker, "Dreads," introduction to Francesco Mastalia and Alfonse Pagano, *Dreads,* pp. 8–9. On the evolution of dreadlocks, see also Ayana D. Byrd and Lori L. Tharps, *Hair Story: Untangling the Roots of Black Hair in America* (New York: St. Martin's, 2001).

100 *"costume echo"* Joey Bartolomeo, "Dress Code," *Allure,* March 2002, p. 84.

100 *"When in doubt, add one."* Jack Yan, quoted in Julia Ptasznik, "Baby Needs a New Pair of Shoes," *Visual Arts Trends,* http://www.visualartstrends.com/Ea/Ea4/eS19-shoes.html. Richard L. Berke, "Gore Dots the i's That Bush Leaves to Others," *The New York Times,* June 9, 2000, p. A-1. Greg Lindsay, "I Want a Unique Logo—Just Like Theirs," *Fortune Advisor/E-Company,* July 2000, p. 334.

100 *"Even if you engage"* Luc Sante, "Be Different! (Like Everyone Else!)," *The New York Times Magazine,* October 17, 1999, pp. 136–40.

100 *"urban tribe"* of Chicago Joey Bartolomeo, "Dress Code."

102 *"I cut my hair very short"* Stuart Ewen, *All Consuming Images,* p. 5.

103 *"All choices of clothing"* Anne Hollander, *Seeing Through Clothes* (Berkeley: University of California Press, 1978), pp. 347–48.

103 *The job of graphic design* Stephen Doyle, interview with the author, January 31, 2002.

104 *"People are amazed"* Brooke McCurdy, interview with the author, August 23, 2000.

105 *"mock-up Macs"* Leander Kahney, "Ersatz Designs Honor Apple," *Wired News,* January 31, 2002, http://www.wired.com/news/mac/ 0,2125,49898,00.html. Leander Kahney, "Master Maker of Mockup Macs," *Wired News,* January 31, 2002, http://www.wired.com/news/ mac/0,2125,49918,00.html. Leander Kahney, "Absorbing Apple's Aesthetic," *Wired News,* February 4, 2002, http://www.wired.com/news/mac/0,2125,49920,00.html. Leander Kahney, "The Passion for Designing Macs," *Wired News,* February 5, 2002, http://www.wired.com/news/mac/0,2125,49971,00.html.

105 *"In advertising"* Stuart Ewen, *All Consuming Images,* p. 22.

105 *Naomi Klein* Naomi Klein, *No Logo* (New York: Picador, 2002).

106 *The same khakis* Samantha Critchell, "Teen's New Book Sends Message: Labels Are for Clothes, Not People," *Los Angeles Times,* July 17, 2002,

sec. 5, p. 4. According to teen author Aisha Muharrar, profiled in the article, "If the shirt is worn with khaki chinos, it signals a 'prep'; if the rest of the outfit is black, the wearer could be a 'goth.' But those super-preppy khaki pants become a 'hippie' style if worn rumpled with a protest shirt."

106 *two chains attract different customers* Richard Martini, senior vice president, design and construction, interview with the author, October 13, 2000.

107 *Cruising the luxury shops* James B. Twitchell, *Living It Up*, pp. 90–91, 119–120.

108 *"The environment I'm in"* Mico Rodriguez, interview with the author, October 19, 2001. Virginia Postrel, "We Are Where We Eat," *D Magazine*, January 2002, pp. 57–59.

109 *"Even if we went to all native plants"* James Ricci, "They're Not Natural, But What Is in This Self-Invented Place?" *Los Angeles Times Magazine*, June 11, 2000, p. 10.

109 *"For architects, to say a work"* Robert Ivy, "Getting Real," *Architectural Record*, November 2001, p. 21.

110 *"Folklore" is the authentic voice* On the pursuit of authenticity within the discipline of folklore and on the difficulties of the concept more generally, see Regina Bendix, *In Search of Authenticity: The Formation of Folklore Studies* (Madison: University of Wisconsin Press, 1997).

110 *"will diminish the authenticity"* Suzanne Stephens, "TWA's Fight for Flight: What Preserves a Landmark Most?" *Architectural Record*, November 2001, pp. 63–66. Some architects, notably Philip Johnson, would rather see the terminal destroyed than used for some other purpose. Witold Rybczynski, "A Cure for Terminal Decline," *The Wall Street Journal*, August 22, 2001, p. A16. Karen Matthews, Associated Press, "Architects Build Case To Preserve Landmark," August 15, 2001.

110 *"white female blues singers"* Kenneth Brower, "Photography in the Age of Falsification," *The Atlantic Monthly*, May 1998, p. 93.

111 *"At Nike, you can't use the* fashion *word"* Coleman Horn, quoted in Jack Hitt, "The Magic of Shoes," *Men's Journal*, September 2001, p. 116.

111 *"if museums look like factories"* Léon Krier, quoted in James Howard Kunstler, "The Modernist Prison," *The American Enterprise*, September/October 1998, http://www.theamericanenterprise.org/taeso98c.htm.

111 *"to her age, her shape"* Wolf's definition of authenticity also includes a reverence for the natural.

111 *"loathing of the term"* Ada Louise Huxtable, *The Unreal America: Architecture and Illusion* (New York: The New Press, 1997), p. 18.

112 *The idea of "aura"* Walter Benjamin, "The Work of Art in the Age of Mechanical Reproduction," in *Illuminations: Essays and Reflections*, ed. Hannah Arendt (New York: Schocken Books, 1968), pp. 220–21.

112 *U.S. Department of the Interior's* National Park Service, Heritage Preservation Services, "Historic Buildings: New Additions," http://www2.cr.nps.gov/tps/tax/rhb/new01.htm. Department of the Interior, Federal Historic Preservation Tax Incentives, "The Secretary of the Interior's Standards for Rehabilitation," http://www2.cr.nps.gov/tps/tax/rehabstandards.htm: "The new work shall be differentiated from the old and shall be compatible with the massing, size, scale, and architectural features to protect the historic integrity of the property and its environment."

113 *"those of us who feel misrepresented"* Joan Kron, *Lift: Wanting, Fearing, and Having a Face-Lift* (New York: Penguin, 1998), p. 89.

115 *When a Cheyenne, Wyoming* Tim Lockwood, "Locals Support, Oppose City Parking Structure," *Wyoming Tribune-Eagle*, November 30, 2001, p. A1.

115 *So are the young Japanese women* Rebecca Mead, "Shopping Rebellion: What the Kids Want," *The New Yorker*, March 18, 2002, p. 109.

116 *"Today, adherence to the 'truth'"* Paola Antonelli, "Mutant Materials in Contemporary Design," http://www.moma.org/exhibitions/mutant-materials/MuMA1.html.

117 *"I am not the sort of woman"* Jane Smiley, "Let There Be Light," *Allure*, September 2001, pp. 147–48.

118 *Denied public respect* African Americans' use of personal style to affirm dignity in the face of public discrimination has been written about in many places. See, for instance, Shane White and Graham White, *Stylin': African American Expressive Culture from Its Beginnings to the Zoot Suit*; Barbara Summers, *Black and Beautiful: How Women of Color Changed the Fashion Industry*; and, on a more particular subject, Michael Cunningham and Craig Marberry, *Crowns: Portraits of Black Women in Church Hats* (New York: Doubleday, 2000).

118 *The popularity of cut glass* Penny Sparke, *As Long As It's Pink: The Sexual Politics of Taste*, pp. 45–46, 59–60.

119 *The Stalinist-era stilyagi* Charles Paul Freund, "In Praise of Vulgarity,"
 Reason, March 2002, pp. 24–35.

120 *One teenager unhappy* For a good discussion of this point, see Jonathan
 Rauch, "Buff Enough," *Reason*, November 2000, pp. 59–61, a review of
 The Adonis Complex: The Secret Crisis of Male Body Obsession, by
 Harrison G. Pope Jr., Katharine A. Phillips, and Roberto Olivardia
 (New York: The Free Press, 2000).

120 *the sort of satisfaction* Mihaly Csikszentmihalyi, *Flow: The Psychology
 of Optimal Experience* (New York: HarperCollins, 1990).

Chapter Five: The Boundaries of Design

122 *Los Angeles artist Mike McNeilly* The building has continuously dis-
 played patriotic murals since February 1999. McNeilly eventually won
 his case in a state appellate court, and the original charges were dropped.
 He continued to illegally erect patriotic murals on the spot, including
 one honoring firefighters and rescue workers after September 11. When
 the city charged him with new offenses for the September 11 mural, the
 American Civil Liberties Union filed a federal lawsuit on his behalf, cit-
 ing his First Amendment right to engage in noncommercial political
 speech. The building's owner, who gave McNeilly permission to erect
 the murals, has also sued the city. Mike McNeilly, interviews with the
 author, July 1999 and June 13, 2002. Gary Mobley, attorney for Mike
 McNeilly, interviews with the author, July 1999 and October 6, 1999.
 Daniel Hienerfeld, interview with the author, July 1999. Virginia
 Postrel, "The Esthetics Police," *Forbes*, November 1, 1999, p. 174. Bob
 Pool, "Yearning to Paint Freely, Artist Battles the City," *Los Angeles
 Times*, May 17, 2000, p. B1. Bob Pool, "Ruling Will Allow Trial of Artist
 over Building Mural," *Los Angeles Times*, May 18, 2000, p. B5. Lawrence
 Ferchaw, "Painter Places Canvas over Mural for Holiday," *Daily Bruin*,
 May 30, 2000, p. 1. *Michael McNeilly v. City of Los Angeles*, complaint for
 injunctive and declaratory relief, U.S. District Court for the Central
 District of California, October 23, 2001.

124 *"The 'not in my backyard' creed"* Kathryn Shattuck, "Beware the Cry of
 'Niyby': Not in Your Backyard!" *The New York Times*, May 11, 2000,
 p. F1. The official quoted is Adolph M. Orlando, a building inspector
 in Scarsdale, New York.

124 *The Highlands Ranch community* Ron Lieber, "Is This *Your* Beautiful
 House?" *Fast Company*, July 2001, pp. 124–40.

125 *A 1993 survey found that 83 percent* Brenda Case Scheer, "The Debate on Design Review," in *Design Review: Challenging Urban Aesthetic Control*, ed. Brenda Case Scheer and Wolfgang F. E. Preiser (New York: Chapman & Hall, 1994), p. 1. Brenda Scheer, e-mail to the author, February 7, 2001. The survey includes only laws, not private covenants. Note that 83 percent of all cities and towns does not mean 83 percent of all people, since many municipalities are fairly small and some of the largest cities don't have design review.

125 *"the* strangest *things"* Brenda Scheer, interview with the author, July 18, 2002.

125 *Minutes of routine meetings* Gladstone, Missouri, City Council meeting minutes, March 27, 2000. Roswell, Georgia, Design Review Board minutes, February 1, 2000.

126 *In Eden Prairie* Chuck Haga, "Do Palm Trees Distort the 'Image' of Eden Prairie?" *Star Tribune*, July 8, 2001, p. 1A. After a spate of bad publicity, the city reached a compromise with the restaurant, allowing it to keep the palm trees for the summer, provided they were replaced with more traditional shade trees in the fall. James Lileks, "Eden Prairie's Parrot Is in a Pickle over Palms," *Star Tribune*, July 13, 2001, p. 3B. Stuart Sudak, "Restaurant's Palm Trees Get Reprieve from City," *Eden Prairie News*, July 11, 2001, http://www.edenprairienews. com/main.asp?Search=1&ArticleID=2021&SectionID=18&SubSectio nID=79&S=1.

126 *Savannah, Georgia* Vernon Mays, "Historic Savannah Says No to Fake Bricks," *Architecture*, December 2000, p. 25.

126 *Mequon, Wisconsin* Mike Johnson, "McDonald's Retro Colors Have Some Seeing Red," *Milwaukee Journal Sentinel*, July 23, 2000, http://www.jsonline.com/news/wauk/jul00/mcdon24072300a.asp.

126 *In Fairfax, Virginia* Tom Jackman, "Freedom Has Its Price in Fairfax," *The Washington Post*, May 25, 2001, p. B1. Leef Smith, "Landscapers Storm Driving Range Early," *The Washington Post*, May 26, 2001, p. B1.

126 *In Portland, Oregon* City of Portland, "Base Zone Design Standards: City Council Adopted Report," July 27, 1999.

126 *"put a stop to the ugly"* Charlie Hales, commissioner, City of Portland, letter to Jane M. Leo, governmental affairs director, Portland Metro Association of Realtors, January 11, 1998.

126 *"To feel secure"* Brenda Case Scheer, "When Design Is Against the Law," *Harvard Design Magazine*, Winter/Spring 1999, p. 47.

127 *"I just take it as a protocol"* Mary Jo Feldstein, "Piercing, Tattoos Create Workplace Issues," Reuters, June 22, 2001.

127 *When Harrah's casino* Rhina Guidos, "Fashion Checklist: No Blush, No Lipstick . . . No Job," *The Christian Science Monitor*, July 17, 2001, p. 1. Martin Griffith, "Nevada Bartender Sues Harrah's over Makeup Policy," Associated Press, July 7, 2001.

127 *When the Dallas Police Department* Drake Witham and Connie Piloto, "Dreadlocks Policy Prompts Complaint," *The Dallas Morning News*, May 30, 2001, p. A16. Connie Piloto, "Officer Fired for Not Cutting Dreadlocks," *The Dallas Morning News*, June 2, 2001, p. A31. Teresa Gubbins, "Identity Crisis: Police Hairstyle Restrictions Forced Soul-Searching Decisions," *The Dallas Morning News*, January 29, 2002, p. C1.

129 *"young, very friendly"* Chris Warhurst and Dennis Nickson, *Looking Good, Sounding Right: Style Counselling in the New Economy* (London: The Industrial Society, 2001), p. 15.

129 *After celebrity hotelier Ian Schrager U.S. Equal Opportunity Commission v. Ian Schrager Hotels Inc.*, Second Amended Complaint, U.S. District Court, Central District of California, July 20, 2000. U.S. Equal Employment Opportunity Commission, "EEOC and Mondrian Hotel Settle Title VII Lawsuit," press release, August 9, 2000, http://www.eeoc.gov/press/8-9-00.html. The EEOC's suit charged that the hotel discriminated in its recruitment practices, which included "hiring talent agencies to locate prospective hotel employees, searching for prospective employees at a shopping mall and placing advertisements in entertainment trade publications seeking individuals who are 'high energy, upbeat, handsome/pretty with cool looking individual style.'" Virginia Postrel, "When the 'Cool' Look Is Illegal," *Forbes*, November 27, 2000, p. 90.

129 *A jury made up of uncool* Eric Steele, interview with the author, September 7, 2000.

129 *"would also have to be multiage"* Michael S. Mitchell, interview with the author, August 16, 2000.

129 *The EEOC's lawyer* Donna Harper, the EEOC's acting assistant general counsel in Mondrian case, interview with the author, September 6, 2000.

130 *Jazzercise Inc. declined to certify* Elizabeth Fernandez, "Teacher Says Fat, Fitness Can Mix; S.F. Mediates Complaint Jazzercise Showed Bias," *The San Francisco Chronicle*, February 24, 2002, p. A21. Patricia

Leigh Brown, "240 Pounds, Persistent and Jazzercise's Equal," *The New York Times*, May 8, 2002, p. A20. City and County of San Francisco Human Rights Commission, "Compliance Guidelines To Prohibit Weight and Height Discrimination," July 26, 2001, http://www.ci.sf.ca.us/sfhumanrights/guidelines_final.htm. Portnick declined Jazzercise's eventual offer of employment.

131 *"Don't tell me her 'appearance'"* Ellen Goodman, "'Fat Chance' to Fat Chic," *The Boston Globe*, March 31, 2002, p. E7.

131 *The hosts of ABC's* Elizabeth Fernandez, "Size-16 Aerobics Teacher Gets National Attention," *The San Francisco Chronicle*, March 18, 2002, p. A11.

131 *"Surely, there must be room"* "Battle over Fitness," *The San Francisco Chronicle*, March 1, 2002, p. A34.

133 *the minutes of the design review board* Mount Pleasant, South Carolina, Commercial Development Design Review Board minutes, April 24, 2002.

134 *"Design review turns"* . . . *"In short"* Denise Scott Brown, "With the Best of Intentions," *Harvard Design Magazine*, Winter/Spring 1999, pp. 37–42.

134 *"Projects submitted were more and more acceptable"* Brenda Case Scheer, "The Debate on Design Review," p. 2. Despite all the limitations on architects' designs, Scheer also says she found the process "lame," unable to affect the larger-scale features of urban life. Brenda Scheer, interview with the author, July 18, 2002.

135 *"all over the country, in every state"* Brenda Case Scheer, "When Design Is Against the Law," p. 47.

136 *"demonstrated that a modern architect"* Raymond P. Rhinehart, *Princeton University: The Campus Guide* (New York: Princeton University Architectural Press, 2000), p. 123.

136 *"It is the outer layer which is saying"* Robert Venturi, interview with the author, June 9, 2002.

136 *"a little Potemkin façade"* . . . *"We have a long experience"* Thomas Wright, interview with the author, July 24, 2002.

137 *With a typical combination of anger* Robert Venturi, "Frist Campus Frieze—Definition and Justification: The Polite (Sort of) Version," memo, March 24, 1998, and "Why the Tasteful Frieze on the Front of the Frist Campus Center Is Not a Vulgar Sign but a Tasteful Frieze— Designed Also by a Highfalutin' Architect," memo, March 23, 1998. Jennifer Potash, "Campus Center Approval Expected," *The Princeton*

Packet, July 7, 1998, http://www.pacpubserver.com/new/news/7-7-98/center.html. Jonathan Goldberg, "University Receives Approval for Building of Frist Loggia," *The Daily Princetonian*, October 14, 1998, http://www.dailyprincetonian.com/content/1998/10/14/news/goldberg.html. Jim Wallace, Venturi, Scott Brown and Associates, e-mail to the author, June 10, 2002.

138 *"If you go to Germany"* Pierluigi Zappacosta, interview with the author, September 27, 2000.

139 *"something for 'everyone'"* Zandl Group, "Shopping Attitudes," press release, July 22, 2002.

139 *While air or water pollution* I do not mean to minimize the difficulty of setting environmental standards or the controversies that often swirl around them. The point is that it is not possible *even in theory* to establish objective standards of aesthetic pollution levels. At best, we might be able to measure an effect on real estate prices, which themselves reflect subjective tastes and can thus fluctuate with the fashion cycle or the makeup of the community.

140 *reflecting personal quirks* Robert Venturi notes that the death or retirement of a design review board member often changes what architectural plans a board will approve. Review boards are not generally elected, and members often hold office indefinitely. Robert Venturi, interview with the author, June 9, 2002.

140 *The Washington Fine Arts Commission* Richard Tseng-yu Lai, "Can the Process of Architectural Design Review Withstand Constitutional Scrutiny?" in Brenda Case Scheer and Wolfgang F. E. Preiser, eds., *Design Review: Challenging Urban Aesthetic Control* (New York: Chapman & Hall, 1994), pp. 31–41. "Given the human nature of all professionals," writes Lai, "expertness can just as easily be a cloak for dogma and subjectivity as a basis for disinterested objectivity."

140 *When Bard College proposed* Tracie Rozhon, "From Gehry, a Bilbao on the Hudson," *The New York Times*, August 20, 1998, p. F1. Tracie Rozhon, "Bard College Bends on Arts Center," *The New York Times*, February 19, 1999, p. B5. The added cost was because the relocated center could no longer share dressing rooms and other facilities with existing buildings.

140 *"The Bard development was a modernist"* William Baldwin, note to the author, October 6, 1999.

140 *Not surprisingly, most aesthetic conflicts* The aesthetic ratchet effect may

itself be considered an externality—though whether it's positive (because it raises standards) or negative (because it raises costs) depends on who's doing the evaluating. In *Luxury Fever*, Robert Frank treats the effect as a negative externality, ignoring the positive spillovers of a more appealing world.

141 *Economist Ronald Coase asked* R. H. Coase, "The Problem of Social Cost," in *The Firm, the Market, and the Law* (Chicago: University of Chicago Press, 1988), pp. 95–156. (Reprinted from *The Journal of Law and Economics*, October 1960, pp. 1–44.)

142 *In either case, the pollution will be set* Obviously, the final allocation of money does depend on who starts out with the rights and gets paid to transfer them. But to a third party observing only the pollution level, the world looks the same in either case.

142 *especially when a lot of people are involved* Even when there are no transaction costs, there can still be problems if the group involved is large enough. Avinash Dixit and Mancur Olson, "Does Voluntary Participation Undermine the Coase Theorem," *Journal of Public Economics,* June 2000, pp. 309–35.

144 *Because the social value of mobile phone* Christine Woodside, "Cell Phone Towers Are Sprouting in Unlikely Places," *The New York Times*, January 9, 2000, sec. 14CN (Connecticut Weekly), p. 1.

144 *A big-box store whose architecture* Peter Glen, "Here Comes the Neighborhood," *VM+SD Magazine*, November 1999, http://www.visu alstore.com/people/glen/pglen1199.html. "A New Wal-Mart. Custom Fit for Your Neighborhood," Wal-Mart brochure.

145 *"They want us essentially to tear"* David Kiser, quoted in Martha Elson, "Family's Dream Home, Neighbors' Nightmare," *The Courier-Journal*, April 25, 2002, http://www.courier-journal.com/ localnews/2002/04/25/ke042502s194117.htm. Deed restrictions dating to 1925 specified that house exteriors must be of brick, brick veneer, stucco, or stone, but the restrictions hadn't been enforced for decades; many homes in the neighborhood had façades of wood, vinyl, or aluminum siding. Martha Elson, "Judge to Decide Fate of Lakeside House," *The Courier-Journal*, April 27, 2002, p. 8-B. Martha Elson, "Contemporary House's Owners Win Court Case," *The Courier-Journal*, July 24, 2002, http://courier-journal.com/local-news/2002/07/24/ke072402s247377.htm.

145 *"a beautiful addition"* John Gilderbloom, quoted in Martha Elson, "Family's Dream Home, Neighbors' Nightmare."

146 *If you don't like the rules* National boundaries, like the difference between Switzerland and Italy, are obviously drawn way too expansively for this approach. The switching costs are too high.

147 *In Louisville, some of the most* Allison Arieff, "Slugging It Out in Louisville," *Dwell*, April 2002, pp. 42–51. Martha Elson, "Family's Dream Home, Neighbors' Nightmare."

148 *"high-production, high-velocity"* Steve Kellenberg, interview with the author, April 19, 2002.

152 *From 1970 to 2002,* Robert H. Nelson, "Local Government as Private Property," mimeo., May 2002.

152 *Some proposals envision* Robert H. Nelson, "Privatizing the Neighborhood: A Proposal to Replace Zoning with Private Collective Property Rights to Existing Neighborhoods," *George Mason Law Review*, Summer 1999, pp. 827–80. William A. Fischel, "Voting, Risk Aversion, and the NIMBY Syndrome: A Comment on Robert Nelson's 'Privatizing the Neighborhood,'" *George Mason Law Review*, Summer 1999, pp. 881–903. Steven J. Eagle, "Privatizing Urban Land Use Regulation: The Problem of Consent," *George Mason Law Review*, Summer 1999, pp. 905–21. These scholars don't seem to have substantially addressed the model provided by existing preservation districts, which tend to be at a similar scale and usually require a supermajority of local residents to petition for district status.

152 *"if artists were to concentrate"* Robert Ellickson, "New Institutions for Old Neighborhoods," *Duke Law Journal*, October 1998, pp. 75–110.

153 *In Los Angeles* Los Angeles Municipal Code, Ordinance 174422, effective March 11, 2002.

153 *A San Fernando Valley resident* Adriene Biondo, interview with the author, February 20, 2002.

154 *"If you get the lots right"* Brenda Scheer, interview with the author, July 18, 2002.

154 *It echoes the pattern identified by Stewart Brand* Stewart Brand, *How Buildings Learn: What Happens After They're Built* (New York: Penguin Books, 1994), pp. 12–23.

155 *"tacky, in bad taste"* Barbara Baer Capitman, *Deco Delights: Preserving the Beauty and Joy of Miami Beach Architecture* (New York: Dutton, 1988), pp. 42, 16. Also, see Denise Scott Brown, "My Miami Beach," *Interview*, September 1986, pp. 156–58.

156 *Los Angeles has spent* Kevin Starr, "Landscape Electric," *Los Angeles*

Times, July 4, 1999, pp. M1, M6. Nathan Marsak and Nigel Cox, *Los Angeles Neon* (Atglen, Penn.: Schiffer, 2002).

156 *a critic called the Golden Gate Bridge* Cited in John J. Costonis, *Icons and Aliens: Law, Aesthetics, and Environmental Change* (Urbana: University of Illinois Press, 1989), frontispiece.

156 *"Because of his idiosyncratic"* Suzanne Stephens, "The Difficulty of Beauty," *Architectural Record*, November 2000, pp. 96–97.

157 *Acclaimed twenty years earlier* "The Twentieth Century's Worst Design Ideas," *Metropolis*, August/September 2002, p. 154. The list is labeled "humor," but is at least partly serious.

157 *After the Twin Towers* David Dillon, "Building Debate: Should Towers Go Up Again," *The Dallas Morning News*, September 16, 2001, p. 23A. Kari Haskell, "Before & After: Talking of the Towers," *The New York Times*, September 16, 2001, sec. 4, p. 4. Michael Fainelli, "Twin Giants: What Will Fill Their Shoes?" *The Christian Science Monitor*, October 4, 2001, p. 17.

158 *"Let's face it"* John English, quoted in Scott Timberg, "Modern Love," *New Times Los Angeles*, July 11–17, 2002, p. 13.

158 *Even Mount Vernon* "Mount Vernon Fact Sheet," http://www. mountvernon.org/press/mv_fact.asp.

159 *"respond to our perception"* John J. Costonis, *Icons and Aliens*, p. 37.

159 *Consider Oklahoma City's Gold Dome* Gregory Potts, "Protesters Stage Rally To Save Golden Dome," *The Daily Oklahoman*, July 24, 2001, p. 1A. Gregory Potts, "Dome Support Spreads; Bank One Plan Meets Protests," *The Sunday Oklahoman*, July 29, 2001, sec. 3, p. 1. Gregory Potts, "Bank One To Try Selling Gold Dome; Decision Encourages Preservationists," *The Daily Oklahoman*, August 2, 2001, p. 1A. Arnold Hamilton, "Raising the Gold Standard," *The Dallas Morning News*, August 16, 2001, p. 23A. Jody Noerdlinger, "Economics, History Weigh in Dome's Fate; Bank One's Bottom Line May Seal Building's Future," *The Daily Oklahoman*, December 27, 2001, p. 1C. Arnold Hamilton, "Optometrist's Bid May Save Landmark," *The Dallas Morning News*, May 20, 2002, p. 17A.

159 *In the era of ATMs* Because of federal and state regulations, the era of convenience came late to banking, while banks in the 1950s and 1960s lavished spending on their buildings, making the industry a notable exception to today's aesthetic imperative. Virginia Postrel, "The New Republic," *D Magazine*, December 2001, pp. 48–52.

159 *"It may be financial folly"* Charles Crumpley, "Dome Creates Dilemma," *The Sunday Oklahoman*, July 22, 2001, p. 1C.

160 *"All things being equal"* Bill Scheihing, president of Bank One Oklahoma, quoted in "Contract Delivered in Bid To Save Landmark Building," Associated Press, May 18, 2002.

160 *At particular issue are four-room* Jason Hardin, "Row of Houses Spared, But Owner Says Restoration Too Costly," *The Post and Courier*, May 23, 2002, p. 3B. Herb Frazier, "Owner of Freedmen's Cottage Receives Demolition Approval," *The Post and Courier*, September 22, 1998, p. 1B.

161 *Giving the public a voice* A similar approach is to give building owners tax breaks or other compensation, in exchange for agreeing to maintain iconic structures. Unfortunately, in practice such incentives tend to emphasize authenticity-as-purity rather than icons-as-communal-meaning, often selecting buildings for historical details or "living museum" purposes and paying undue attention to aesthetic minutiae.

161 *"the culture of aesthetic poverty"* Brenda Case Scheer, "Sympathy with the Devil: Design Review and the Culture of Aesthetic Poverty," *Loeb Fellowship Forum*, Spring/Summer 1996, http://www.scheerand scheer.com/aesthetic.pdf.

Chapter Six: Smart and Pretty

165 *"When Mr. Schy opened"* Shirley Leung, "Local Restaurants Find Big Chains Eating Their Lunch," *The Wall Street Journal*, July 9, 2002, pp. A1, A8.

166 *"In science, the lab report"* Joanne Jacobs, "Dumb, But Pretty," *Tech Central Station*, January 31, 2002, http://www.techcentralstation.com/ 1051/techwrapper.jsp?PID=1051-250&CID=1051-013102A.

167 *"Crayola curriculum"* Donna Harrington-Lueker, "'Crayola Curriculum' Takes Over," *USA Today*, September 16, 2002, p. 13A.

170 *"I think that young children"* Erica Eden Cohen, quoted in Jenny Schnetzer, "Tooling Around," *I.D. Magazine*, October 2002, p. 63.

170 *Galileo used pictures* For more on the relation between art and natural science in Galileo's day, see David Freedberg, *The Eye of the Lynx: Galileo, His Friends, and the Beginning of Modern Natural History* (Chicago: University of Chicago Press, 2002).

171 *"Luxury is a word"* David Hume, "Of Refinement in the Arts," *Essays on Economics*, ed. Eugene Rotwin (Madison: University of Wisconsin

Press, 1970), pp. 19–20. Following current conventions, a few commas have been removed to improve readability.

173 *"Because the savings in labor costs"* Leslie Kaufman, "A Walk on the Wild Side Stirs the Shoe Industry," *The New York Times*, July 9, 2000, sec. 3, p. 8. Increased sales without higher profit margins would increase productivity somewhat if shoe companies have significant fixed costs.

173 *Adjusted for inflation, the price of a movie ticket* Robert Sahr, "Movie Ticket Prices in Current and Constant (2001) Dollars, Selected Years 1935 to 2001," compiled from Department of Commerce and Motion Picture Association of America data, http://www.orst.edu/Dept/pol_sci/fac/sahr/movie.htm.

174 *The more we invest in aesthetics* On the general problem, without specific reference to aesthetics, see Advisory Commission to Study the Consumer Price Index, Michael J. Boskin, chairman, *Toward a More Accurate Measure of the Cost of Living: Final Report to the Senate Finance Committee*, December 4, 1996. Mark Bils and Peter J. Klenow, "The Acceleration of Variety Growth," *American Economic Review*, May 2001, pp. 274–80.

175 *"The emphasis now on grooming"* Elaine Showalter, interview with the author, June 4, 2001.

176 *We were headed toward a "two-tier" society Crossfire*, CNN, January 2, 1995. Jeremy Rifkin, *The End of Work* (New York: G. P. Putnam, 1995).

176 *"The notion now that a corporation"* David Brown, interview with the author, November 9, 2000.

177 *"What seems normal to me"* Gully Wells, "The Buddy System," *Vogue*, April 2001, p. 311.

177 *the demand for style experts* In some cases, the official statistics haven't kept up. The Bureau of Labor Statistics identifies "manicurist" as one of the fastest-growing jobs but grossly undercounts the number of people practicing the profession, which requires state licenses for both individuals and nail salons. The BLS estimates the number of manicurists at around 40,000, while the annual *Nails* magazine survey of state licensing statistics counts more than 300,000. There are nearly 50,000 nail salons in the United States, most employing more than one manicurist, and there are enough manicurists to support three trade magazines, suggesting that the *Nails* estimate is much

closer to reality. Virginia Postrel, "The Acrylic Sector," *Forbes*, November 2, 1998, p. 104. U.S. Department of Labor, Bureau of Labor Statistics, *Occupational Outlook Handbook 2002–03 Edition*, http://www.bls.gov/oco/ocos169.htm. *Nails Fact Book 2001–2002*, p. 40.

177 *"I have more eight-year-olds"* Laurie Smith, quoted in "Night and Day," *ASID Icon*, August 2002, p. 14.

178 *"Design is* not *style"* Paola Antonelli, quoted in "A Conversation About the Good, the Bad, and the Ugly," *Wired*, January 2001, p. 179.

178 *"interior design shows' mission"* "Night and Day," *ASID Icon*, August 2002, p. 14.

179 *"When color computer displays"* "Emotion and Affect," interview with Don Norman, *Ubiquity*, http://www.acm.org/ubiquity/interviews/d_norman_2.html.

180 *"change the parameters of thought"* Donald A. Norman, "Emotion & Design," *Interactions*, July–August 2002, pp. 36–42.

180 *"At one of our meetings, the state's Secretary"* Richard Florida, *The Rise of the Creative Class: And How It's Transforming Work, Leisure, Community and Everyday Life* (New York: Basic Books, 2002), pp. 85–86.

181 *"We span the whole spectrum"* George Joblove, senior vice president for technology at Sony Pictures Imageworks, quoted in Michael A. Hiltzik, "Digital Cinema Take 2," *Technology Review*, September 2002, p. 41.

182 *"By the time I was thirteen"* Barbara Robinette Moss, "The Other Side of Ugly," *Allure*, September 2000, pp. 132–35.

183 *"always planned on discovering"* Barbara Robinette Moss, quoted in Patricia Beard, "Skin Deep," *Elle*, August 2000, p. 109.

183 *"a thoroughly superficial identity"* Norah Vincent, "San Francisco Gives In to Theorists: Welcome to the Transsexual Age," *Village Voice*, May 21, 2001, p. 14. Writing about sex-change operations, as opposed to purely cosmetic surgeries, Vincent rejects the connection between our physical and metaphysical selves, mocking the idea that physical transformations can be more than "mere exercises in vanity" or can allow people to "be themselves." She writes that transsexuality "signifies the death of the self, the soul, that good old-fashioned indubitable 'I' so beloved of Descartes, whose great adage 'I think, therefore I am' has become an ontological joke on the order of 'I tinker and there I am.' . . . Being yourself used to be metaphysical. It had nothing to do with what

you wore or which set of genitals you had. It was sexless, and genderless, and classless. It just was, and always had been since the day you were born." This vision of the self largely rejects its corporeal existence, along with the important role of surfaces in signaling to others who we are.

185 *"Instead of a secret weapon"* Lynn Snowden, "Face Forward," *Vogue*, August 2002, p. 256.

186 *"She feels she must be beautiful"* Rick Bragg, "Beauty Reigns Supreme in a Florida Enclave," *The New York Times*, May 28, 2000, p. A1.

187 *To stoke fears of genetic medicine WorldWatch*, July/August 2002. The political subtext was that people with blue eyes are Nazis or the products of totalitarian eugenics. A cover of blue-eyed blondes with café-au-lait skin would not have carried the same baggage. Leaving aside fears of skin cancer, few critics object when naturally fair people seek to be tan.

187 *cosmetic gene therapy* George Cook, quoted in Clive Cookson, "Unease Over 'Beauty Genes'," FT.com, January 25, 2001, http://specials.ft.com/davos2001/FT3ED70YEIC.html. Rick Weiss, "Cosmetic Gene Therapy's Thorny Traits," *The Washington Post*, October 12, 1997, p. A1. Devin Friedman, "The Makeup That Changes Your Identity," *The New York Times Magazine*, June 11, 2000, pp. 56–57. E. M. Swift and Don Yaeger, "Unnatural Selection," *Sports Illustrated*, May 14, 2001, pp. 86–94.

188 *"The fashionistas don't write books"* David Brooks, "The Clothing of the American Mind," *The Weekly Standard*, March 12, 2001, p. 29.

189 *"Feeling—perception, emotion"* Bruce Sterling, "The Beautiful and the Sublime," in *Crystal Express* (New York: Ace Books, 1989), pp. 181–209.

190 *"If there's anything we've recognized"* . . . Glenda Bailey, editor in chief, *Harper's Bazaar*, and Karim Rashid, interviewed by Francine Maroukian, "What's Really Important," *Town and Country*, January 2002, p. 80.

191 *"What really endures are artifacts"* Ibid.

ACKNOWLEDGMENTS

Someone once said journalism is getting your education in public and being paid for it. The great fun of writing this book was learning about the world of aesthetics. I'm deeply indebted to the many design professionals, businesspeople, and cultural analysts who generously shared their time and ideas with me.

I learned a lot from attending the conferences of the Industrial Design Society of America and the American Institute for Graphic Arts. I thank *Architecture* and *Interiors* magazines for inviting me to speak at their Applied Brilliance Conference and the Urban Land Institute for a similar invitation to its conference on master-planned communities.

Much of this book was researched and written while I was editor-at-large of *Reason* magazine. I'm grateful to *Reason* editor in chief Nick Gillespie and former Reason Foundation presidents Bob Poole and Lynn Scarlett for their moral and financial support and to *Reason* reporters Jessica Cater, Ryan Sager, and Rhys Southan for their research assistance.

I was fortunate to spend a week as a media fellow at the Hoover Institution at Stanford University, whose library was a great

resource. At the Southern Methodist University library Carol Baker kindly arranged research borrowing privileges for me.

Several editors gave me the opportunity to explore these topics in articles, both before and after I embarked on the book. I thank Peter Passell at the *Milken Institute Review*; Jim Michaels, Bill Baldwin, and Betty Franklin at *Forbes*; Tom Redburn and Hubert Herring at *The New York Times*; and Wick Allison and Jennifer Chininis at *D Magazine*.

I owe a huge debt to the many friends and readers of my dynamist.com Web site who cheered on the book's progress, answered questions I posted on the site, sent e-mails with their own aesthetic observations, and forwarded virtual clips from local newspapers and other publications I might not have otherwise seen. A number are quoted in the book, but there are more than I can thank individually.

Michael Cox of the Federal Reserve Bank of Dallas let me rummage through his files of old Sears catalogs and other historic materials to compare prices of aesthetic goods.

Karlyn Bowman of the American Enterprise Institute provided current and historical information on polls about political candidates' looks.

Nick Gillespie, Lynn Scarlett, Denis Dutton, and Grant McCracken read early chapter drafts, and Michael Bierut, Lynne Kiesling, and Brink Lindsey read later versions. All provided valuable feedback. Pete Klenow of the Minneapolis Fed reviewed the price-index discussion in chapter 6 for accuracy; the conclusions are my own. Richard Tracey and David Young proofread the page proofs. Judy Kip did the index.

I thank my agents Andrew Wylie and Sarah Chalfant for their enthusiasm and professionalism—the combination every writer hopes for in an agent.

The same combination is what every writer needs in an editor, and Tim Duggan provided it. He was a delight to work with.

Without Chuck Freund's careful reading, tough and thoughtful critiques, ongoing interest, and general brilliance, this book would be a much poorer work.

My greatest debt is always to my beloved husband, Steven Postrel. His initial skepticism about its premise made this book better, as did his patient critiques of many, many chapter drafts and our ongoing conversations about the book's definitions and arguments. Steve always gives me honest criticism and, even more important, he makes me happy.

This book is dedicated to him and to the memory of two formidable women who understood that surface and substance can and should coexist: the brilliant journalist Edith Efron, whose last few works I was proud to publish and whose friendship I cherished, and my grandmother, Margaret Inman, whose beauty and love of "fine things" never detracted from her belief in the fundamental importance of good character.

INDEX